FIVE HUNDRED
SELF-PORTRAITS

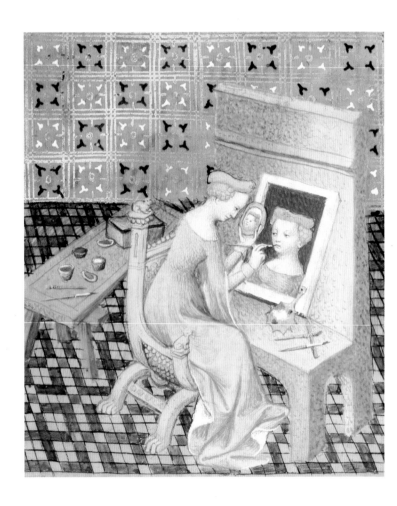

ANONYMOUS
*Marcia Painting her Self-Portrait, c.*1402
Detail from an illuminated manuscript
Bibliothèque Nationale, Paris

FIVE HUNDRED
SELF-PORTRAITS

4

INTRODUCTION BY JULIAN BELL

I HAVE A FACE, BUT A FACE IS NOT WHAT I AM. Behind it lies a mind, which you do not see but which looks out on you. This face, which you see but I do not, is a medium I own to express something of what I am. Or so it seems till I turn to the mirror. Then, my face may seem to own me; to confront me as a condition to which I am bound.

Ways exist to modify that condition – make-up, moustaches or the like – and in some cultures the chance may come to shake loose of it entirely, if only for a night, beneath a mask. But alternatively, I could try to face up to my face. I could examine the ways in which it defines my nature; setting down a record of it, I could explore the assertion, 'That is me.'

Self-portraiture is a singular, in-turned art. Something eerie lurks in its fingering of the edge between seer and seen. Looking over the faces collected in this book, we may be disconcerted by the cumulative intensity of so many wary, wondering, self-surprised eyes. Yet what unites the individuals gathered to stare is that they are all artists. People, that is, prepared to set down their self-examination in markings that may be examined by others. Seen in this light, as a set of crafted statements, the collection becomes a sociological record of the ways a certain trade has opted to present itself. There is comedy as well as unease, as we catch on to the compromised eagerness at once to

astonish and to ingratiate that runs through this profession of self-promoters. And often we fall for their self-presentations. It is stimulating to think that we are seeing Raphael in his youth [p. 64] or Picasso at his end [p. 353] 'as they saw themselves', but it might be more accurate to say that we are looking at fictions, in which the evidence of the mirror has been masterfully edited. What confronts us: five hundred unveilings, or a ream of further masks?

This volume is based on an identically titled book by Ludwig Goldscheider, published in 1937. Updating his work, we have again faced the questions he faced. What are the limits of self-portraiture as a tradition? Are there characteristics that hold these pictures together as an artistic genre? And are some examples of this everyone-to-themselves practice in some way more crucial, more exemplary than others?

The answers are bound up with the meanings we now give to 'selfhood' or individuality. Looking at world art history, most of what people have made looks towards or represents the shared concerns of their societies. To introduce a unique, unshared testimony – *this is me, I saw this scene* – could be a way to make such shared stories more compelling. This device of proposing a me signalling my presence within the picture – and thus a you outside it whom I address – can cut across the sideways-moving space of the surrounding scene. Ni-Ankh-Ptah [p. 11] – the earliest known self-portraitist, enjoying a drink while his Egyptian sailors joust – and Brother Rufillus [p. 14], the monk sneaking himself into his own initial, are not so much witnesses as contrary, disruptive presences. In the latter case, evidently, there is a spirit of pushiness abroad, one caught from the jostling competitive world of European medieval town guilds.

Probably the classical art world, which had its celebrity artists, had had its self-portraits – Roman writers credit the Greek sculptors Phidias and Theodore with them, and tell of a painter named Marcia working from her mirror – but the evidence is too fragmentary to argue from. Evidence as to quite how many portrait heads of the early Renaissance represent their own makers is also disputed by scholars, though those we have included here all come with long traditions attesting this status. What is certain, however, is that between the turn of the fifteenth century, when a manuscript illumination depicts Marcia at her work [frontispiece], and 1500, when Dürer searches in himself for the likeness of Christ [p. 46], self-portraiture moves from the margins of Western art to centre-stage.

The factors of the shift are multiple. On a simple practical level, larger and flatter mirrors were being manufactured in Venice. On a social level, the push to upgrade the artist's status led Italians such as Alberti [p. 19] to commemorate themselves in the manner mentioned by the classical texts; while in spiritual affairs, the crumbling credibility of the Church after its schisms meant that preaching was directed as never before towards the emotions and judgement of the solitary soul. Newly emboldened as artists, newly perturbed as individuals, Dürer and his fellows in pre-Reformation Germany discovered a new world of self – an isolated zone of intense and restless consciousness, tied to no visible object but a set of features.

Dürer's images stake out a definition of the individual as primary and central that successors can only re-enact for themselves – whether in the line of male artists that stretches to Samuel Palmer [p. 263] and Stanley Spencer [p. 463], or in female claims for an equivalent sense of artistic self-determination, like Artemisia Gentileschi [p. 155] fitting herself up for the allegorical figure of 'Painting'. Each such rediscovery of the isolated self comes with its own surprise: Zacharie Vincent, the Huron Indian picking up his European portraitist's brush [p. 281], or Alice Neel, staking out pictorial rights for the elderly female body [p. 512], introduce a startling sense of modern individuality into new contexts.

Yet what we have here is not simply a scattering of islands of self. Setting them together, it is tempting to sketch some provisional chart of the assembled archipelago. What are the social and cultural co-ordinates on these achieved points of solitude?

'How do I look?' is the first question most of us ask of the mirror: the *how* being measured on the shared, communal scales of beauty and age. A lucky few, like Luis Meléndez [p. 215] and Elisabeth Vigée-Lebrun [p. 236], have good enough material for their own vanity to pull off a crowd-pleaser; but more often, a tempered, disappointed self-assessment emerges, even if most artists manage to escape Félix Vallotton's withering contempt for the features supplied him by birth [p. 321] or the curse that transformed Diego Rivera into a toad [p. 471]. If it is vanity that leads artists to worry over their wrinkles, it is a kind of integrity that leads them to transcribe them. Here I am, goes the common account, caught up in this decaying flesh, and where am I bound? Spelling out the inevitable answer becomes a habitual concomitant to self-inspection: when artists from Gerrit Bakhuizen [p. 211] and Johann Zoffany

[p. 232] to Edvard Munch [p. 338] point to the bone beneath the flesh, each is looking for fresh ways to animate an old-established rhetoric of honesty.

The attempt to confront death may be soberingly honest, but it always carries in itself a kind of consolation. 'The work lives' remains a hope implicit in any act of making, and sometimes it can be seen written all over self-portraitists' faces. Some hope to commit their likenesses to the plane of the ideal and eternal – classicists like Nicolas Poussin [p. 149] or Bertel Thorvaldsen [p. 271]. Others, notably in the twentieth century, hope to align themselves with the impersonal, the dynamic, the cosmic. 'I am simply an instrument; a medium; a unit in the scheme; just one more object for observation': these are common messages in modern self-portraiture, whether by El Lissitsky [p. 420], by Chuck Close [p. 500] or Francesco Clemente [p. 508], and maybe they too are ways of consoling oneself, insofar as they are only half-truths. (Artists, it is true, have long set mirrors on the one model who never needs paying when they simply require material for observation. But it is the presence of some here-I-am indication that distinguishes self-portraiture from figure painting in general.)

On a more modest plane, artists seek reassurance by signing up for the arts club. They want a place on the walls of the Uffizi in Florence, where worthy palette-holders have been accumulating in profusion ever since Cardinal Leopoldo de' Medici started his unique collection of self-portraits in 1664. They look for ways to hobnob with this company – by adopting the cloaks and poses of distinguished forebears, by donning the melancholy mien customarily assigned to their saturnine vocation (Carlo Dolci [p. 185]), or by sprawling ostentatiously in the clutter of their trade. Scruffy seventeenth-century Dutchmen like Adriaen van Ostade [p. 178] offer early versions of the bohemian chic that would take on new Romantic meanings in the early nineteenth century. The contrasting urge, to demonstrate to the clientele that the artist is a perfectly socialized amenable all-rounder, dominated not only in the Renaissance but among the urbane, role-friendly individuals of the eighteenth century. It lost out historically: the artist as devout Christian, honest citizen, loving spouse and parent has been overshadowed in the communal imagination by the artist as epitome of alienation, angst and defiance.

During the century following Courbet's *Desperate Man* [p. 273] of 1844, the serial self-portrait was an outstanding mode of expressing this vision. Following the examples of Michelangelo posing as a flayed skin [p. 81] and

Caravaggio as a severed head [p. 113], modern art's line of male protagonists did not so much analyse as melodramatize their own physiognomies, subjecting them to extreme renditions in extreme predicaments. Their quest for existential heroism often risked absurdity; it is easier to get along with the scowls of Giorgio de Chirico [pp. 414–15] or Lovis Corinth [pp. 344–5] if one infers a knowing element of bluster in their act. But a will to induce imaginative discomfort, whether social or physical, is integral to this heyday of self-portraiture. Women of the era also handle the sensation of pain, but as a rule more soberly than the men; the rawest of all paintings-as-woundings being Frida Kahlo's oeuvre of self-images [pp. 464–5].

Kahlo treats her subjectivity as subject-matter, like another painter might treat light. The posture-parading of the early twentieth century yields to a predominantly investigative, cool handling of the specimen of selfhood in more recent art. Individuality, body, gender all become matters for speculative exploration. Does this new handling of self-portraiture indicate some broad shift towards a postmodern version of personality which separates us from the past? You can best judge by the flavour of your own responses to the faces collected here. Are their eyes, like those of animals, ultimately opaque to us, or do they return a common humanity that brings other times and places (even if only from a tiny swathe within world history) as close to us as the mirror we confront? While I gaze, my own sense of self, and the distinctness of the individual who made what I am looking at, seem to feed upon and grow off one another.

9

Yet this mutual promotion of individuality and art – the genre's cultural contribution, you might say – is a symbiosis of precarious fictions. A trickle of painters in the wake of Dürer's pictorial discovery of the modern self nag away at its fundamental instability. Italians like Giovanni Battista Paggi [p. 106] explore the subversive potential of the self-portrait-with-companion; while Annibale Carracci, late in his neurotic career, produces one of the most disruptively anomalous canvases of his age [p. 115]. Does the painting within his painting adequately represent himself, or is not the subject of his experience rather the irresolute gloom in which it stands lost? A comparable restlessness with the means and meanings of self-portraiture fires the greatest and most obsessive of all its practitioners. Every conceivable motive makes its presence felt somewhere among Rembrandt's two-hundred-odd self-images; but what abides beyond all factors, even their humour and their pathos, is a drive to find some pictorial equivalent for the spirit, the

consciousness within him [pp. 134–43]. However richly he reimagines his own physicality, however intently he peers into the dark of his own gaze, it is a drive that can never be satiated.

This volume has a kind of celebrity interest – what the famous names looked like – but the image that seems most nearly to epitomize its whole enterprise comes, perhaps fittingly, from a virtual nobody, a painter forgotten but for his comedy surname. Johannes Gumpp [p. 164], an Austrian in Florence in 1646 who seems to remember Carracci's scurried cat and dog, paints mirror, canvas, painter locked in an enclosed circle, the hope of delivering a complete self-representation shifting forever from one to the other. The painter keeps his back turned: what I am you cannot see.

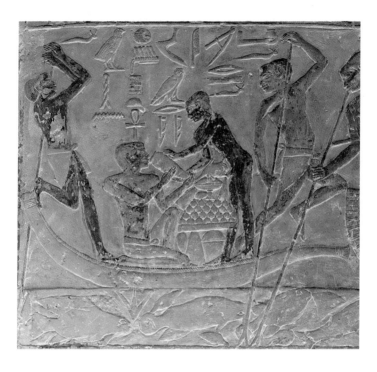

NI-ANKH-PTAH (dates unknown)
Self-Portrait, Kneeling in a Boat, c.2350 BC
Detail from a limestone relief depicting a mock river-battle
Tomb of the vizier Ptah-Hotep, Saqqara, Egypt

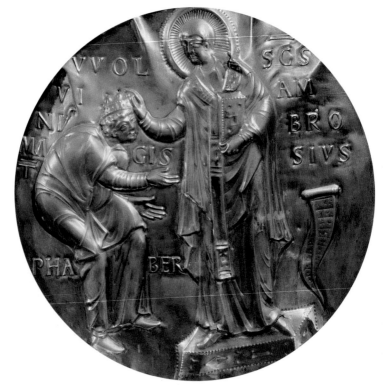

VUOLVINIUS (dates unknown)
Vuolvinius the Smith Receiving a Crown from Saint Ambrose, c.835
Roundel on the back of the Golden Altar, silver gilt
S. Ambrogio, Milan

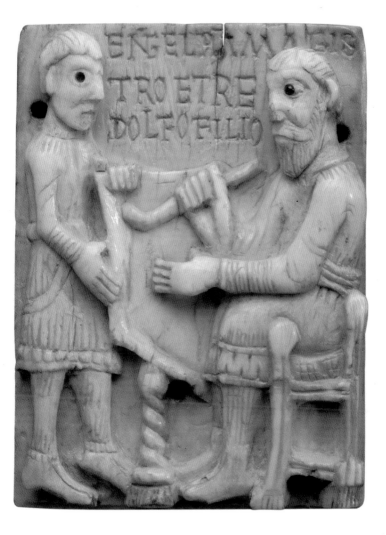

13

ENGELRAMNUS (dates unknown)
*Self-Portrait, c.*1070 (self-portrait, seated figure)
Plaque from an ivory casket
Hermitage, St Petersburg

14

BROTHER RUFILLUS (dates unknown)
Self-Portrait, 12th century
Decorated initial from an illuminated manuscript
Bibliotheca Bodmeriana, Geneva

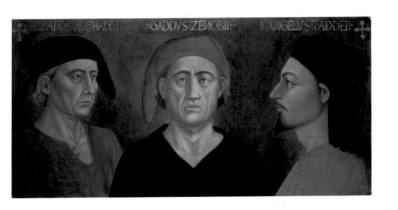

AGNOLO GADDI (*fl.*1369–96)
*Self-Portrait, c.*1380 (self-portrait on right)
Tempera on wood, 47 × 89 cm (18½ × 35 in)
Uffizi, Florence

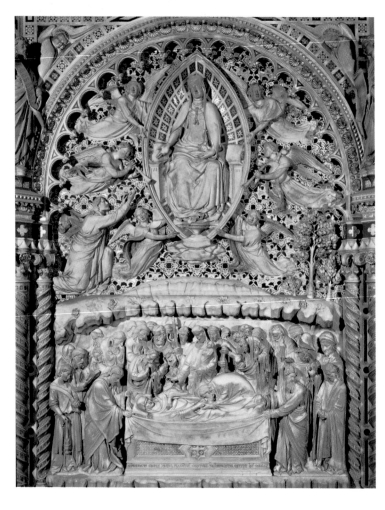

16

ANDREA ORCAGNA (1315/20–68)
Death and Assumption of the Virgin, 1352–60 (self-portrait lower right)
Marble relief from the Tabernacle
Or San Michele, Florence

Detail from *Death and Assumption of the Virgin*

18

LEON BATTISTA ALBERTI (1404–72)
Self-Portrait, c.1436
Bronze plaque, 20.1 × 13.6 cm (7⅞ × 5⅜ in)
National Gallery of Art, Washington DC

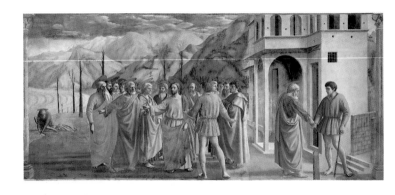

20

MASACCIO (1401–28)
The Tribute Money, 1425–8 (self-portrait wearing a red cloak, right of main group)
Fresco, 2.5 × 6 m (8 × 19 ft 8 in)
Brancacci Chapel, S. Maria del Carmine, Florence

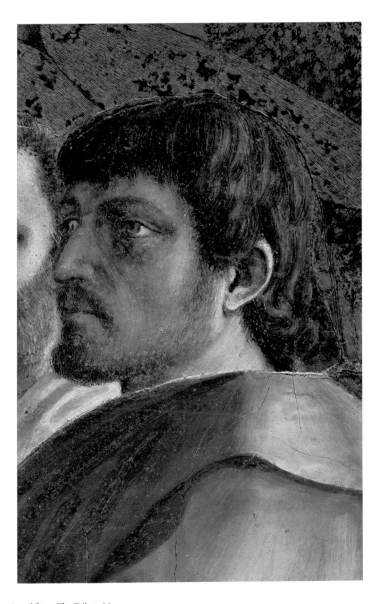

21

Detail from *The Tribute Money*

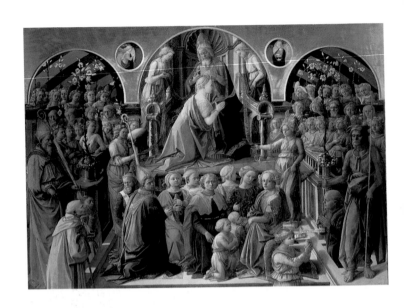

22

FILIPPO LIPPI (*c.*1406–69)
Coronation of the Virgin, 1439–47 (self-portrait kneeling on left, with his chin in his hand)
Tempera on wood, 200 × 287 cm (78¾ × 113 in)
Uffizi, Florence

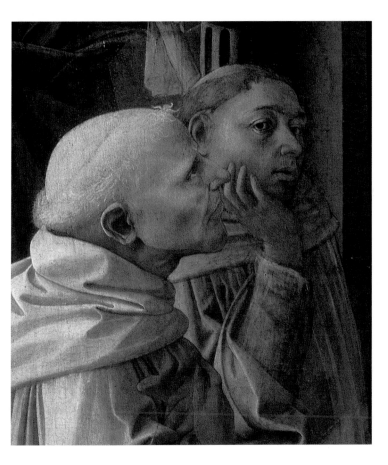

Detail of the *Coronation of the Virgin*

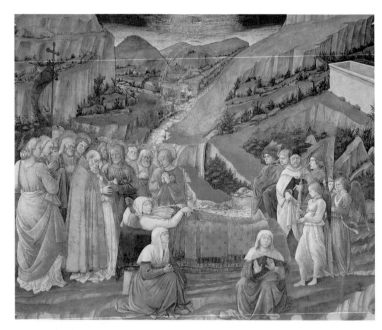

24

FILIPPO LIPPI (*c*.1406–69)
Dormition and Assumption of the Virgin, 1466–9 (self-portrait wearing a black cap, right-hand group of figures)
Fresco
Cathedral of Santa Maria Assunta, Spoleto

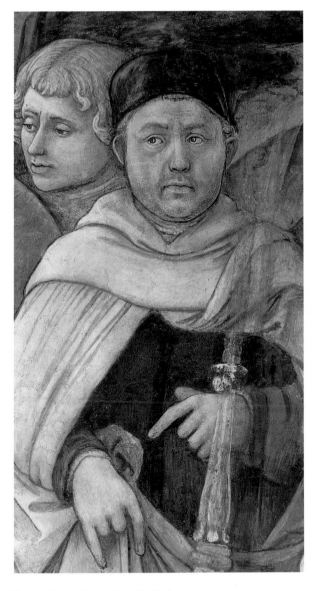

Detail of the *Dormition and Assumption of the Virgin*

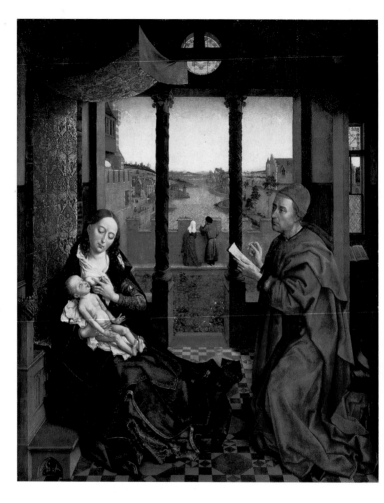

26

ROGER VAN DER WEYDEN (*c.*1399–1464)
*Saint Luke Drawing the Virgin and Child, c.*1435 (self-portrait as Saint Luke)
Oil on wood, 137.5 × 110.8 cm (54$^{1}/_{8}$ × 43$^{5}/_{8}$ in)
Museum of Fine Arts, Boston

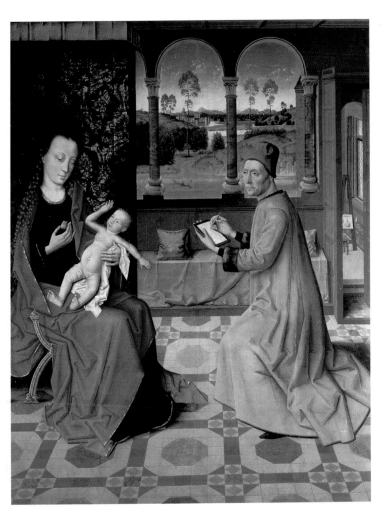

DIERIC BOUTS (c.1415–75)
Saint Luke Drawing the Virgin and Child, c.1455 (self-portrait as Saint Luke)
Oil on canvas transferred from wood, 109 × 86 cm (42⅛ × 33⅞ in)
Private collection

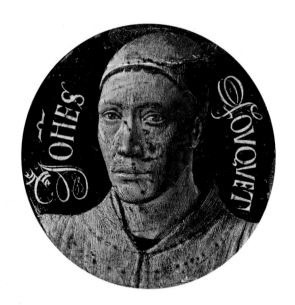

28

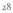

JEAN FOUQUET (*c.*1420–*c.*1481)
*Self-Portrait, c.*1450
Gold and enamel on copper, diameter 7 cm (2³⁄₄ in)
Louvre, Paris

LORENZO GHIBERTI (1378–1455)
Self-Portrait, 1450
Detail of gilt bronze door frame
Baptistery, Florence

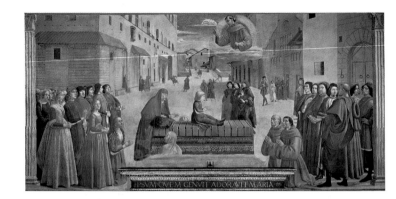

DOMENICO GHIRLANDAIO (1448/9–94)
Saint Francis Restoring a Child to Life, c.1458 (self-portrait, figure on far right)
Fresco
S. Trinità, Florence

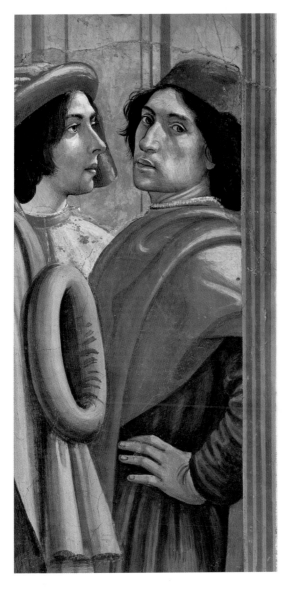

Detail from *Saint Francis Restoring a Child to Life*

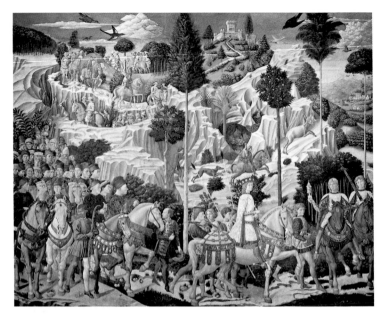

32

BENOZZO GOZZOLI (c.1420–97)
The Procession of the Magi, 1459 (self-portrait in a red cap, centre of group on left)
Fresco
Palazzo Medici–Riccardi, Florence

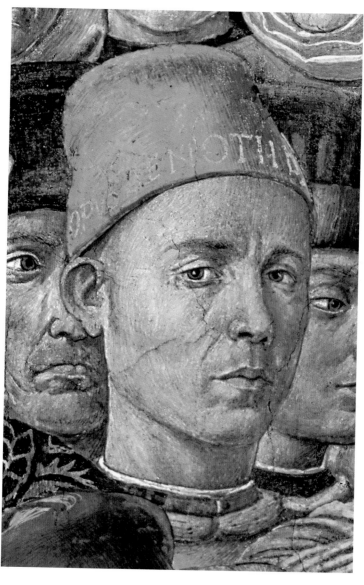

33

Detail from *The Procession of the Magi*

34

ANDREA MANTEGNA (1431–1506)
The Presentation in the Temple, c.1460 (self-portrait in background on right)
Tempera on canvas, 68.9 × 86.3 cm (27^1/8 × 34 in)
Gemäldegalerie, Berlin

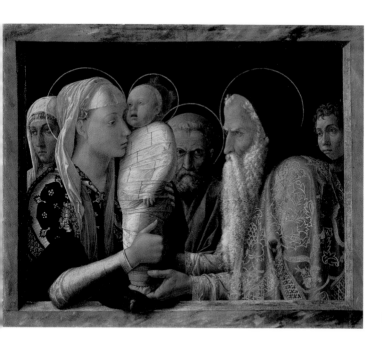

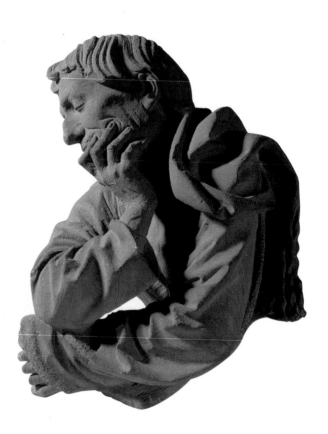

NICOLAUS GERHAERT (*fl.*1462–73)
*Self-Portrait, c.*1467
Sandstone, 44 × 32 × 31 cm (17⅝ × 12⅝ × 12¼ in)
Musée de l'Oeuvre Notre-Dame de Strasbourg

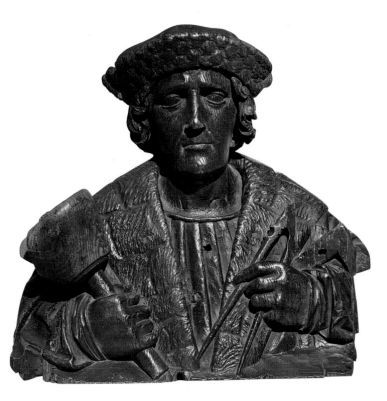

HEINRICH ISELIN (*d.*1513)
*Self-Portrait, c.*1510
Wood carving from a choir stall, 31.5 × 34 × 4 cm (12³⁄₈ × 13³⁄₈ × 1⁵⁄₈ in)
Rosgartenmuseum, Constance

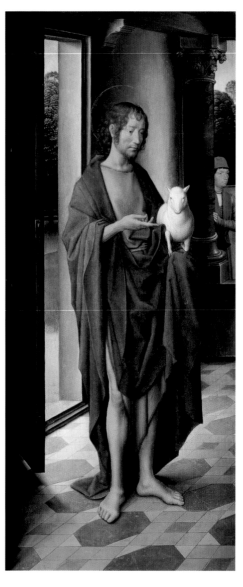

38

HANS MEMLING (1430/40–94)
Saint John the Baptist, c.1475 (self-portrait peering round pillar)
Left wing of a triptych, oil on wood, 71.1 × 30 cm (28 × 11⁷⁄₈ in)
National Gallery, London

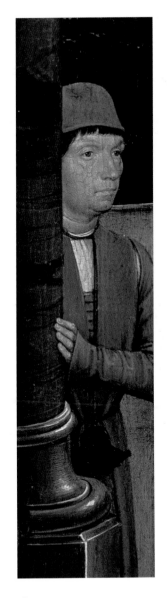

Detail from *Saint John the Baptist*

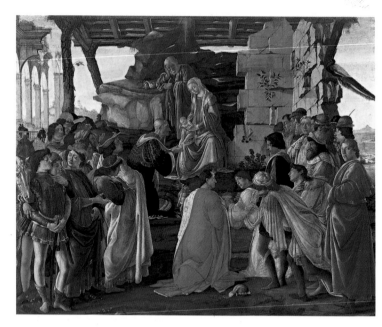

40

SANDRO BOTTICELLI (1444/5–1510)
Adoration of the Magi, 1476 (self-portrait, figure on the far right)
Tempera on wood, 111 × 134 cm (43³⁄₄ × 52³⁄₄ in)
Uffizi, Florence

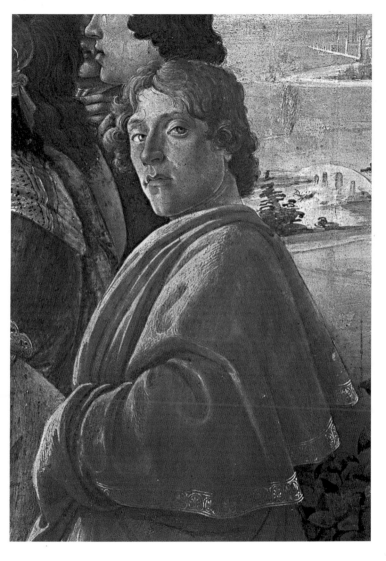

Detail from the *Adoration of the Magi*

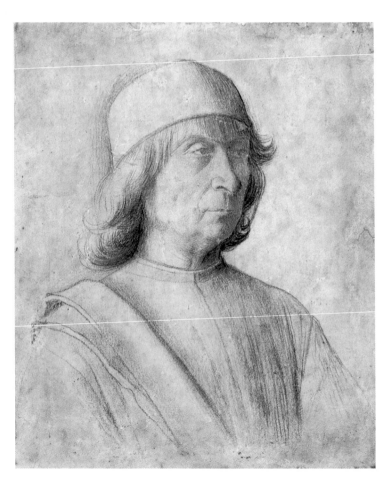

GENTILE BELLINI (1429?–1507)
Self-Portrait, 1480
Silverpoint on paper, 23 × 19.5 cm (9 × 7⁵⁄₈ in)
Kupferstichkabinett, Berlin

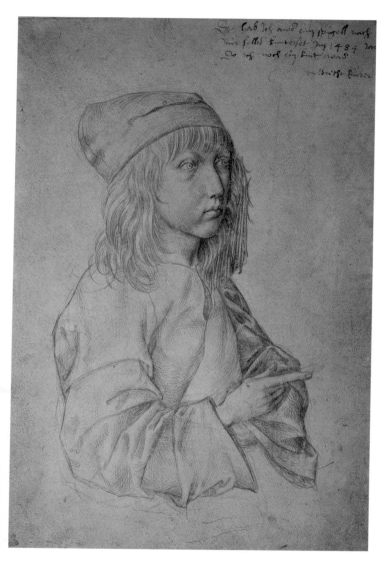

ALBRECHT DÜRER (1471–1528)
Self-Portrait at 13, 1484
Silver point on paper, 27.5 × 19.6 cm (10⁷/₈ × 7³/₄ in)
Graphische Sammlung Albertina, Vienna

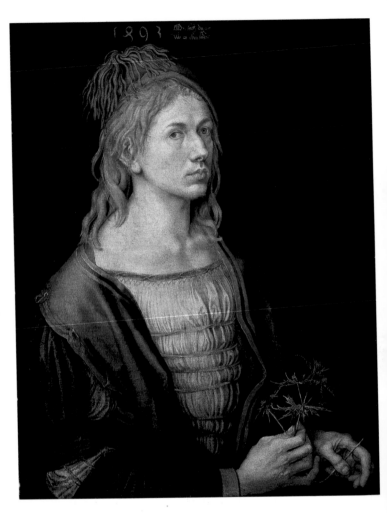

44

ALBRECHT DÜRER (1471–1528)
Portrait of the Artist with a Thistle, 1493
Oil on parchment on canvas, 56 × 44 cm (22 × 17⅛ in)
Louvre, Paris

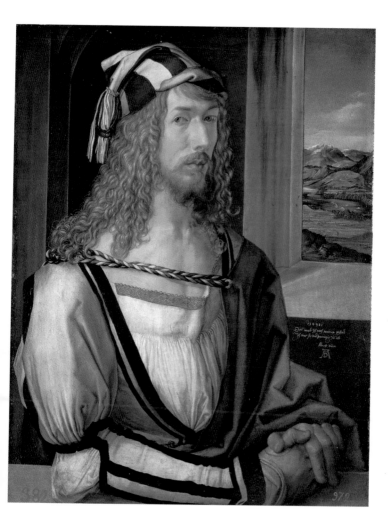

ALBRECHT DÜRER (1471–1528)
Self-Portrait with Landscape, 1498
Oil on wood, 52 × 41 cm (20¹⁄₂ × 16¹⁄₈ in)
Prado, Madrid

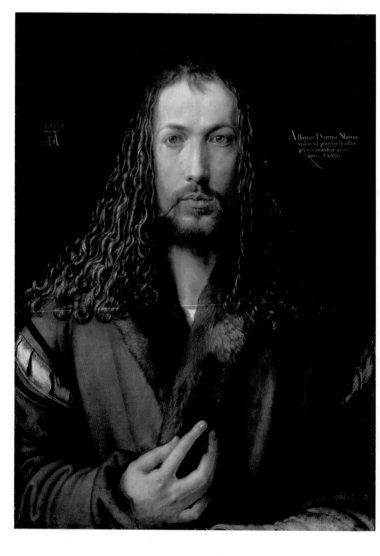

46

ALBRECHT DÜRER (1471–1528)
Self-Portrait, 1500
Oil on wood, 67 × 49 cm (26³⁄₈ × 19¹⁄₄ in)
Alte Pinakothek, Munich

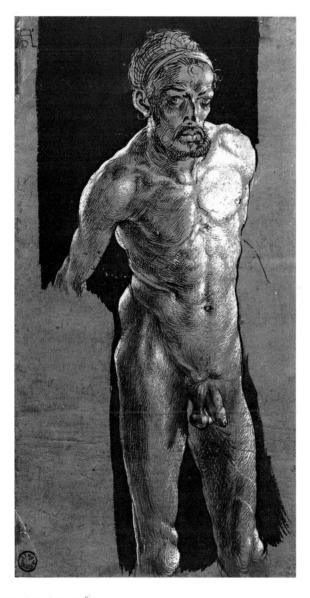

47

ALBRECHT DÜRER (1471–1528)
*Self-Portrait in the Nude, c.*1507
Black ink heightened with white on green paper, 29.2 × 15.4 cm (11¹⁄₂ × 6¹⁄₈ in)
Schlossmuseum, Weimar

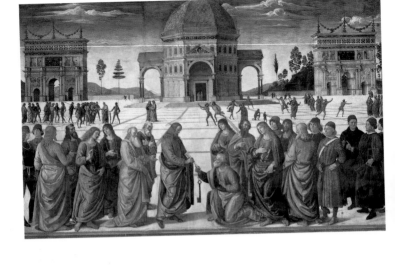

48

PERUGINO (c.1450–1523)
Christ Giving the Keys to Saint Peter, c.1480–2 (self-portrait, fifth figure from right)
Fresco
Sistine Chapel, Vatican, Rome

Detail from *Christ Giving the Keys to Saint Peter*

FILIPPINO LIPPI (1457/8–1504)
*Self-Portrait, c.*1485 (detail)
Fresco on ceramic tile, dimensions of whole 50 × 31 cm (19³⁄₄ × 12¹⁄₄ in)
Uffizi, Florence

LORENZO DI CREDI (c.1457–1536)
Self-Portrait, 1488
Oil on wood transferred to canvas, 46 × 32.5 cm (18 × 12¾ in)
National Gallery of Art, Washington DC

52

Figuracio · facierum · Israhelis · et · Ide · eius · vxoris · · I · V · M ·

ISRAHEL VAN MECKENEM THE YOUNGER (1440/5–1503)
*The Artist and His Wife Ida, c.*1490
Engraving, 12 × 17 cm (4³⁄₄ × 6³⁄₄ in)

MASTER OF FRANKFURT (1460–1533?)
Portrait of the Artist and his Wife, 1496
Oil on wood, 37.5 × 26 cm (14³⁄₄ × 10¹⁄₂ in)
Koninklijk Museum voor Schone Kunsten, Antwerp

ADAM KRAFT (*c.*1460–*c.*1508)
Self-Portrait, 1493–6
Stone carving on the Shrine of the Sacrament
St Lorenz, Nuremberg

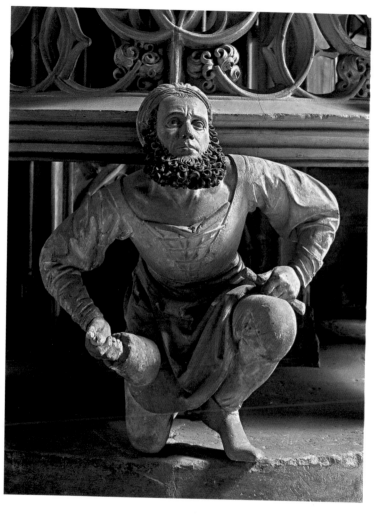

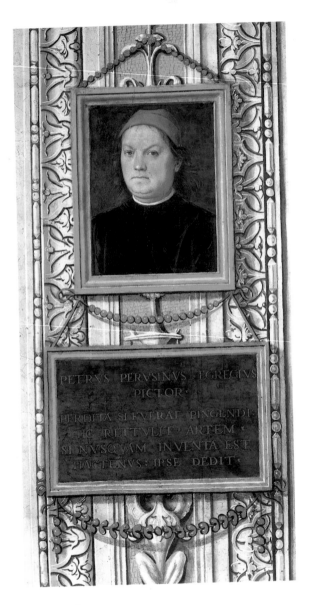

56

PETRVS PERVSINVS EGREGIVS
PICTOR·

PERDITA SI FVERAT PINGENDI
HIC RETTVLIT ARTEM
SI NVSQVAM INVENTA EST
HACTENVS· IPSE DEDIT·

PERUGINO (c.1450–1523)
Self-Portrait, 1496
Trompe l'oeil pilaster, detail from a fresco scheme
Collegio del Cambio, Perugia

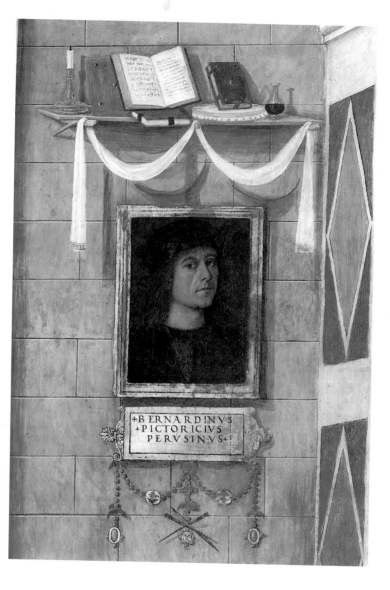

57

BERNARDINO PINTURICCHIO (c.1452–1513)
Self-Portrait, 1502
Trompe l'oeil detail from an *Annunciation* fresco
Santa Maria Maggiore, Spello

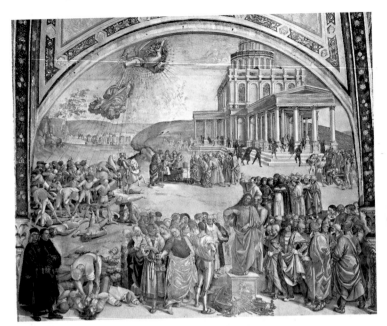

58

LUCA SIGNORELLI (c.1450–1523)
The Appearance of the Antichrist, 1500 (self-portrait, far left)
Fresco
Orvieto Cathedral

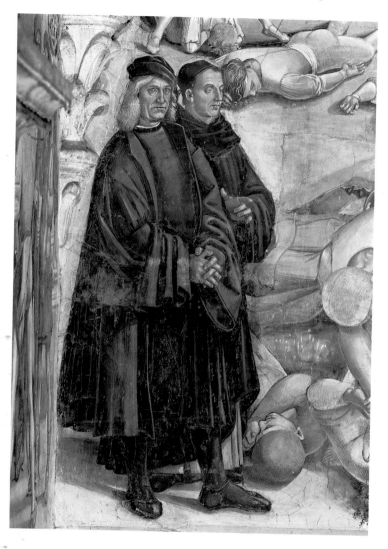

59

Detail from *The Appearance of the Antichrist*

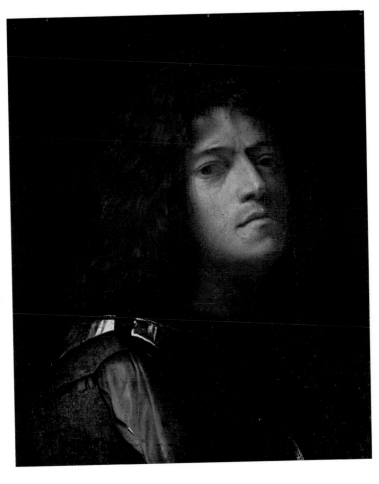

60

GIORGIONE (c.1477–1510)
Self-Portrait as David, c.1500
Oil on canvas, 52 × 43 cm (20½ × 17 in)
Herzog Anton-Ulrich Museum, Braunschweig

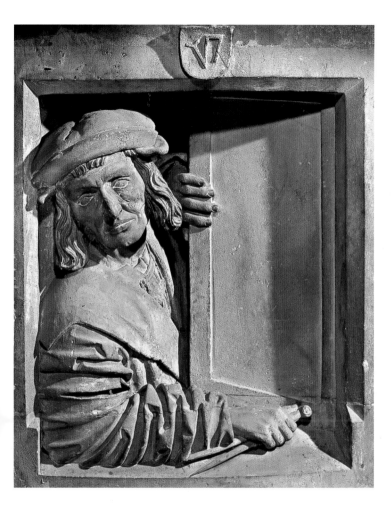

ANTON PILGRAM (c.1450–1515)
Self-Portrait, c.1512–13
Stone carving beneath the organ loft, 64 × 52 × 33 cm (25¼ × 20½ × 13 in)
St Stephen's Cathedral, Vienna

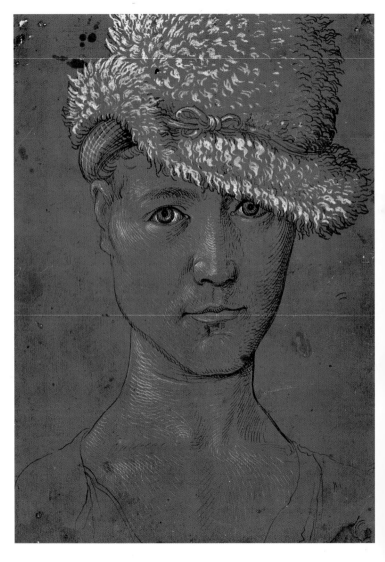

62

HANS BALDUNG (1484/5–1545)
Self-Portrait, 1504
Lead on grey paper heightened with white, 22 × 16 cm (8⅝ × 6¼ in)
Kupferstichkabinett, Basle

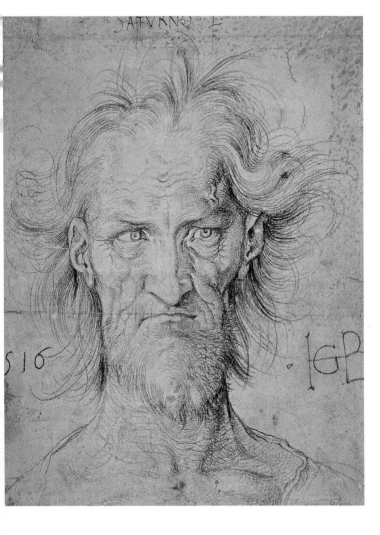

63

HANS BALDUNG (1484/5–1545)
Head of Saturn, or *The Melancholic Temperament*, 1516
Black chalk on paper, 33.2 × 25.5 cm (13$\frac{1}{8}$ × 10 in)
Graphische Sammlung Albertina, Vienna

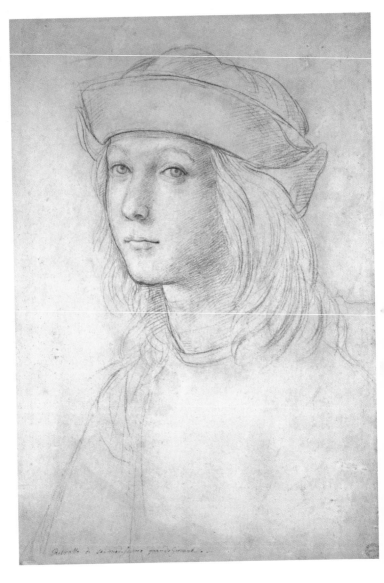

64

RAPHAEL (1483–1520)
Self-Portrait, c.1504
Black chalk on paper, 38 × 26 cm (15 × 10¼ in)
Ashmolean Museum, Oxford

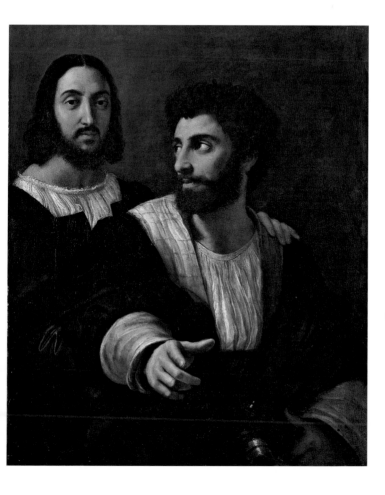

65

RAPHAEL (1483–1520)
Portrait of the Artist with a Friend, 1518 (self-portrait on left)
Oil on canvas, 99 × 83 cm (39 × 32¾ in)
Louvre, Paris

66

Detail of the *Assumption of the Virgin* altarpiece

GÉRARD DAVID (*c*.1460–1523)
Virgo inter Virgines, *c*.1509 (self-portrait, top left)
Oil on wood, 120 × 213 cm (47¹⁄₄ × 80 in)
Musée des Beaux-Arts, Rouen

Detail from the *Virgo inter Virgines*

HANS KERN (dates unknown)
Self-Portrait, 1512
Detail of carved wood choir-stall
Spitalskirche, Baden-Baden

PETER VISCHER THE ELDER (*c*.1460–1529)
Self-Portrait, 1510
Brass figure from the Shrine of Saint Sebald, height 35 cm (17½ in)
St Sebald, Nuremberg

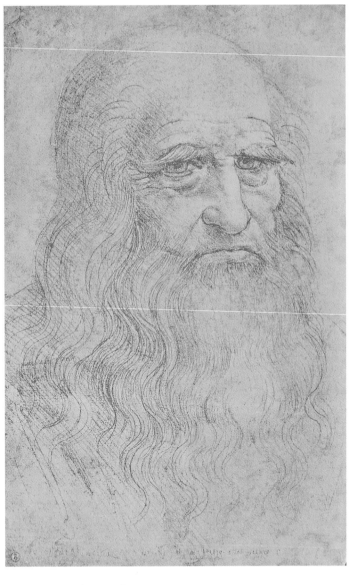

LEONARDO DA VINCI (1452–1519)
Self-Portrait, 1510
Red chalk on paper, 33.3 × 21.4 cm (13¹⁄₈ × 8³⁄₈ in)
Palazzo Reale, Turin

73

HANS HOLBEIN THE ELDER (*c.*1465–1534)
Self-Portrait, 1517
Silverpoint and red chalk on paper, 13 × 10 cm (5^1⁄$_8$ × 3^7⁄$_8$ in)
Musée Condé, Chantilly

74

JOOS VAN CLEVE THE ELDER (c.1485–1540/1)
*Self-Portrait, c.*1519
Oil on wood, 38 × 27 cm (15 × 10⅝ in)
Museo Thyssen-Bornemisza, Madrid

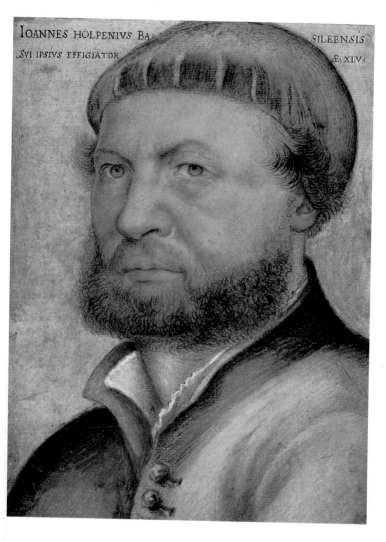

IOANNES HOLPENIVS BA SILEENSIS
SVI IPSIVS EFFIGIATOR Æ XLV

HANS HOLBEIN THE YOUNGER (1497/8–1543)
*Self-Portrait, c.*1540–3
Coloured chalks on paper, 32 × 26 cm (12⅝ × 10¼ in)
Uffizi, Florence

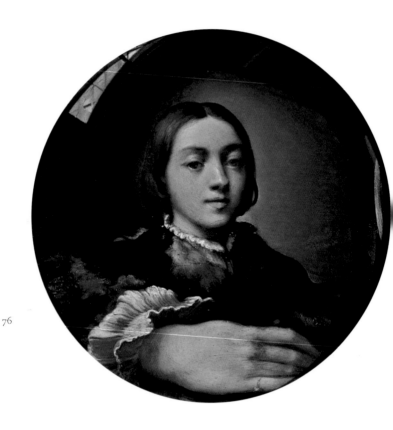

76

PARMIGIANINO (1503–40)
Self-Portrait, 1523
Oil on wood, diameter 24.4 cm (9⅝ in)
Kunsthistorisches Museum, Vienna

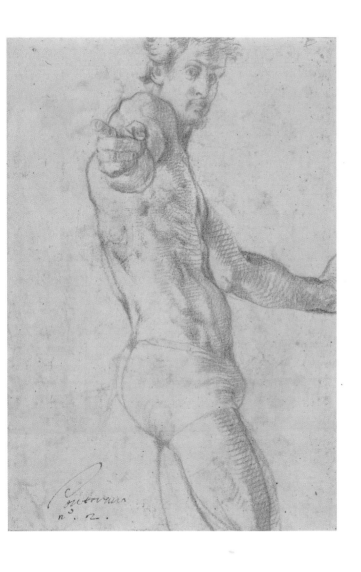

JACOPO DA PONTORMO (1494–1556)
*Self-Portrait, c.*1525
Red chalk on paper, 28.4 × 20.2 cm (11¼ × 8 in)
British Museum, London

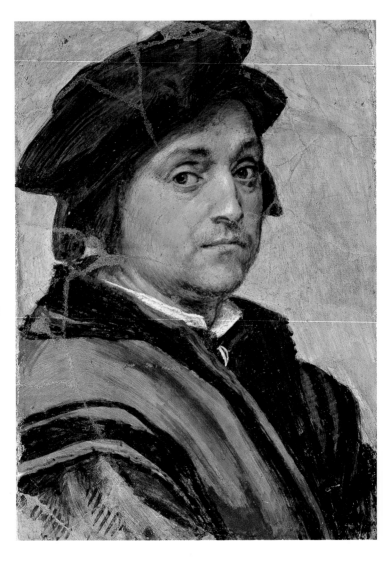

78

ANDREA DEL SARTO (1486–1530)
*Self-Portrait, c.*1528–30
Fresco on ceramic tile, 51.5 × 37.5 cm (20¼ × 14¾ in)
Uffizi, Florence

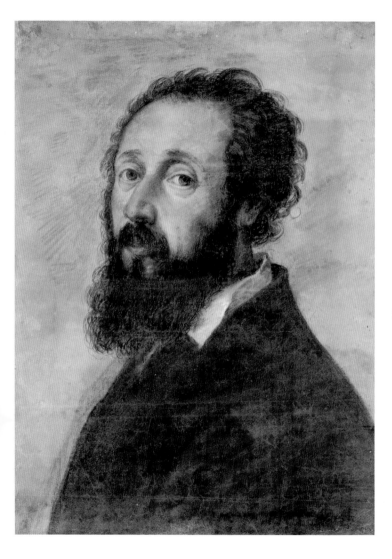

GIULIO ROMANO (1499?–1546)
*Self-Portrait, c.*1540
Pastel on paper, 55 × 41 cm (21⁵⁄₈ × 16¹⁄₈ in)
Uffizi, Florence

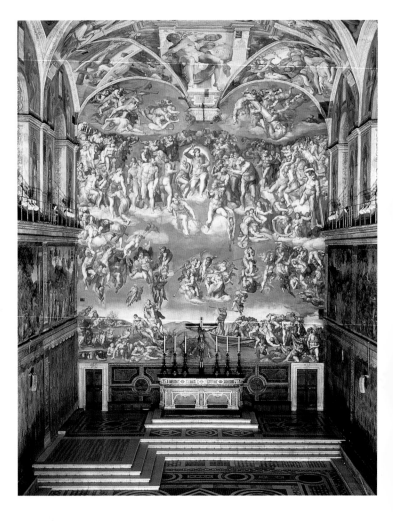

80

MICHELANGELO (1475–1564)
Last Judgement, 1536–41 (self-portrait in the flayed skin of Saint Bartholomew, centre-right)
Fresco
Sistine Chapel, Vatican, Rome

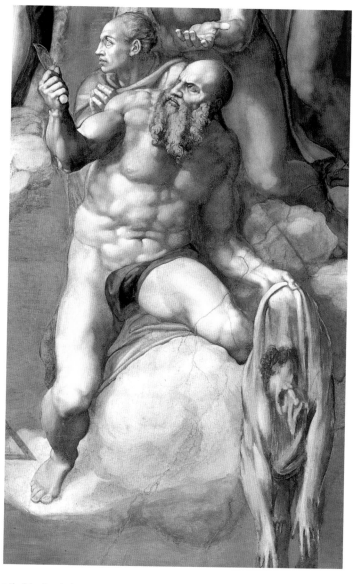

81

Detail of the *Last Judgement*

MICHELANGELO (1475–1564)
Pietà, 1550–5 (self-portrait with hood)
Marble, height 233.4 cm (92 in)
Duomo, Florence

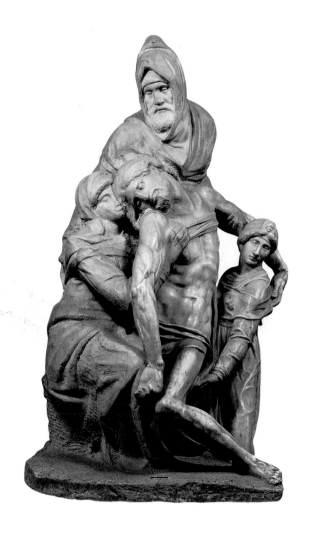

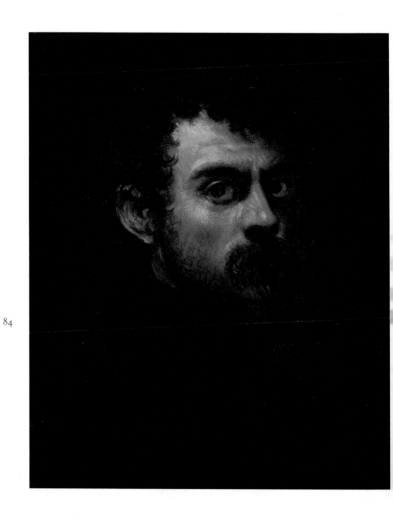

84

JACOPO TINTORETTO (1518–94)
Self-Portrait, *c.*1545–50
Oil on canvas, 45.7 × 38 cm (18 × 15 in)
Philadelphia Museum of Art

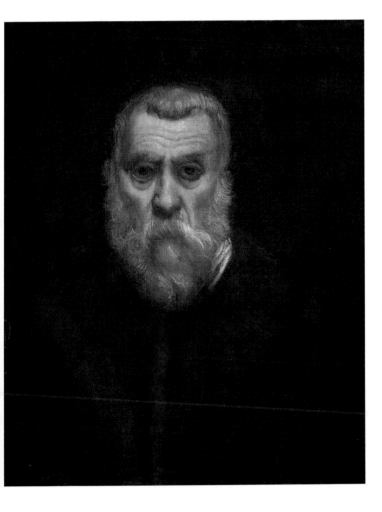

JACOPO TINTORETTO (1518–94)
Self-Portrait, 1587
Oil on canvas, 62.5 × 52 cm (24⅝ × 20½ in)
Louvre, Paris

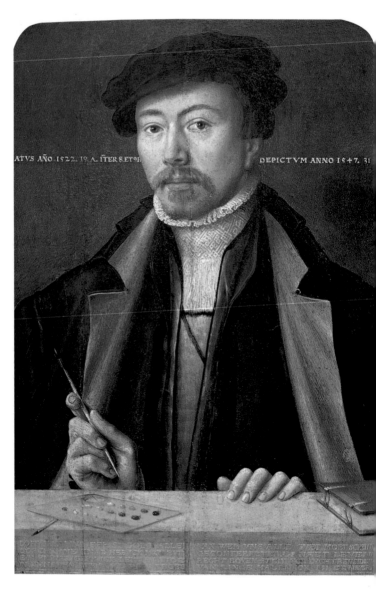

ATVS AÑO 1522. 19 A. ITERS ET⁹H. DEPICTVM ANNO 1547. 31

LUDGER TOM RING THE YOUNGER (1522–84)
Self-Portrait, 1547
Oil on wood, 35 × 24.5 cm (13³⁄₄ × 9⁵⁄₈ in)
Private collection

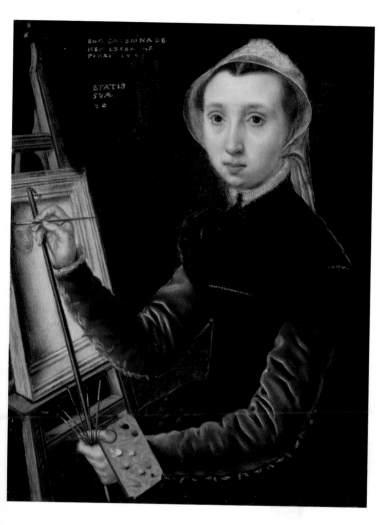

CATHARINA VAN HEMESSEN (1528–after 1587)
Self-Portrait at the Easel, 1548
Tempera on wood, 32 × 25 cm (12⅝ × 9⅞ in)
Kunstmuseum, Basle

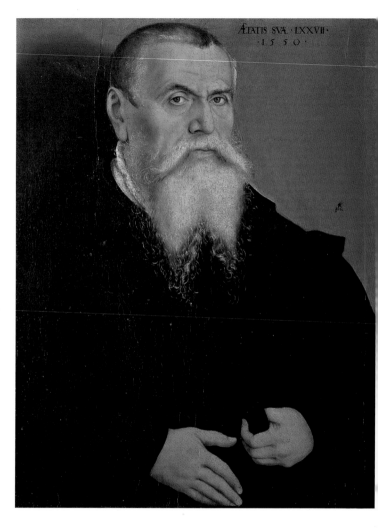

ÆTATIS SVÆ · LXXVII·
·1 5 5 0 ·

LUCAS CRANACH THE ELDER (1472–1553)
Self-Portrait, 1550
Oil on wood, 64 × 49 cm (25¼ × 19¼ in)
Uffizi, Florence

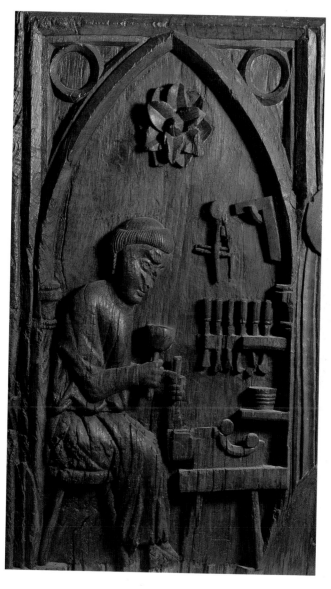

MASTER OF THE POEHLDE CHOIR-STALLS (dates unknown)
Self-Portrait, second half of the 16th century
Detail of carved wood choir-stall, height 146 cm (57½ in)
Niedersächsisches Landesmuseum, Hanover

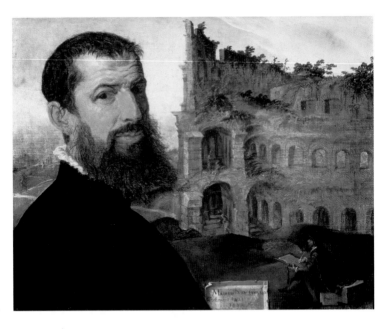

90

MAERTEN VAN HEEMSKERCK (1498–1574)
Self-Portrait of the Painter with the Colosseum in the Background, 1553
Oil on wood, 42.2 × 54 cm (16⅝ × 21¼ in)
Fitzwilliam Museum, Cambridge

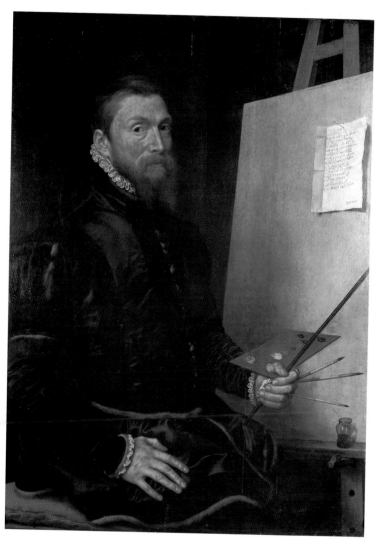

ANTONIS MOR (c.1516/20–76?)
Self-Portrait, 1558
Oil on wood, 113 × 87 cm (44$^{1}\!/_{2}$ × 34$^{1}\!/_{4}$ in)
Uffizi, Florence

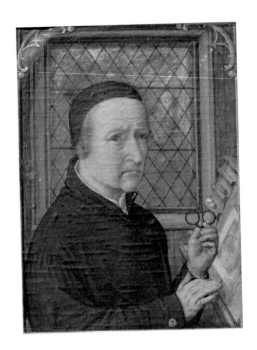

92

SIMON BENING (1483/4–1561)
Self-Portrait, 1558
Watercolour on vellum, 8.1 × 6.9 cm (3¼ × 2¾ in)
Victoria and Albert Museum, London

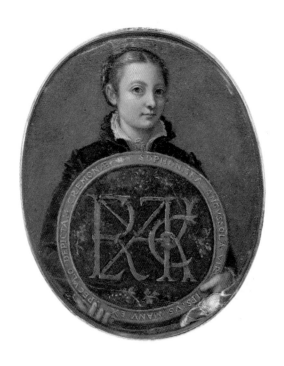

93

SOFONISBA ANGUISSOLA (*c*.1532–1625)
Self-Portrait Holding a Medallion with the Letters of her Father's Name, early 1550s
Miniature, 8.3 × 6.8 cm (3¼ × 2⅝ in)
Museum of Fine Arts, Boston

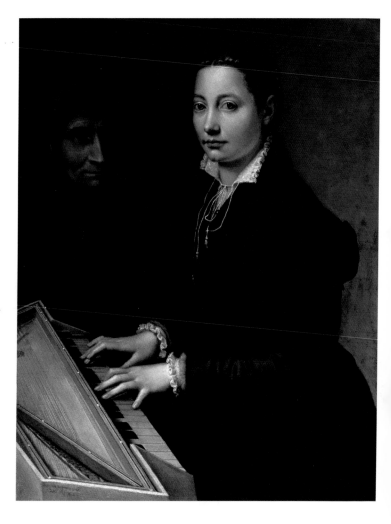

94

SOFONISBA ANGUISSOLA (c.1532–1625)
Self-Portrait, 1561
Oil on canvas, 83 × 65 cm (32³⁄₄ × 25⁵⁄₈ in)
Althorp, Northamptonshire

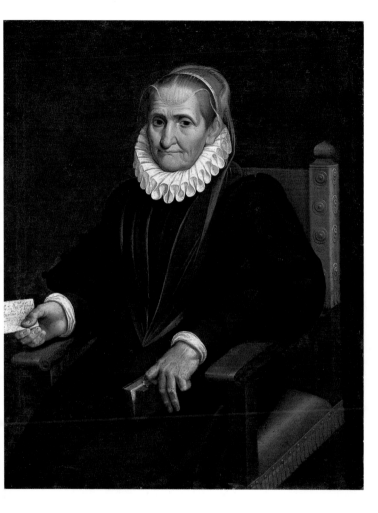

SOFONISBA ANGUISSOLA (*c.*1532–1625)
Self-Portrait as an Old Woman, 1610
Oil on canvas, 96.5 × 76 cm (38 × 29⅞ in)
Kunsthaus, Zurich

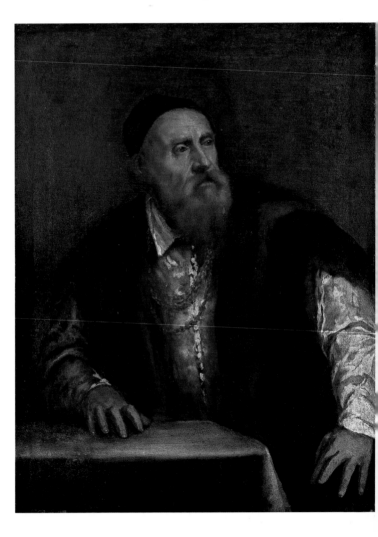

96

TITIAN (c.1485–1576)
Self-Portrait, c.1560
Oil on canvas, 96.4 × 74.8 cm (38 × 29½ in)
Gemäldegalerie, Berlin

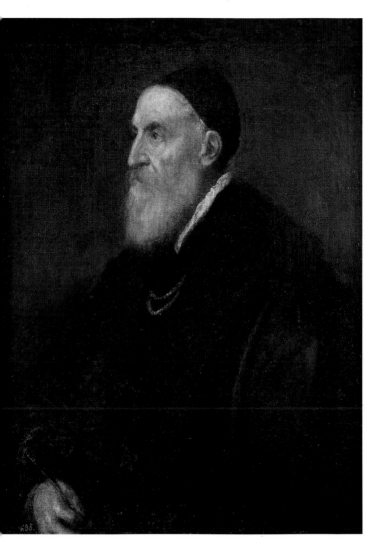

TITIAN (c.1485–1576)
Self-Portrait, 1568–71
Oil on canvas, 86 × 65 cm (33⅞ × 25⅝ in)
Prado, Madrid

98

PAOLO VERONESE (1528–88)
The Marriage at Cana, 1562–3 (self-portrait playing a viol, centre of foreground)
Oil on canvas, 6.7 × 9.9 m (22 ft 4 in × 32 ft 6 in)
Louvre, Paris

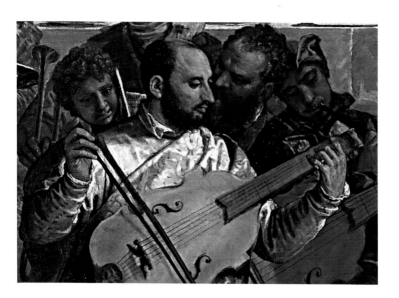

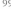

Detail from *The Marriage at Cana*

PAOLO VERONESE (1528–88)
The Feast in the House of Levi, 1573 (self-portrait left of foreground, in front of pillar)
Oil on canvas, 5.6 × 12.8 m (18 ft 3 in × 42 ft)
Accademia, Venice

Detail from *The Feast in the House of Levi*

PIETER BRUEGEL THE ELDER (*c*.1525–69)
Christ Carrying the Cross, 1564 (self-portrait, figure wearing cap on far right)
Oil on wood, 124 × 170 cm (48⁷⁄₈ × 67 in)
Kunsthistorisches Museum, Vienna

Detail from *Christ Carrying the Cross*

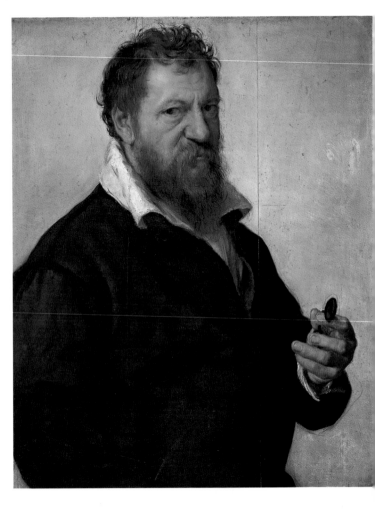

LAMBERT LOMBARD (1505–66)
*Self-Portrait, c.*1566
Oil on wood, 78 × 64 cm (30³⁄₄ × 25¹⁄₄ in)
Musée de l'Art Wallon de la Ville de Liège

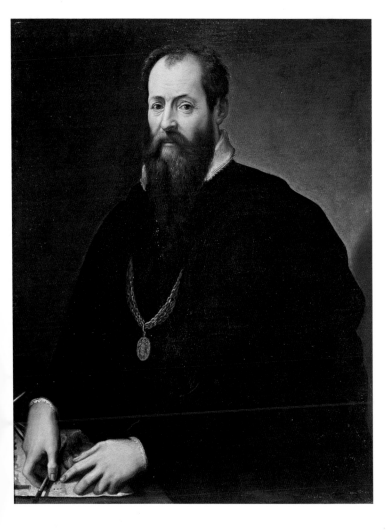

GIORGIO VASARI (1511–74)
Self-Portrait, 1566–8
Oil on wood, 100.5 × 80 cm (39⁵/₈ × 31¹/₂ in)
Uffizi, Florence

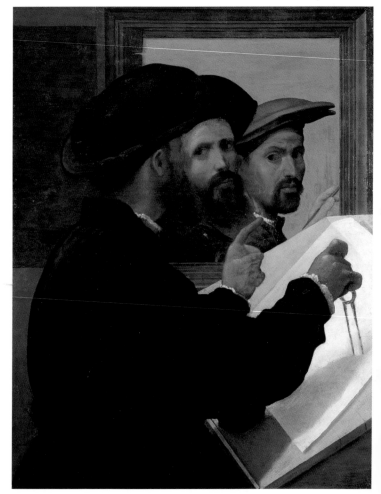

GIOVANNI BATTISTA PAGGI (1554–1627)
Self-Portrait with an Architect Friend, c.1580–90
Oil on canvas, 81 × 62 cm (31⅞ × 24⅝ in)
Martin von Wagner Museum, Würzburg

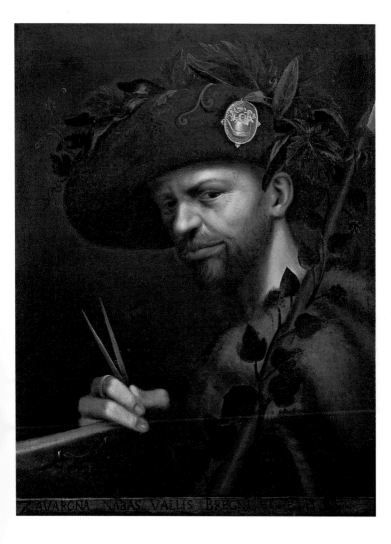

GIOVANNI PAOLO LOMAZZO (1538–1600)
Self-Portrait as Abbot of the Accademiglia, 1568
Oil on canvas, 56 × 44 cm (22 × 17³⁄₈ in)
Brera, Milan

108

NICHOLAS HILLIARD (c.1547–1619)
Self-Portrait, Aged Thirty, 1577
Watercolour on vellum, diameter 4.1 cm (1⅝ in)
Victoria and Albert Museum, London

LAVINIA FONTANA (1552–1614)
Self-Portrait in the Studiolo, 1579
Oil on copper, diameter 15.7 cm (6⅛ in)
Uffizi, Florence

110

ISAAC OLIVER (1558/68–1617)
*Self-Portrait, c.*1590–5
Watercolour on vellum laid on card, 6.2 × 5 cm (2¹/₂ × 2 in)
National Portrait Gallery, London

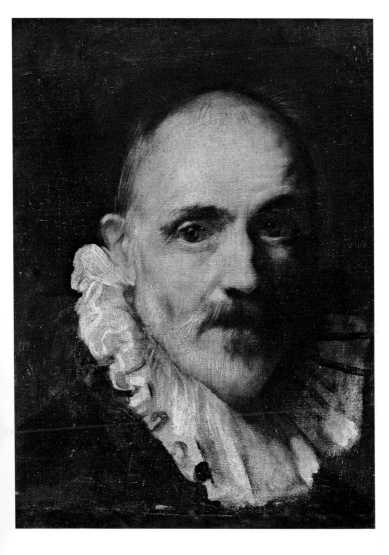

FEDERICO BAROCCI (c.1535–1612)
*Self-Portrait, c.*1600
Oil on canvas, 42.2 × 33.1 cm (16⅝ × 13 in)
Uffizi, Florence

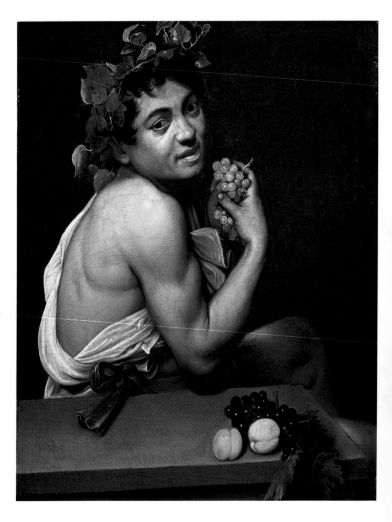

CARAVAGGIO (1571–1610)
Self-Portrait as Bacchus, 1593–4
Oil on canvas, 66 × 52 cm (26 × 20½ in)
Galleria Borghese, Rome

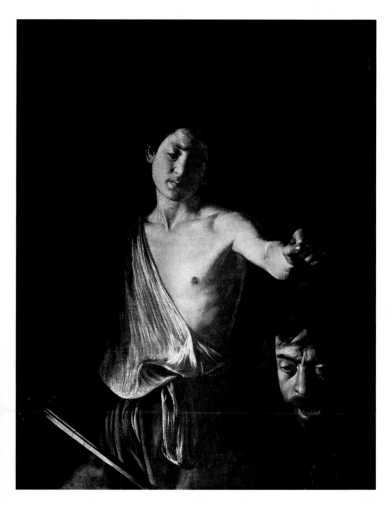

CARAVAGGIO (1571–1610)
*David with the Head of Goliath, c.*1610 (self-portrait as the head of Goliath)
Oil on canvas, 125 × 100 cm (49¹⁄₄ × 39³⁄₈ in)
Galleria Borghese, Rome

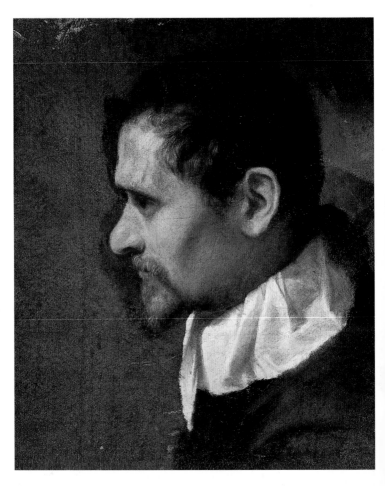

ANNIBALE CARRACCI (1560–1609)
Self-Portrait, c.1595–1600
Oil on canvas, 45.5 × 37.9 cm (17³⁄₄ × 14³⁄₄ in)
Uffizi, Florence

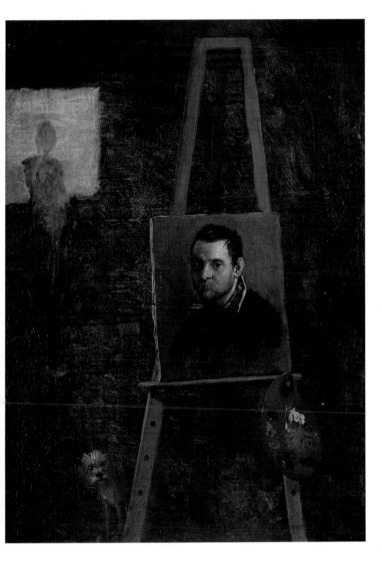

ANNIBALE CARRACCI (1560–1609)
Self-Portrait on an Easel in a Workshop, c.1604
Oil on wood, 42.5 × 30 cm (16¾ × 11⅞ in)
Hermitage, St Petersburg

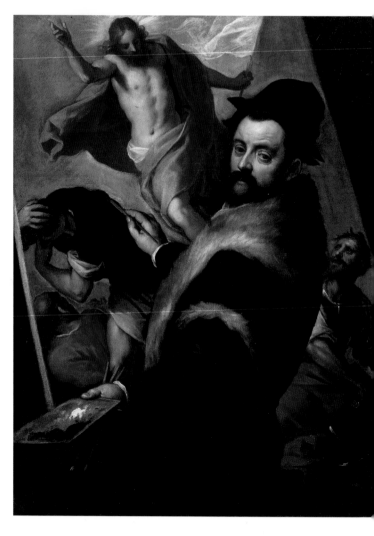

116

PALMA IL GIOVANE (c.1548–1628)
Self-Portrait Painting the Resurrection of Christ, 1590s
Oil on canvas, 126 × 96 cm (49⁵⁄₈ × 37³⁄₄ in)
Brera, Milan

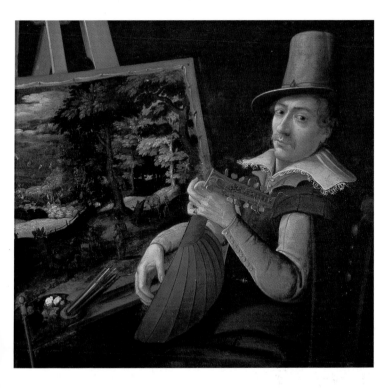

PAUL BRIL (c.1554–1626)
Self-Portrait, c.1600
Oil on canvas, 70.8 × 77.2 cm (27⁷⁄₈ × 30³⁄₈ in)
Museum of Art, Rhode Island School of Design, Providence

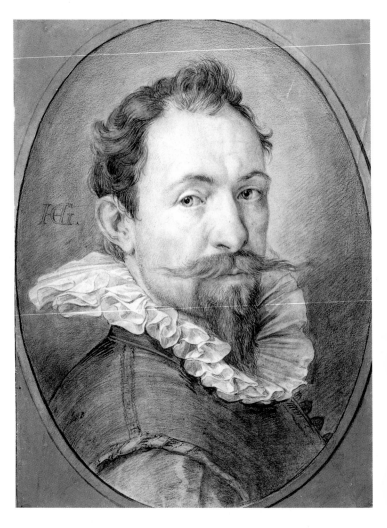

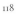

HENDRICK GOLTZIUS (1558–1617)
Self-Portrait, 1600
Black and red chalk and pen and ink on paper, 43 × 32.3 cm (17 × 12³⁄₄ in)
Graphische Sammlung Albertina, Vienna

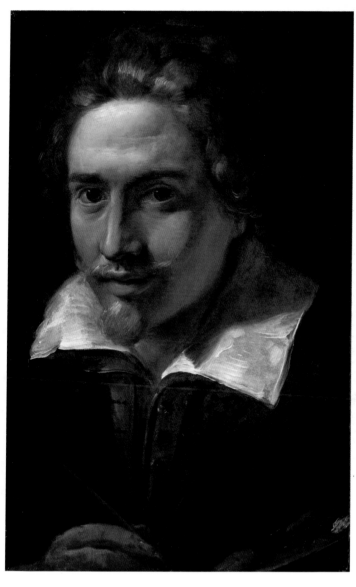

GIULIO CESARE PROCACCINI (1574–1625)
*Self-Portrait, c.*1600
Oil on wood, 42.5 × 27 cm (16³⁄₄ × 10¹⁄₂ in)
Private collection

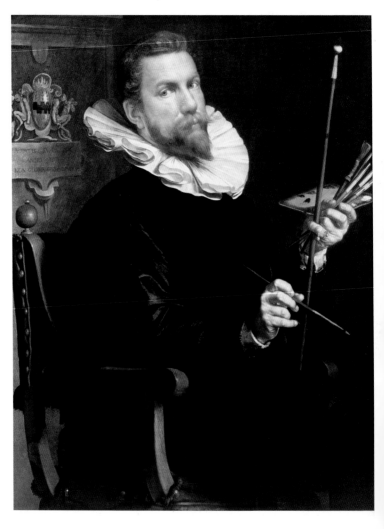

JOACHIM WTEWAEL (1566–1638)
Self-Portrait, 1601
Oil on wood, 98 × 74 cm (38⁵/₈ × 29¹/₈ in)
Centraal Museum, Utrecht

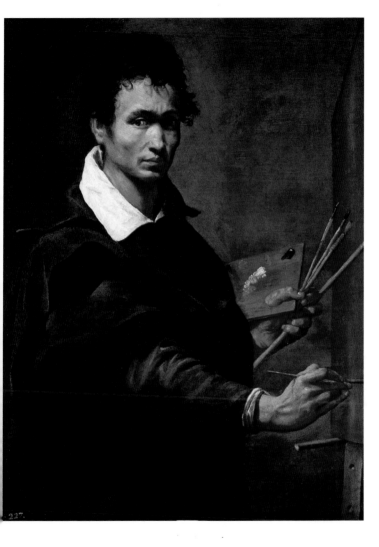

ORAZIO BORGIANNI (*c.*1575–1616)
*Self-Portrait, c.*1615
Oil on canvas, 95 x 71 cm (37³⁄₈ x 28 in)
Prado, Madrid

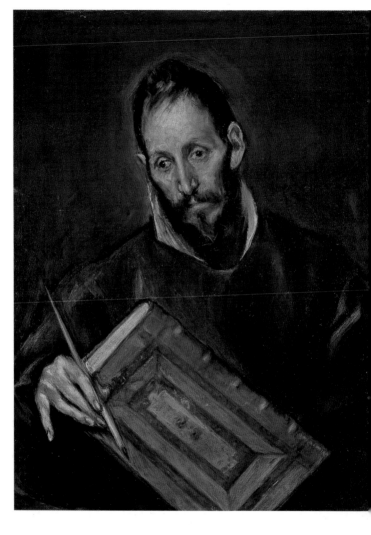

122

EL GRECO (1541–1616)
*Self-Portrait as Saint Luke, c.*1604
Oil on canvas, 70.5 × 54 cm (27¾ × 21¼ in)
Hispanic Society of America, New York

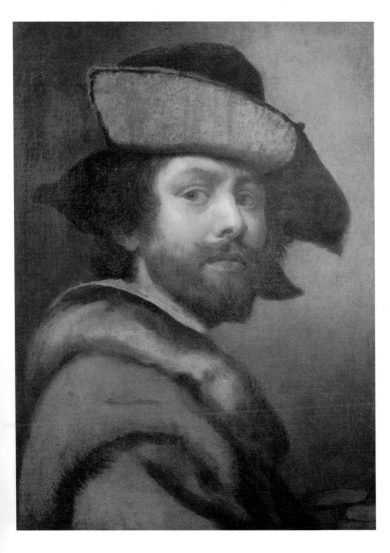

123

CRISTOFANO ALLORI (1577–1621)
Self-Portrait, 1606–10
Oil on canvas, 53.5 × 40.3 cm (21^{1}/$_{8}$ × 15^{7}/$_{8}$ in)
Uffizi, Florence

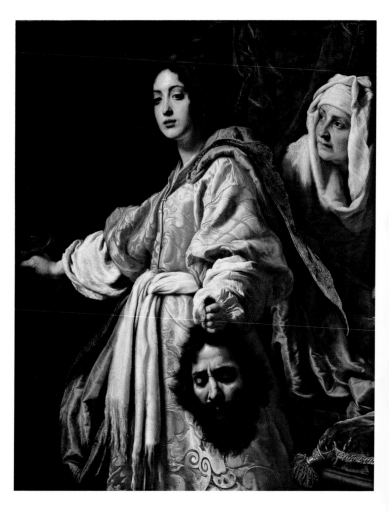

124

CRISTOFANO ALLORI (1577–1621)
Judith and Holofernes, c.1610–12 (self-portrait as the head of Holofernes)
Oil on canvas, 139 × 116 cm (54¼ × 45¾ in)
Palazzo Pitti, Florence

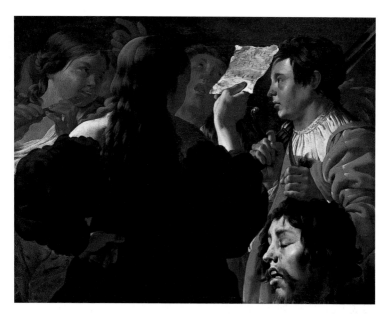

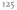

HENDRICK TER BRUGGHEN (1588–1629)
David Praised by the Israelite Women, 1623 (self-portrait as the head of Goliath)
Oil on canvas, 81.8 × 105.3 cm (32¼ × 41½ in)
North Carolina Museum of Art, Raleigh

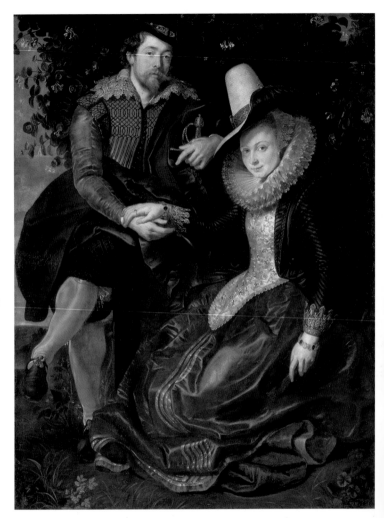

126

PETER PAUL RUBENS (1577–1640)
Self-Portrait with his Wife, Isabella Brant, c.1609
Oil on canvas, 178 × 136.5 cm (70⅛ × 53¾ in)
Alte Pinakothek, Munich

PETER PAUL RUBENS (1577–1640)
Portrait of the Artist, 1623–4
Oil on wood, 86 × 62.5 cm (33^{7}⁄$_{8}$ × 24^{5}⁄$_{8}$ in)
Royal Collection

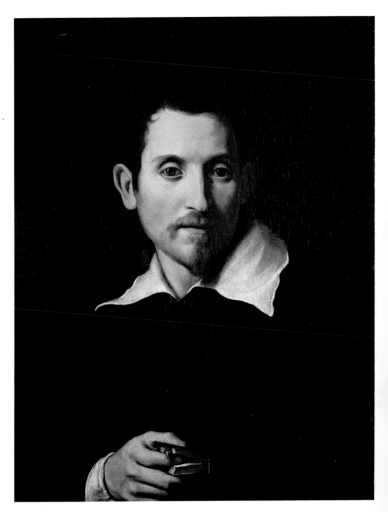

DOMENICHINO (1581–1641)
*Self-Portrait, c.*1610–12
Oil on canvas, 66.4 × 49.9 cm (25⅛ × 19⅝ in)
Palazzo Pitti, Florence

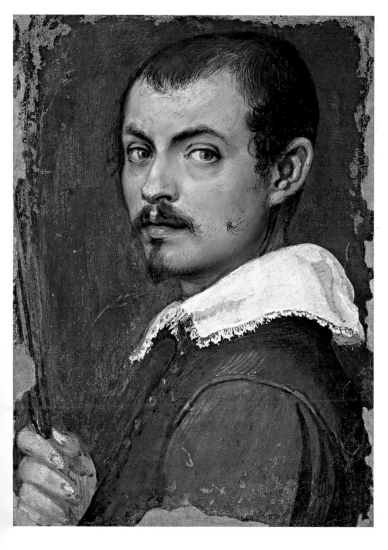

GIOVANNI DA SAN GIOVANNI (1592–1636)
*Self-Portrait, c.*1616
Fresco on ceramic tile, 51.6 × 37.4 cm (20¼ × 14¾ in)
Uffizi, Florence

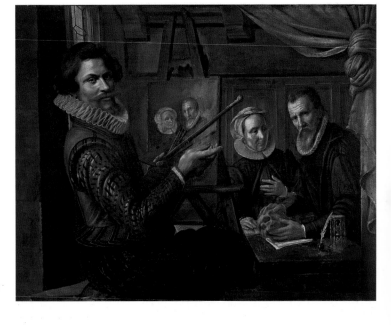

130

HERMAN VAN VOLLENHOVEN (*fl.*1611–27)
Self-Portrait, 1612
Oil on canvas, 89 × 112 cm (35⅛ × 44⅛ in)
Rijksmuseum, Amsterdam

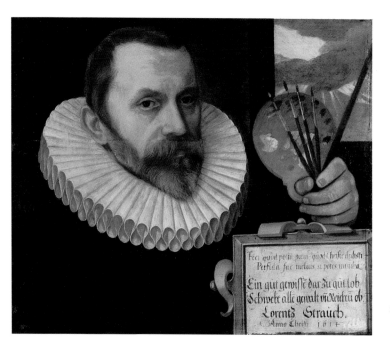

Feci quod potui potui quod Christe dedisti
Perfida fac melius, si potes invidia

Ein gut gewiſſe dar zu gut lob
Schwebt alle gewalt vii Reichtii ob.
Lorentz Strauch.
Anno Christi 1614

LORENZ STRAUCH (1554–1630)
Self-Portrait at the Age of Sixty, 1614
Oil on wood, 43.5 × 52.5 cm (17¹⁄₈ × 20⁵⁄₈ in)
Germanisches Museum, Nuremberg

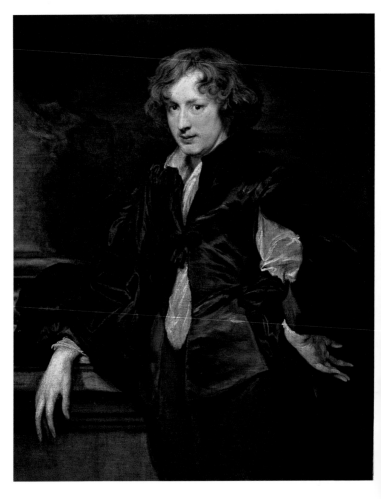

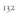

ANTHONY VAN DYCK (1599–1641)
*Self-Portrait, c.*1619–20
Oil on canvas, 116.5 × 93.5 cm (45⅞ × 36⅞ in)
Hermitage, St Petersburg

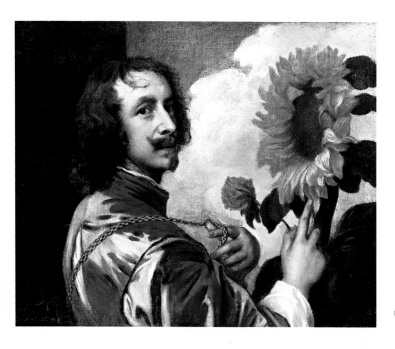

133

REMBRANDT VAN RIJN (1606–69)
Self-Portrait as a Young Man, 1628
Oil on wood, 22.5 × 18.6 cm (8⅞ × 7⅜ in)
Rijksmuseum, Amsterdam

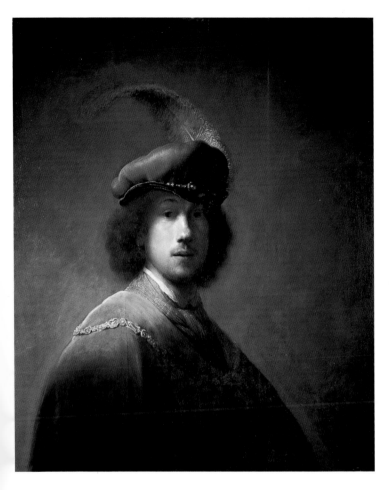

REMBRANDT VAN RIJN (1606–69)
Self-Portrait with Plumed Beret, 1629
Oil on wood, 89.7 × 73.5 cm (35⅛ × 29 in)
Isabella Stewart Gardner Museum, Boston

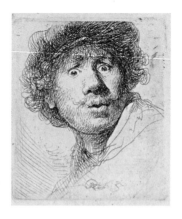

REMBRANDT VAN RIJN (1606–69)
Self-Portrait, Wide-Eyed, 1630
Etching and burin, 5.1 × 4.6 cm (2 × 1³⁄₄ in)

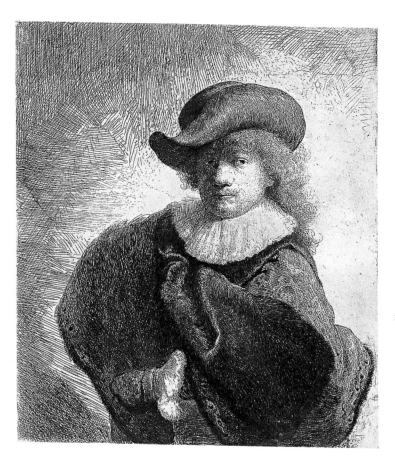

137

REMBRANDT VAN RIJN (1606–69)
Self-Portrait with Hat, Hand on Hip, 1631–2
Etching, 14.8 × 13 cm (5⁷⁄₈ × 5¹⁄₈ in)

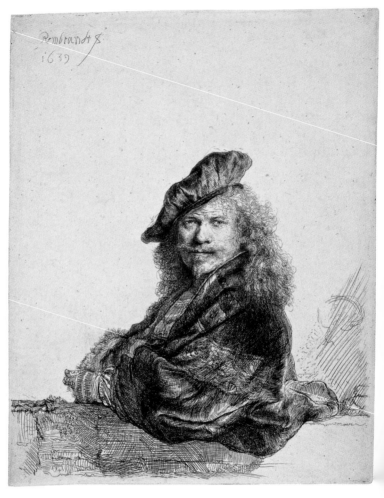

REMBRANDT VAN RIJN (1606–69)
Self-Portrait Leaning on a Stone Wall, 1639
Etching and drypoint, 36.9 × 29.8 cm (14½ × 11¾ in)

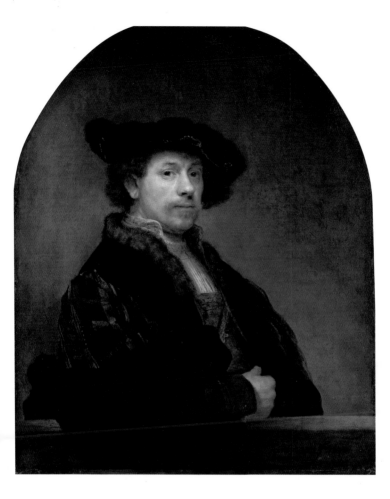

REMBRANDT VAN RIJN (1606–69)
Self-Portrait, 1640
Oil on canvas, 93 × 80 cm (36⅝ × 31½ in)
National Gallery, London

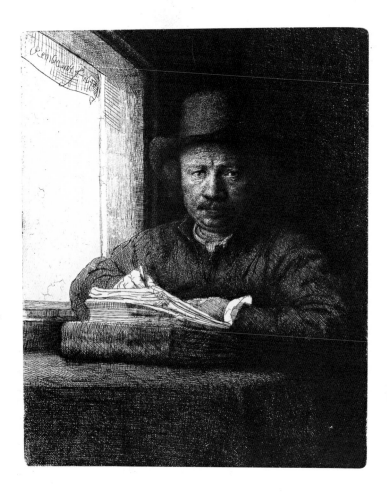

140

REMBRANDT VAN RIJN (1606–69)
Self-Portrait at the Window, Drawing on an Etching Plate, 1648
Etching, 16 × 13 cm (6¼ × 5⅛ in)

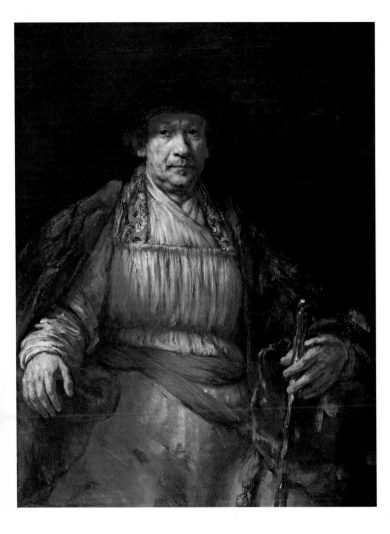

REMBRANDT VAN RIJN (1606–69)
Self-Portrait, 1658
Oil on canvas, 131 × 102 cm (51⁵⁄₈ × 40¹⁄₄ in)
Frick Collection, New York

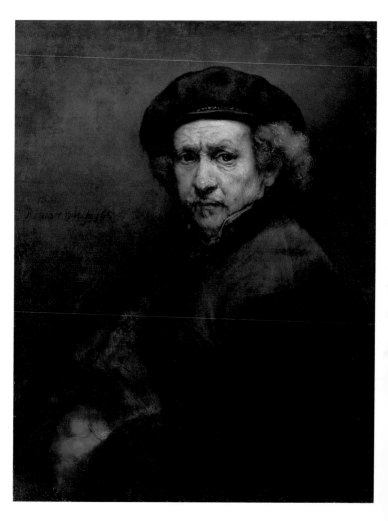

REMBRANDT VAN RIJN (1606–69)
Self-Portrait, 1659
Oil on canvas, 84.5 × 66 cm (33¼ × 26 in)
National Gallery of Art, Washington DC

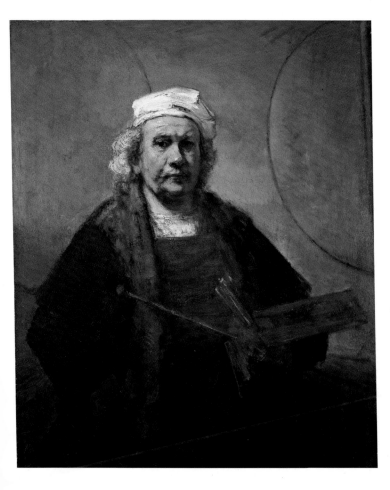

143

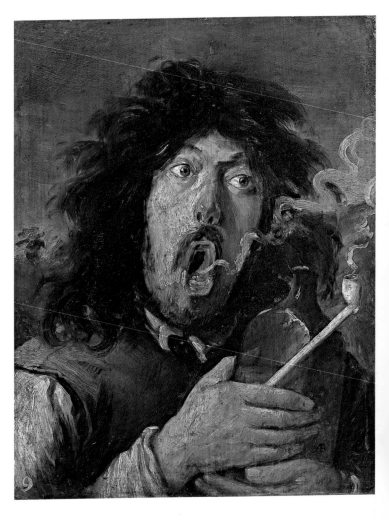

JOOS VAN CRAESBEECK (1605?–54/61)
*The Smoker, c.*1635–40
Oil on wood, 41.5 × 32 cm (16³⁄₈ × 12⁵⁄₈ in)
Louvre, Paris

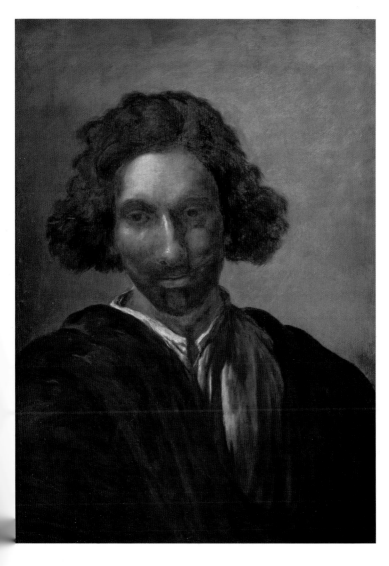

PIETER VAN LAER (1599–1642?)
Self-Portrait, c.1626–30
Oil on wood, 72 × 58 cm (28³⁄₈ × 22⁷⁄₈ in)
Uffizi, Florence

146

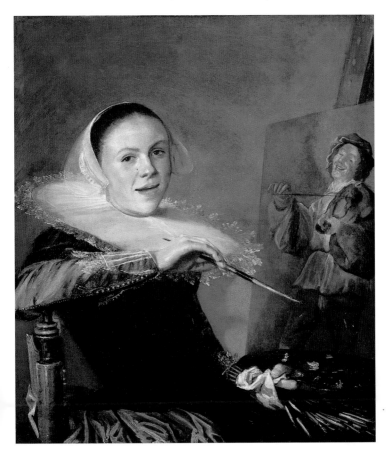

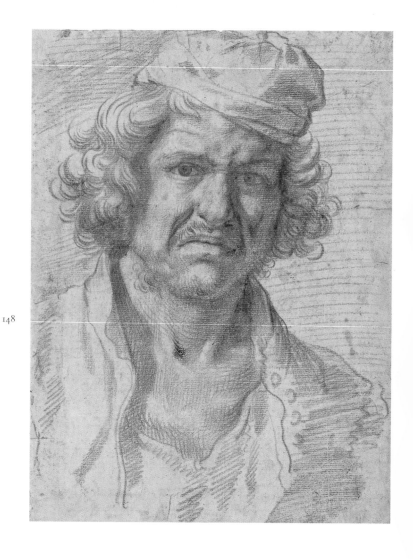

NICOLAS POUSSIN (1594–1665)
*Self-Portrait, c.*1630
Red chalk on paper, 37.5 × 25 cm (14³⁄₄ × 9⁷⁄₈ in)
British Museum, London

148

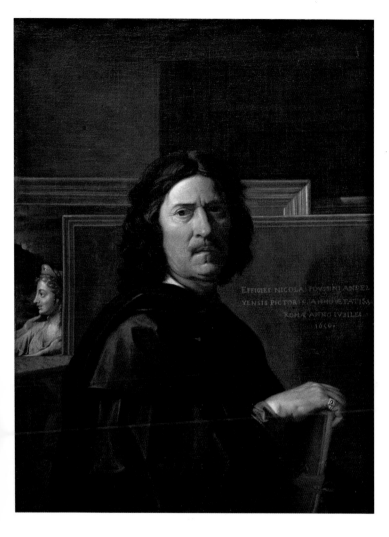

NICOLAS POUSSIN (1594–1665)
Self-Portrait, 1650
Oil on canvas, 98 × 74 cm (38⁵/₈ × 29¹/₈ in)
Louvre, Paris

JACOB JORDAENS (1593–1678)
*Self-Portrait, c.*1630–2
Red and black chalk on paper, 10.1 × 8.7 cm (4 × 3⅜ in)
Kupferstichkabinett, Berlin

JACOB JORDAENS (1593–1678)
*Self-Portrait, c.*1645–9
Oil on canvas, 81.5 × 59 cm (32$\frac{1}{8}$ × 23$\frac{1}{4}$ in)
Alte Pinakothek, Munich

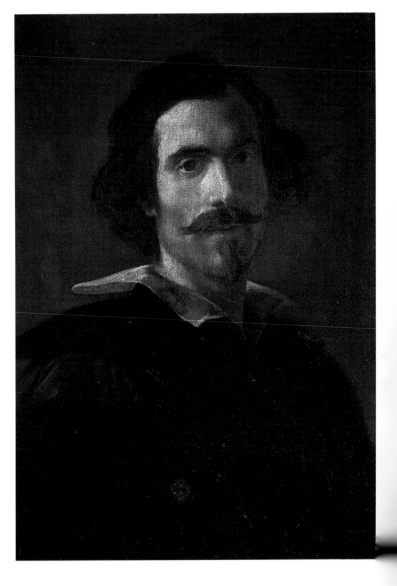

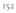

GIANLORENZO BERNINI (1598–1680)
*Self-Portrait, c.*1635
Oil on canvas, 62 × 46 cm (24⅜ × 18⅛ in)
Uffizi, Florence

Ritratto del Cav.^r Bernino

GIANLORENZO BERNINI (1598–1680)
*Self-Portrait, c.*1635
Black and red chalk on paper, 35 × 23.4 cm (13³⁄₄ × 9¹⁄₄ in)
Istituto Nazionale per la Grafica, Rome

SALVATOR ROSA (1615–73)
*Self-Portrait, c.*1645
Oil on canvas, 116.3 × 94 cm (45⅞ × 37 in)
National Gallery, London

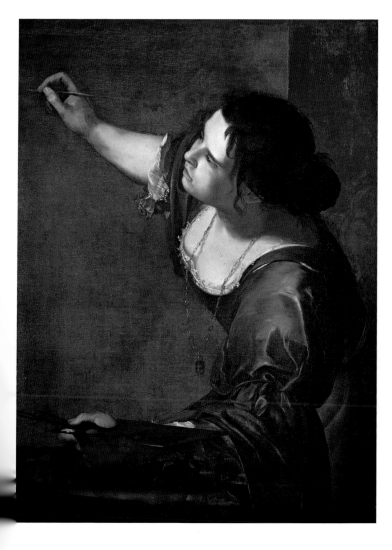

155

ARTEMISIA GENTILESCHI (1593–1652/3)
Self-Portrait as an Allegory of Painting, c.1635–7
Oil on canvas, 98.6 × 75.2 cm (38⁷⁄₈ × 29⁵⁄₈ in)
Royal Collection

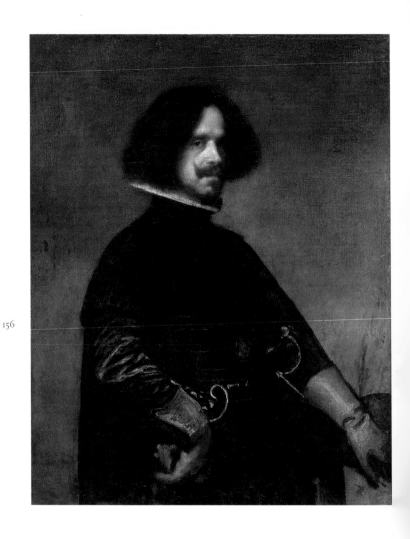

DIEGO VELÁZQUEZ (1599–1660)
*Self-Portrait, c.*1643
Oil on canvas, 101 × 81 cm (39³⁄₄ × 31⁷⁄₈ in)
Uffizi, Florence

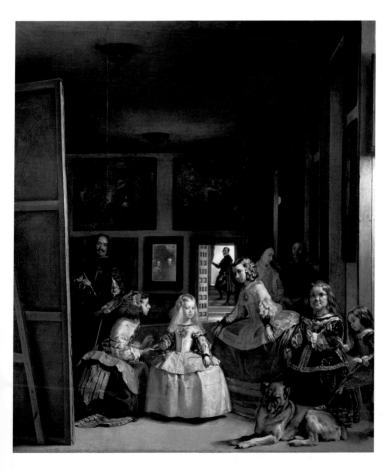

DIEGO VELÁZQUEZ (1599–1660)
Las Meninas, 1656
Oil on canvas, 318 × 276 cm (125 × 109 in)
Prado, Madrid

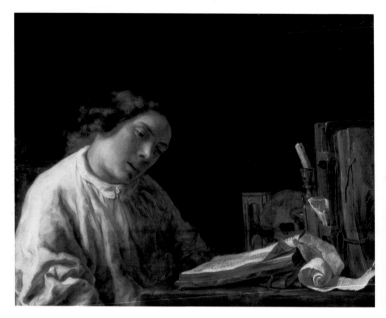

158

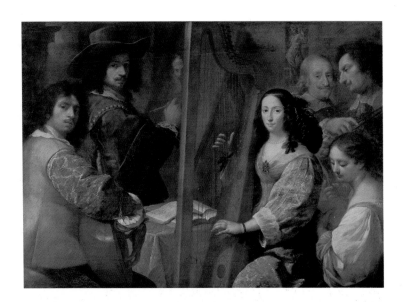

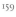

CARLO FRANCESCO NUVOLONE (1608–62)
Portrait of the Artist's Family, c.1646
Oil on canvas, 126 × 180 cm (49⁵⁄₈ × 71 in)
Brera, Milan

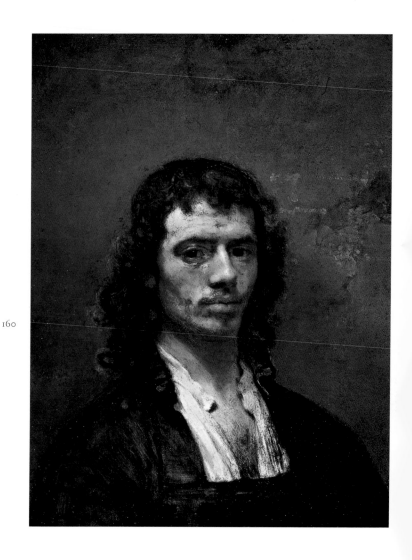

CAREL FABRITIUS (1622–54)
Self-Portrait, 1645
Oil on canvas, 65 × 49 cm (25⁵⁄₈ × 19¼ in)
Museum Boymans–Van Beuningen, Rotterdam

BARENT FABRITIUS (1624–73)
Self-Portrait as a Shepherd, 1655
Oil on canvas, 79 × 64 cm (31⅛ × 25¼ in)
Akademie der Bildenden Künste, Vienna

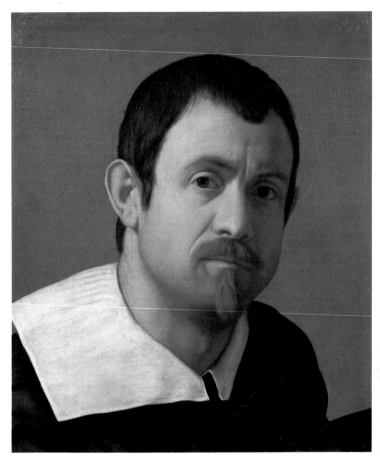

SASSOFERRATO (1609–85)
*Self-Portrait, c.*1650
Oil on canvas, 38 × 32.5 cm (15 × 12¹⁄₂ in)
Uffizi, Florence

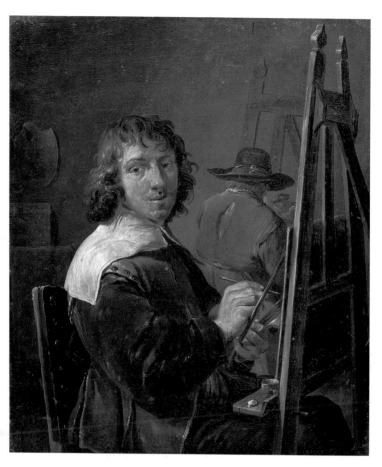

DAVID TENIERS THE YOUNGER (1610–90)
Self-Portrait: The Painter in his Studio, c.1645–9
Oil on wood, 27 × 22.5 cm (10⅜ × 8⅞ in)
Akademie der Bildenden Künste, Vienna

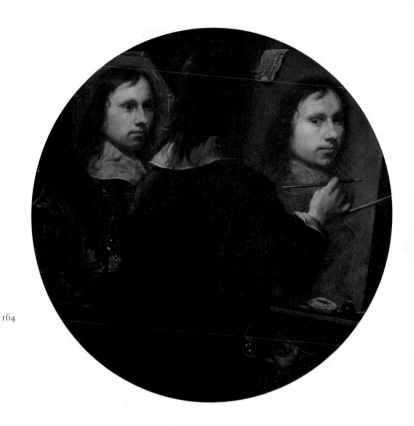

164

JOHANNES GUMPP (1626–after 1646)
Self-Portrait, 1646
Oil on canvas, diameter 89 cm (35⅛ in)
Uffizi, Florence

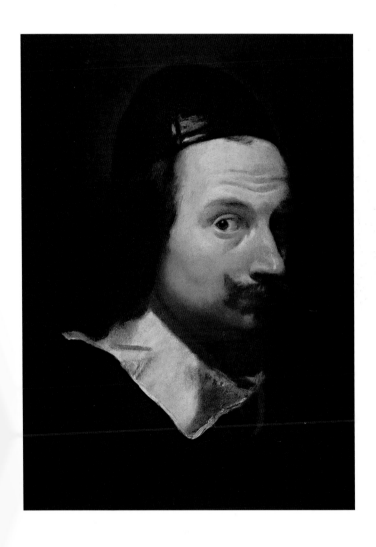

LORENZO LIPPI (1606–65)
Self-Portrait, c.1650–60
Oil on canvas, 49.5 × 36 cm (19¹⁄₂ × 14¹⁄₈ in)
Uffizi, Florence

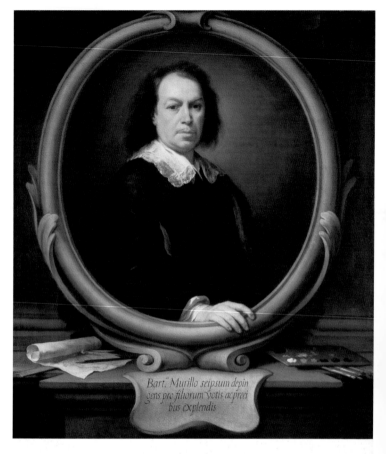

BARTOLOMÉ ESTEBAN MURILLO (1617–82)
Self-Portrait, c.1670–3
Oil on canvas, 122 × 107 cm (48⅛ × 42⅛ in)
National Gallery, London

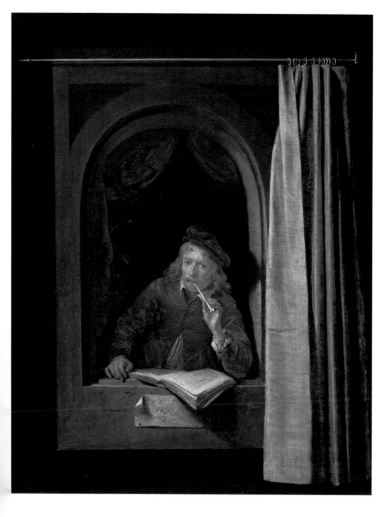

GERARD DOU (1613–75)
Self-Portrait, 1655
Oil on wood, 48 × 37 cm (18⅞ × 14⅝ in)
Rijksmuseum, Amsterdam

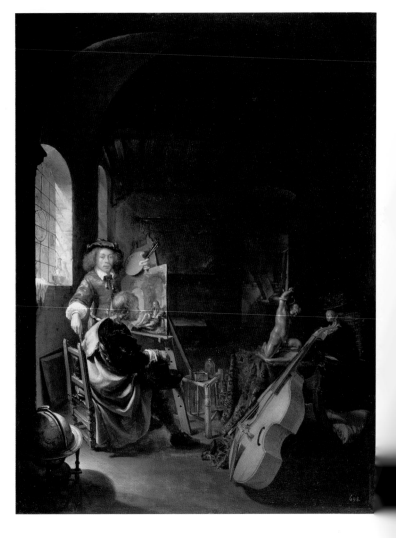

FRANS VAN MIERIS (1635–81)
The Connoisseur in the Artist's Studio, c.1655–6
Oil on wood, 63.5 × 47 cm (25 × 18½ in)
Gemäldegalerie, Dresden

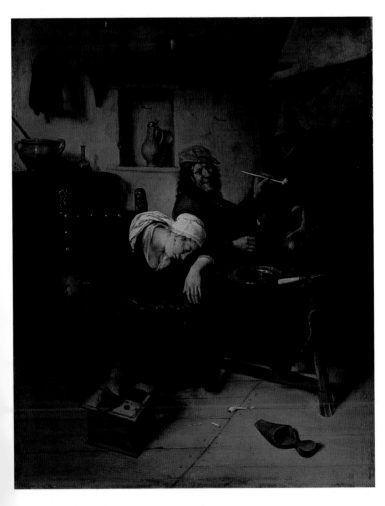

JAN STEEN (1626–79)
*The Idlers, c.*1660
Oil on canvas, 39 × 30 cm (15^{3}/8 × 11^{3}/4 in)
Hermitage, St Petersburg

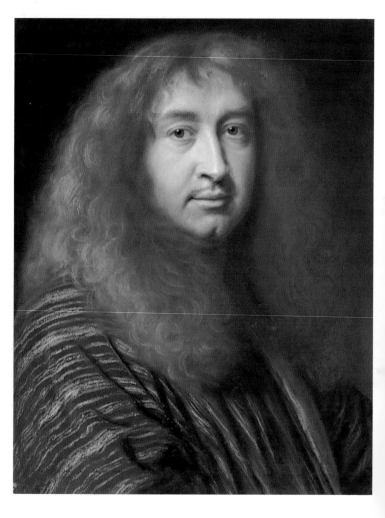

ROBERT NANTEUIL (1623–78)
*Self-Portrait, c.*1660–5
Pastel on paper, 52 × 41 cm (20½ × 16⅛ in)
Uffizi, Florence

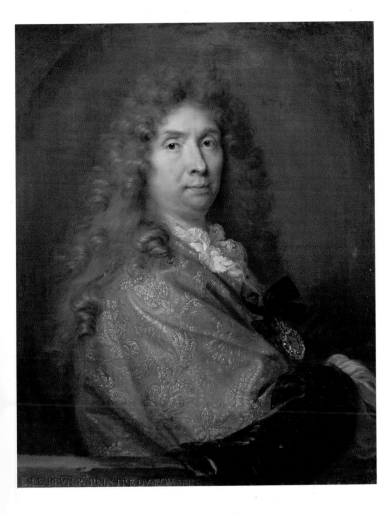

CHARLES LE BRUN (1619–90)
Self-Portrait, 1683–4
Oil on canvas, 80 × 65 cm (31¹⁄₂ × 25⁵⁄₈ in)
Uffizi, Florence

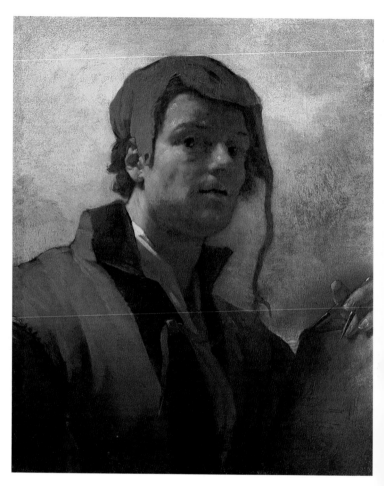

WILLEM DROST (*c.*1630–after 1680)
*Self-Portrait, c.*1662
Oil on canvas, 72 × 64 cm (28³⁄₈ × 25¹⁄₄ in)
Uffizi, Florence

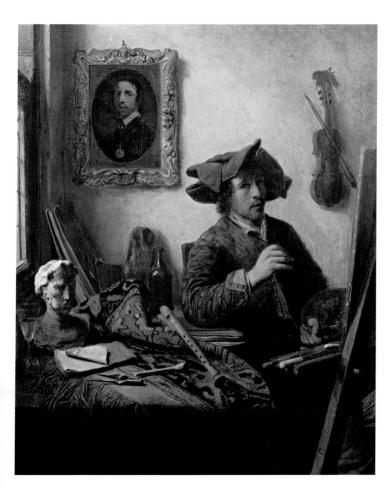

JOB BERCKHEYDE (1630–93)
The Painter in his Studio, 1675
Oil on wood, 36 × 30.7 cm (14⅞ × 12 in)
Uffizi, Florence

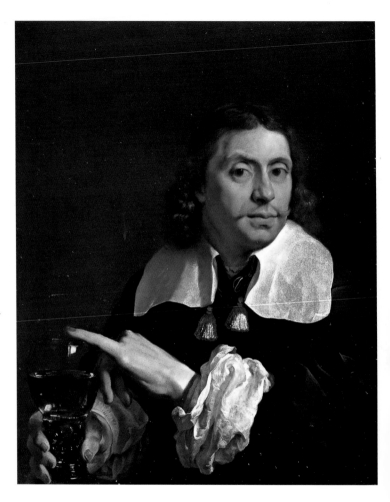

174

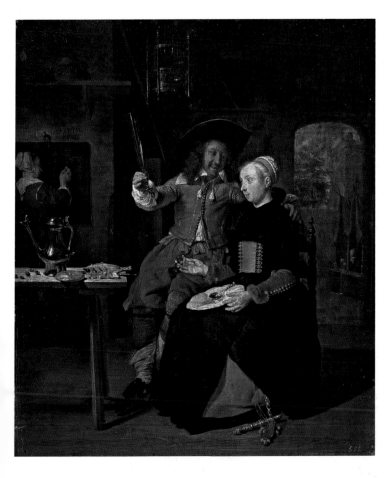

GABRIEL METSU (1629–69)
Self-Portrait with his Wife Isabella de Wolff in an Inn, 1661
Oil on wood, 35.5 × 30.5 cm (14 × 12 in)
Gemäldegalerie, Dresden

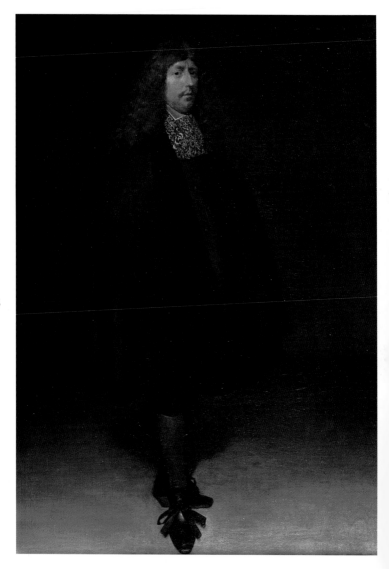

GERARD TER BORCH (1617–81)
Portrait of the Artist, c.1668–70
Oil on canvas, 61 × 42.5 cm (24 × 16¾ in)
Mauritshuis, The Hague

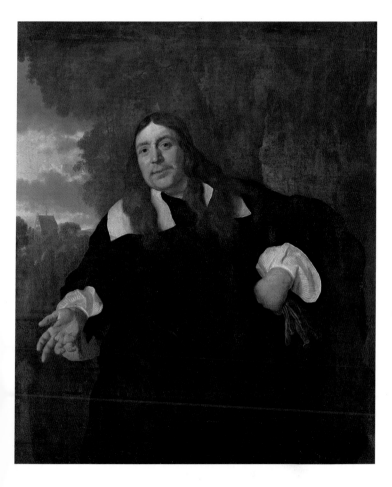

BARTHOLOMEUS VAN DER HELST (c.1613–70)
Self-Portrait, 1662
Oil on canvas, 132.5 × 112 cm (52¼ × 44⅛ in)
Kunsthalle, Hamburg

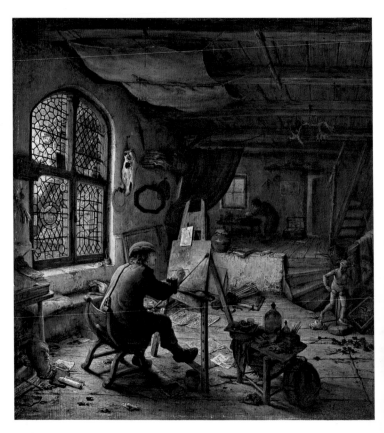

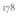

ADRIAEN VAN OSTADE (1610–85)
The Painter in his Studio, 1663
Oil on wood, 38 × 35.5 cm (15 × 14 in)
Gemäldegalerie, Dresden

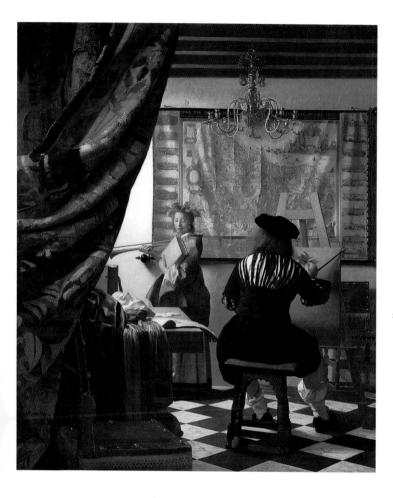

JAN VERMEER (1632–75)
The Art of Painting, 1666–7
Oil on canvas, 120 × 100 cm (47¼ × 39⅜ in)
Kunsthistorisches Museum, Vienna

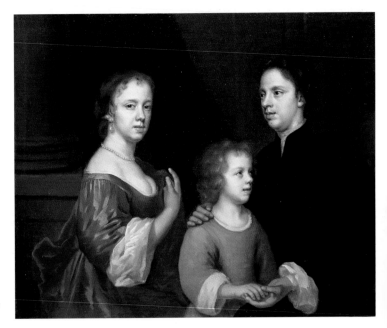

MARY BEALE (1633–99)
Self-Portrait with her Husband, Charles, and their Son, Bartholomew, c.1663–4
Oil on canvas, 63.5 × 76.2 cm (25 × 30 in)
Geffrye Museum, London

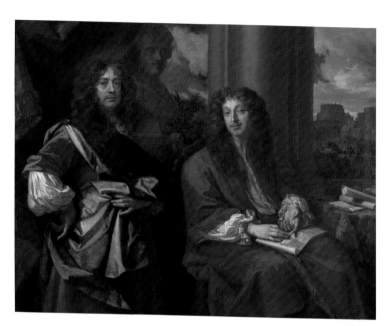

181

PETER LELY (1618–80)
*Self-Portrait with Hugh May, c.*1675 (self-portrait, standing)
Oil on canvas, 144 × 183 cm (56¼ × 72 in)
Audley End, Essex

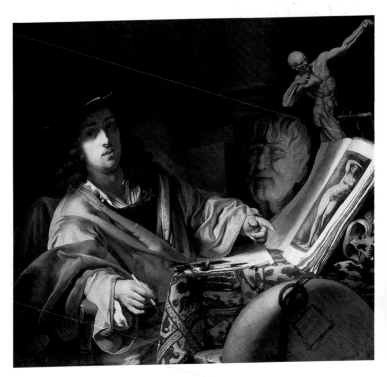

SIR GODFREY KNELLER (1646–1723)
Portrait of the Artist, c.1670
Oil on canvas, 105 × 113.7 cm (41¼ × 44¾ in)
Private collection

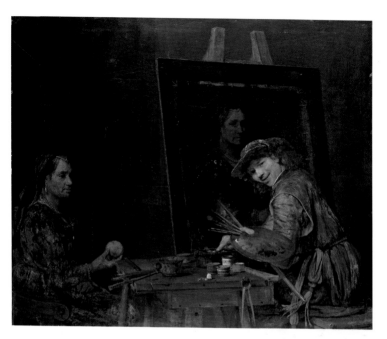

183

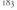

ARENT DE GELDER (1645–1727)
Self-Portrait Painting an Old Woman, 1685
Oil on canvas, 142 × 169 cm (56 × 66⅝ in)
Städelsches Kunstinstitut, Frankfurt am Main

184

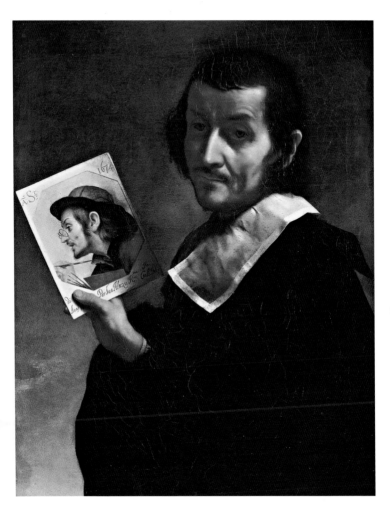

CARLO DOLCI (1616–87)
Self-Portrait, 1674
Oil on canvas, 74.5 × 60.5 cm (29³⁄₈ × 23⁷⁄₈ in)
Uffizi, Florence

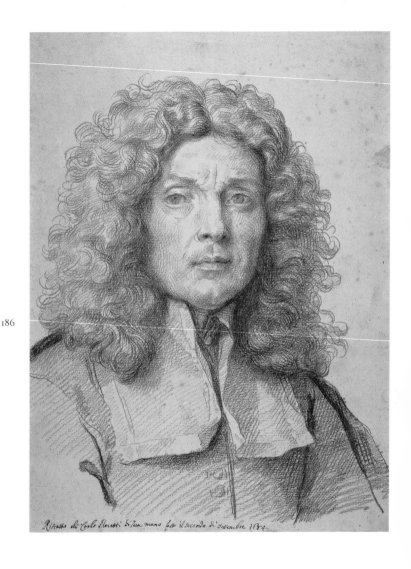

186

CARLO MARATTI (1625–1713)
Self-Portrait, 1684
Red chalk on paper, 36.7 × 27.3 cm (14$\frac{1}{2}$ × 10$\frac{3}{4}$ in)
British Museum, London

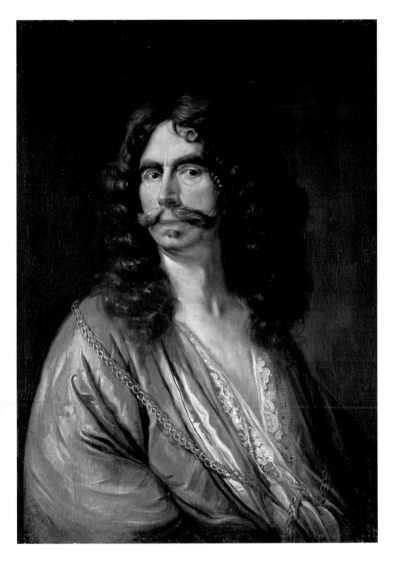

JOHANN HEINRICH ROOS (1631–85)
Self-Portrait, 1682
Oil on canvas, 83 × 60 cm (32⅝ × 23⅝ in)
Herzog Anton-Ulrich Museum, Braunschweig

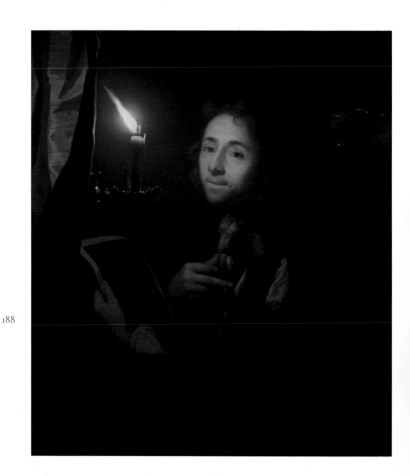

188

GODFRIED SCHALCKEN (1643–1706)
*Self-Portrait, c.*1695
Oil on canvas, 92.3 × 81 cm ($36^3/_8 × 31^7/_8$ in)
Uffizi, Florence

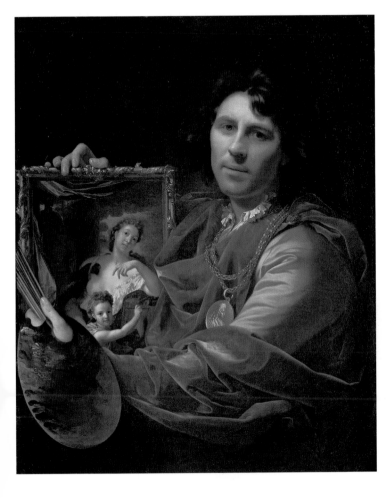

ADRIAEN VAN DER WERFF (1659–1722)
Self-Portrait with a Portrait of his Wife, Margaretha van Rees, and their Daughter, Maria, 1699
Oil on canvas, 81 × 65.5 cm (31⅞ × 25¾ in)
Rijksmuseum, Amsterdam

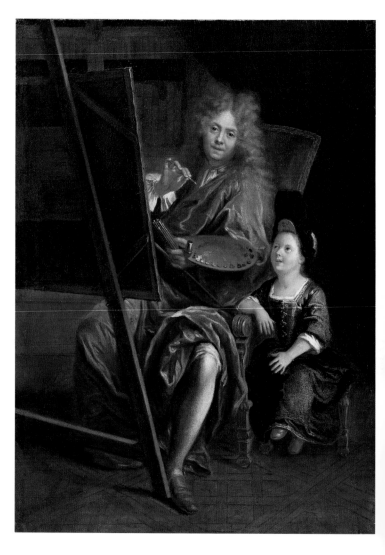

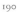

ANTOINE COYPEL (1661–1722)
Portrait of the Artist with his Son, Charles-Antoine, 1698
Oil on canvas, 59 × 42 cm (23¼ × 16½ in)
Musée des Beaux Arts et d'Archéologie de Besançon

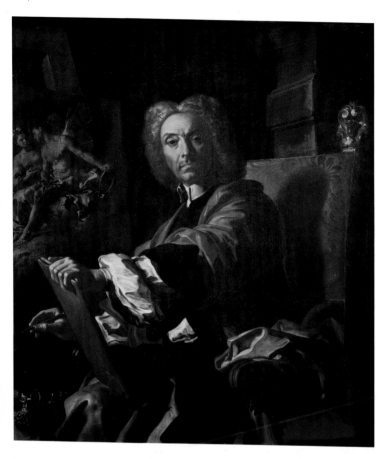

FRANCESCO SOLIMENA (1657–1747)
Self-Portrait, 1730–1
Oil on canvas, 130 × 114 cm (51¼ × 44⅞ in)
Uffizi, Florence

192

Portrait of the Artist in Hunting Dress, 1699
Oil on canvas, 197 × 163 cm (77⁵⁄₈ × 64¹⁄₄ in)
Louvre, Paris

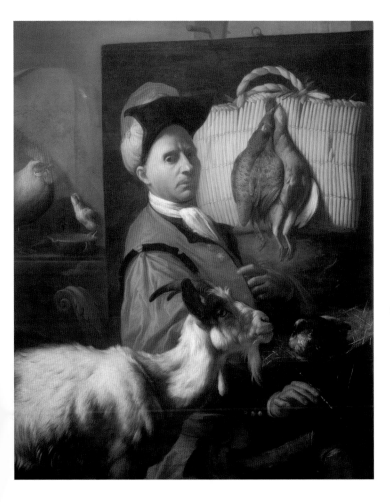

ARCANGELO RESANI (1670–1742)
*Self-Portrait, c.*1713
Oil on canvas, 105 × 87.3 cm (41³⁄₈ × 34³⁄₈ in)
Uffizi, Florence

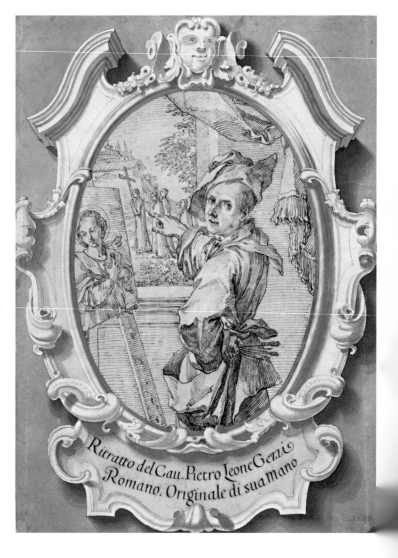

Ritratto del Cau. Pietro Leone Gezzi Romano. Originale di sua mano

PIER LEONE GHEZZI (1674–1755)
*Self-Portrait, c.*1700
Pen and brown ink on paper, 23.6 × 17.3 cm (9¼ × 6⅞ in)
Private collection

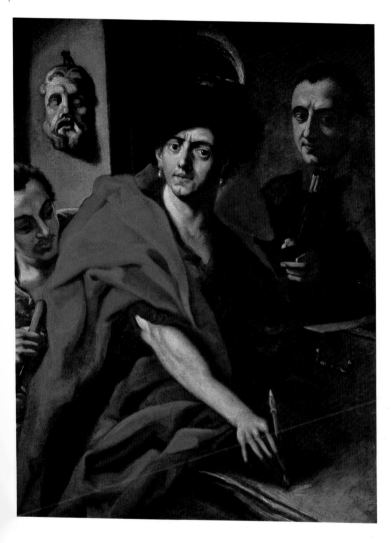

COSMAS DAMIAN ASAM (1686–1739)
Self-Portrait with his Father and Brother, c.1725–30
Oil on canvas, 116 × 98 cm (45⁵⁄₈ × 38⁵⁄₈ in)
Diözesanmuseum, Freising

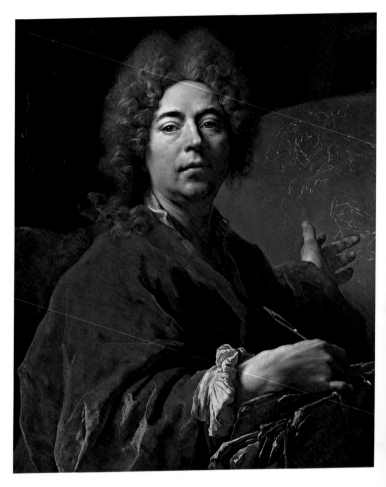

NICOLAS DE LARGILLIÈRE (1656–1746)
Self-Portrait Painting an Annunciation, 1711
Oil on canvas, 80 × 65 cm (31¹⁄₂ × 25⁵⁄₈ in)
Château de Versailles

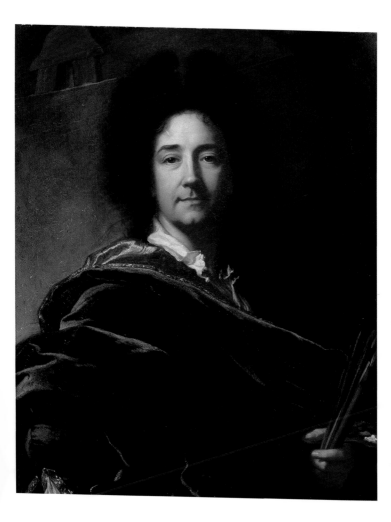

197

HYACINTHE RIGAUD (1659–1743)
Self-Portrait, 1716
Oil on canvas, 80 × 64 cm (31$^1/_2$ × 25$^1/_4$ in)
Uffizi, Florence

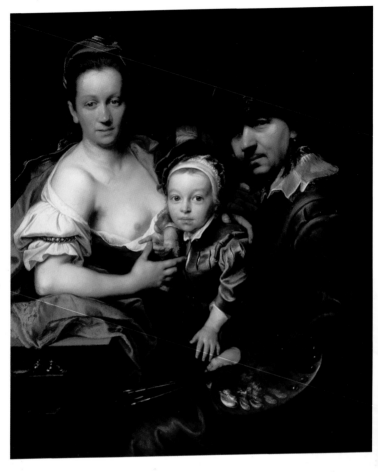

198

JOHANN KUPETZKY (1667–1740)
Portrait of the Artist with his Wife and Son, 1718–19
Oil on canvas, 111 × 91 cm (43¼ × 35⅞ in)
Szépmüvészeti Múzeum, Budapest

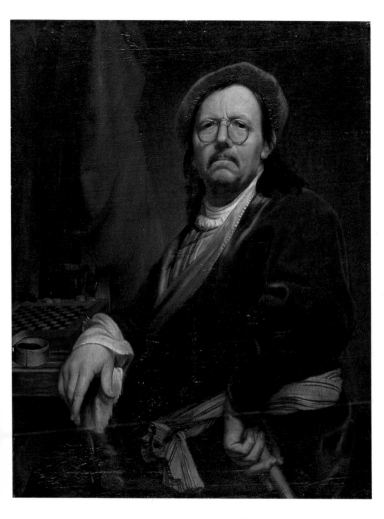

JOHANN KUPETZKY (1667–1740)
*Self-Portrait, c.*1730
Oil on canvas, 94 × 74 cm (37 × 29^1/$_8$ in)
Staatsgalerie, Stuttgart

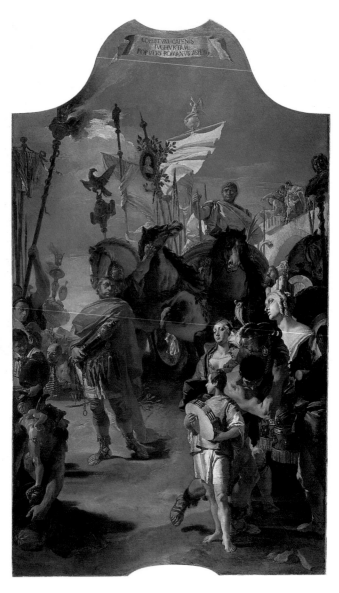

200

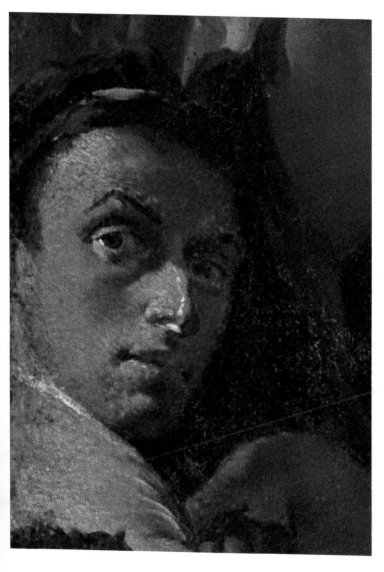

Detail from *The Triumph of Marius*

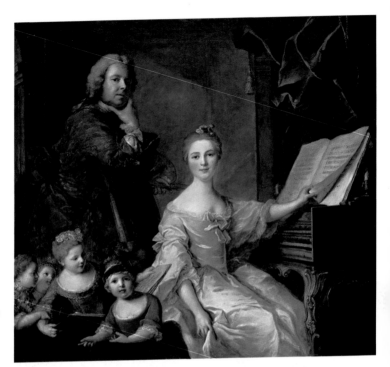

JEAN-MARC NATTIER (1685–1766)
The Artist and his Family, 1730 (completed 1762)
Oil on canvas, 142 × 163 cm (56 × 64¼ in)
Château de Versailles

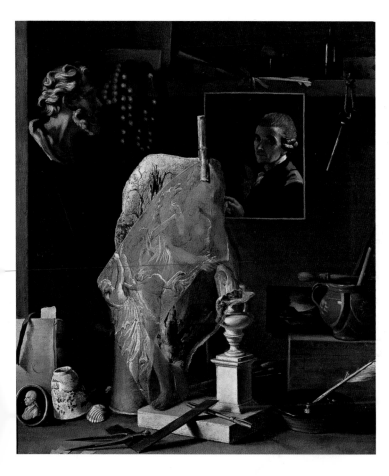

203

ANTONIO CIOCI (fl.1739–92)
Self-Portrait, 1739
Oil on canvas, 67 × 58 cm (26³⁄₈ × 22⁷⁄₈ in)
Uffizi, Florence

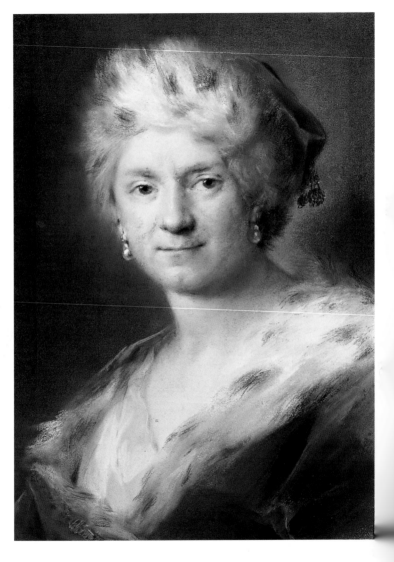

ROSALBA CARRIERA (1675–1757)
Self-Portrait as Winter, 1731
Pastel on paper, 46.5 × 34 cm (18³⁄₈ × 13³⁄₈ in)
Gemäldegalerie, Dresden

GIOVANNI BATTISTA PIAZZETTA (1682–1754)
Self-Portrait, 1735
Charcoal heightened with white chalk on paper, 35 × 24.1 cm (13³/₄ × 9¹/₂ in)
Graphische Sammlung Albertina, Vienna

MAURICE QUENTIN DE LA TOUR (1704–88)
Self-Portrait, c.1735
Pastel on paper, 61.5 × 50.5 cm (24¼ × 19⅞ in)
Uffizi, Florence

MAURICE QUENTIN DE LA TOUR (1704–88)
*Self-Portrait Wearing a Jabot, c.*1751
Pastel on paper, 64 × 53 cm (25¼ × 20⅞ in)
Musée de Picardie, Amiens

208

JEAN-ÉTIENNE LIOTARD (1702–89)
View of Geneva from the Artist's House, 1740
Oil on canvas, 24 × 20 cm (9$\frac{1}{2}$ × 7$\frac{7}{8}$ in)
Rijksmuseum, Amsterdam

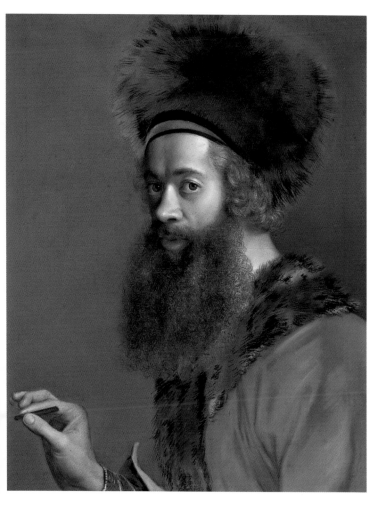

JEAN-ÉTIENNE LIOTARD (1702–89)
Self-Portrait, 1744–5
Pastel on paper, 60.5 × 46.5 cm ($23^{7}/_{8}$ × $18^{3}/_{8}$ in)
Gemäldegalerie, Dresden

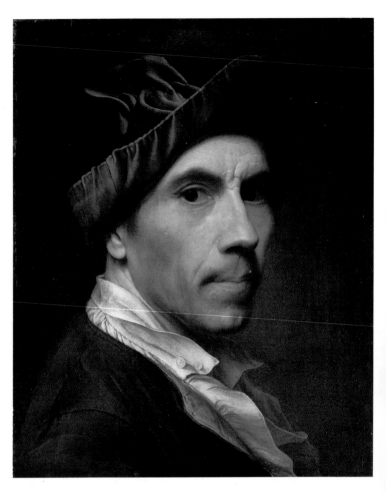

CHRISTIAN SEYBOLD (1690/7–1768)
*Self-Portrait, c.*1745
Oil on canvas, 45.5 × 36.5 cm (17⁷⁄₈ × 14³⁄₈ in)
Louvre, Paris

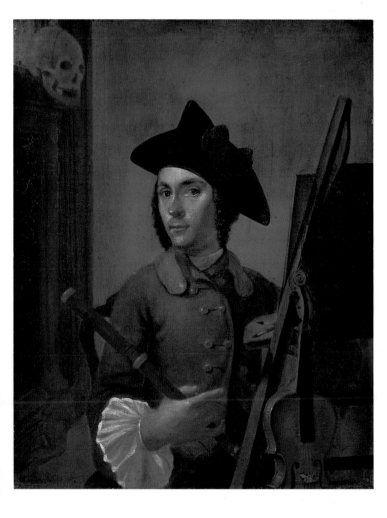

GERRIT BAKHUIZEN (*c.*1700–60)
Self-Portrait, 1745
Oil on wood, 30.5 × 25 cm (12 × 9⁷⁄₈ in)
Rijksmuseum, Amsterdam

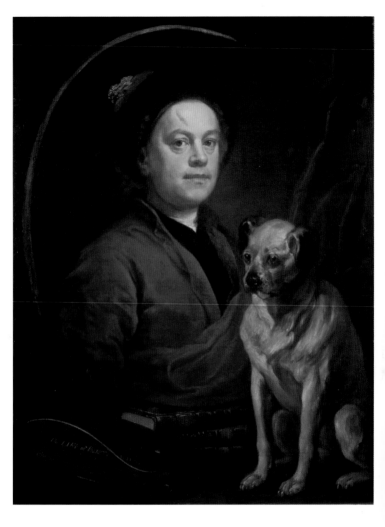

WILLIAM HOGARTH (1697–1764)
Self-Portrait with a Pug, 1745
Oil on canvas, 90 × 69.9 cm (35³⁄₈ × 27¹⁄₂ in)
Tate Gallery, London

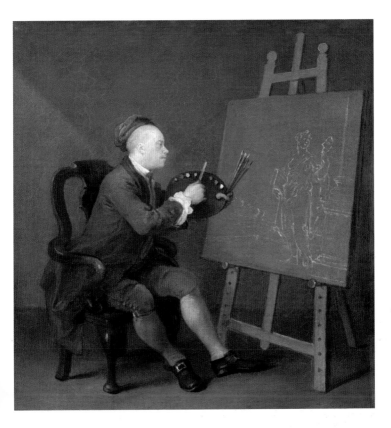

WILLIAM HOGARTH (1697–1764)
Hogarth Painting the Comic Muse, c.1757
Oil on canvas, 45.1 × 42.5 cm (17³⁄₄ × 16³⁄₄ in)
National Portrait Gallery, London

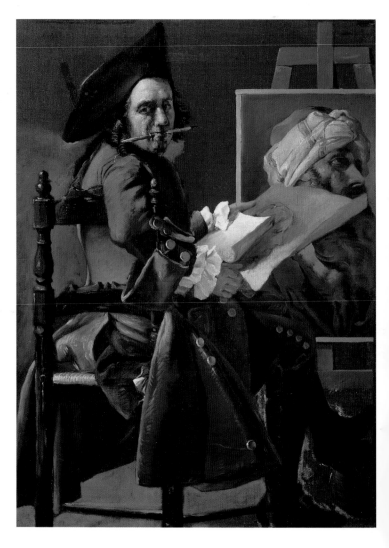

PIERRE SUBLEYRAS (1699–1749)
*Self-Portrait at an Easel, c.*1746
Oil on canvas, 126.3 × 99.3 cm (49¾ × 39 in)
Akademie der Bildenden Künste, Vienna

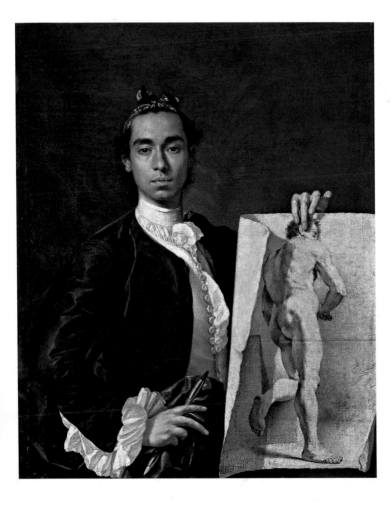

LUIS MELÉNDEZ (1716–80)
Self-Portrait with a Drawing of a Male Nude, 1746
Oil on canvas, 99 × 82 cm (39 × 32⅝ in)
Louvre, Paris

JOSHUA REYNOLDS (1723–92)
*Self-Portrait, c.*1748–9
Oil on canvas, 63 × 74 cm (24¾ × 29⅛ in)
National Portrait Gallery, London

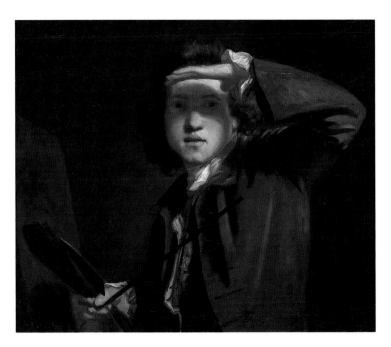

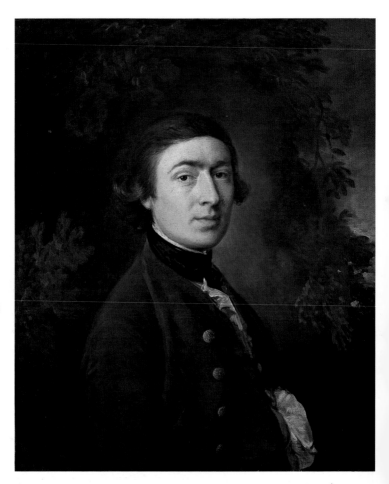

218

THOMAS GAINSBOROUGH (1727–88)
*Self-Portrait, c.*1759
Oil on canvas, 76.2 × 63.5 cm (30 × 25 in)
National Portrait Gallery, London

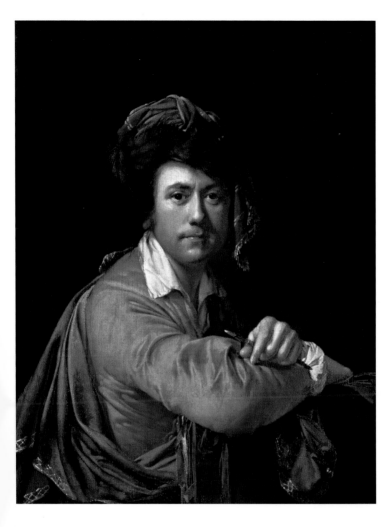

JOSEPH WRIGHT OF DERBY (1734–97)
Self-Portrait at the Age of about Forty, c.1772–3
Oil on canvas, 76.2 × 63.5 cm (30 × 25 in)
Private collection

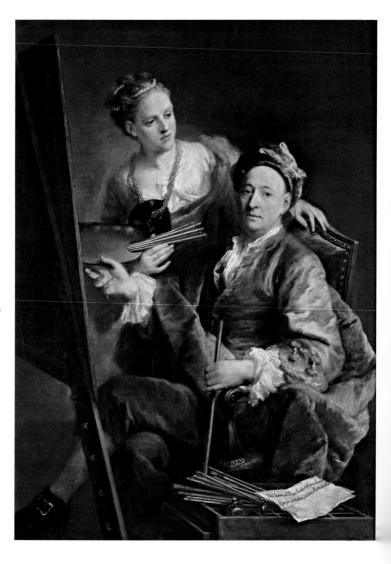

220

GEORGES DESMARÉES (1697–1776)
Self-Portrait with his Daughter, Maria Antonia, 1760
Oil on canvas, 155 × 115 cm (69¹⁄₈ × 45³⁄₈ in)
Staatsgalerie im Neuen Schloss, Oberschleissheim

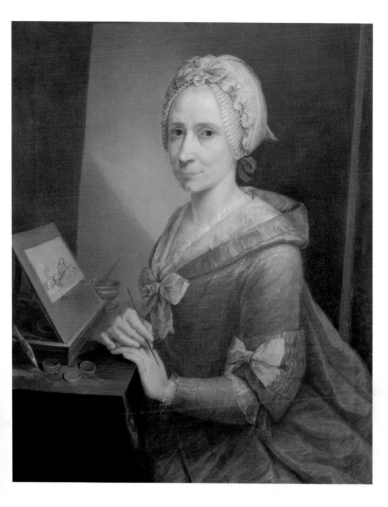

ANNA BACHERINI PIATTOLI (1720–80)
Self-Portrait, 1776
Oil on canvas, 78.2 × 60 cm (30³⁄₄ × 23⁵⁄₈ in)
Uffizi, Florence

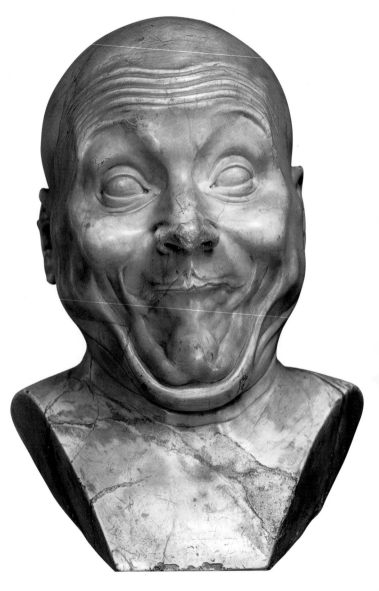

222

FRANZ XAVER MESSERSCHMIDT (1736–83)
*Self-Portrait as a Jester, c.*1770
From a series of character heads, alabaster, height 42 cm (16½ in)
Österreichische Galerie Belvedere, Vienna

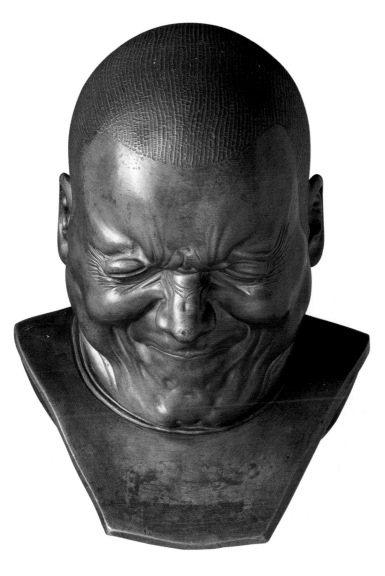

223

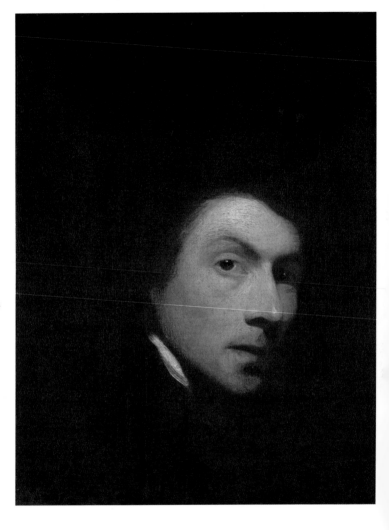

224

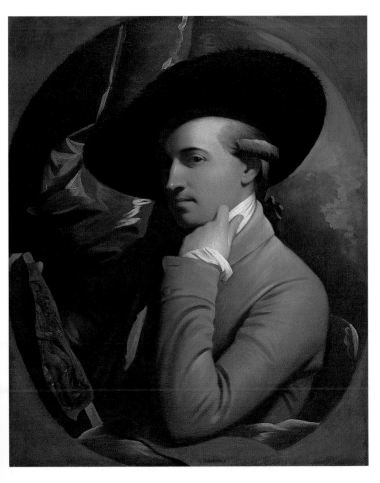

BENJAMIN WEST (1738–1820)
*Self-Portrait, c.*1770–6
Oil on canvas, 76.8 × 63.8 cm (30¼ × 25⅛ in)
Baltimore Museum of Art

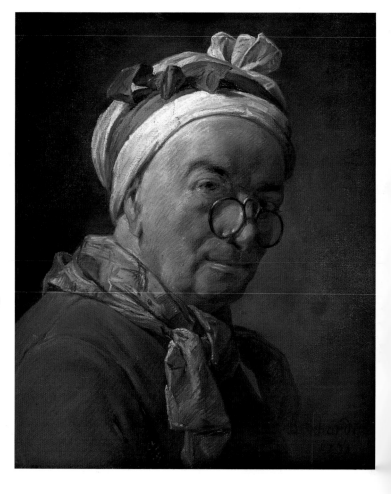

JEAN-BAPTISTE-SIMÉON CHARDIN (1699–1779)
Self-Portrait, 1771
Pastel on paper, 46 × 37.5 cm (18¹⁄₈ × 14³⁄₄ in)
Cabinet des Dessins, Louvre, Paris

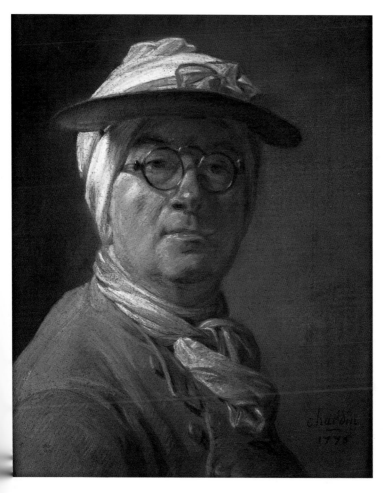

JEAN-BAPTISTE-SIMÉON CHARDIN (1699–1779)
Self-Portrait, 1775
Pastel on paper, 46 × 38 cm (18¹⁄₈ × 15 in)
Cabinet des Dessins, Louvre, Paris

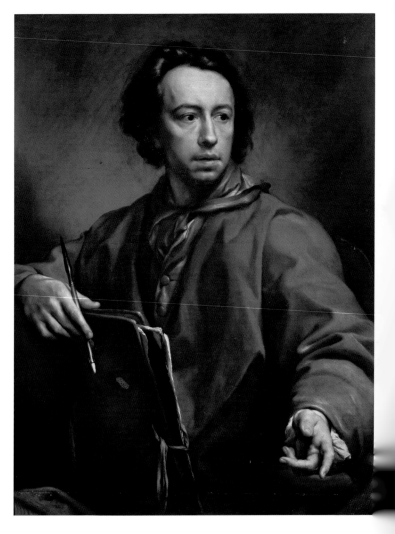

ANTON RAPHAEL MENGS (1728–79)
Self-Portrait, 1773
Oil on canvas, 97 × 72.6 cm (38⅛ × 28⅝ in)
Uffizi, Florence

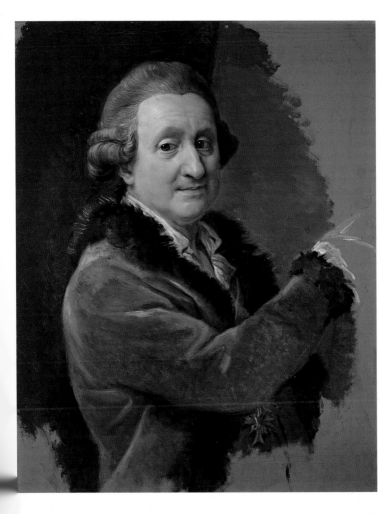

POMPEO BATONI (1708–87)
Self-Portrait, 1773–4
Oil on canvas, 75.5 × 61 cm (29¾ × 24 in)
Uffizi, Florence

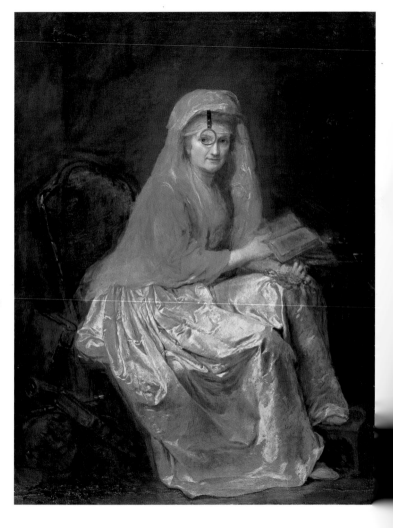

ANNA DOROTHEA THERBUSCH (1721–82)
Self-Portrait, c.1776–7
Oil on canvas, 151 × 115 cm (59½ × 45⅜ in)
Gemäldegalerie, Berlin

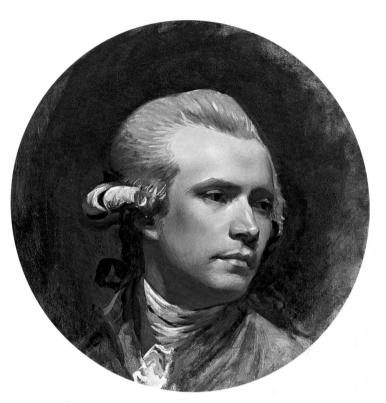

JOHN SINGLETON COPLEY (1738–1815)
Self-Portrait, 1780–4
Oil on canvas, diameter 45.1 cm (17³⁄₄ in)
National Portrait Gallery, Washington DC

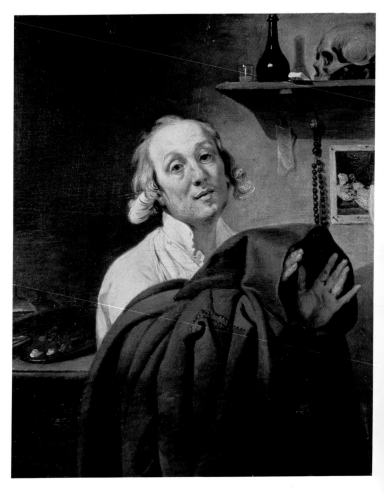

JOHANN ZOFFANY (1733–1810)
Self-Portrait as a Monk, 1779
Oil on wood, 43 × 36.6 cm (17 × 14³⁄₈ in)
Galleria Nazionale, Parma

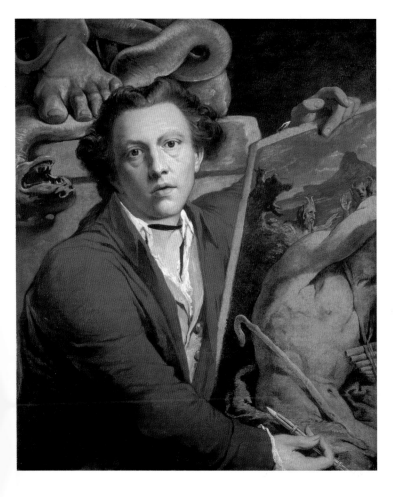

233

JAMES BARRY (1741–1806)
Self-Portrait as Timanthes, *c.*1780 and 1803
Oil on canvas, 76 × 63 cm (29⅞ × 24¾ in)
National Gallery of Ireland, Dublin

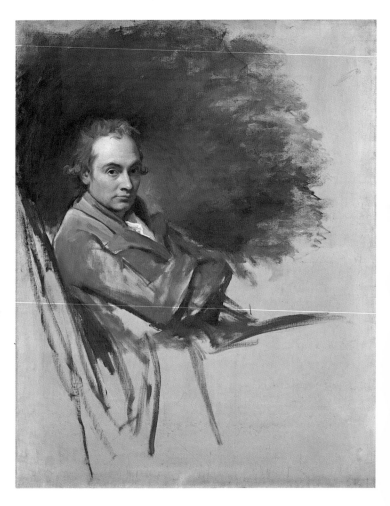

GEORGE ROMNEY (1734–1802)
Self-Portrait, 1782
Oil on canvas, 125.7 × 99.1 cm (49½ × 39 in)
National Portrait Gallery, London

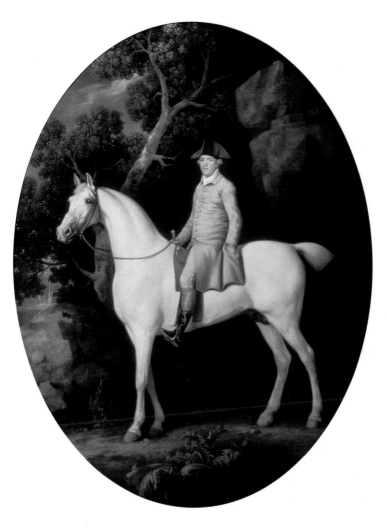

235

GEORGE STUBBS (1724–1806)
Self-Portrait on a White Hunter, 1782
Enamel on Wedgwood biscuit earthenware, 93 × 71 cm (36⅝ × 28 in)
Lady Lever Art Gallery, Port Sunlight

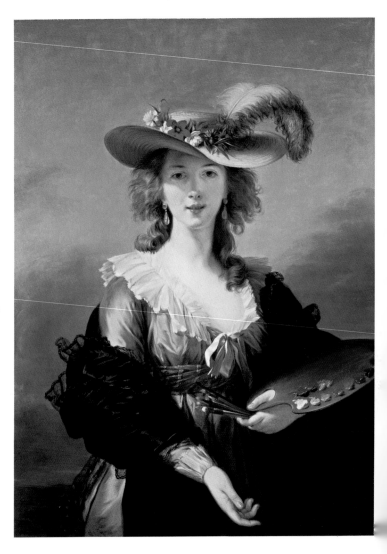

ELISABETH-LOUISE VIGÉE-LEBRUN (1755–1842)
Self-Portrait in a Straw Hat, 1783
Oil on canvas, 97.8 × 70.5 cm (38¹⁄₂ × 27³⁄₄ in)
National Gallery, London

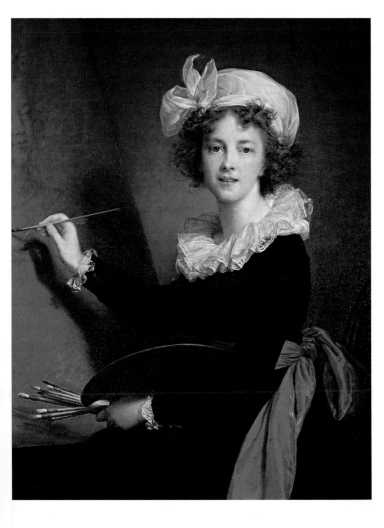

ELISABETH-LOUISE VIGÉE-LEBRUN (1755–1842)
Self-Portrait, 1790
Oil on canvas, 100 × 81 cm (39³⁄₈ × 32 in)
Uffizi, Florence

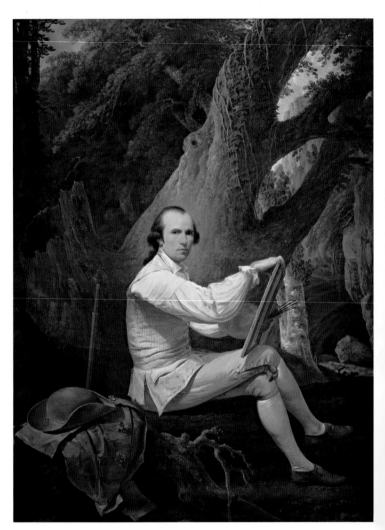

238

JACOB MORE (1740–93)
Self-Portrait Painting in the Woods, 1783
Oil on canvas, 198 × 147.5cm (78 × 58¹⁄₈ in)
Uffizi, Florence

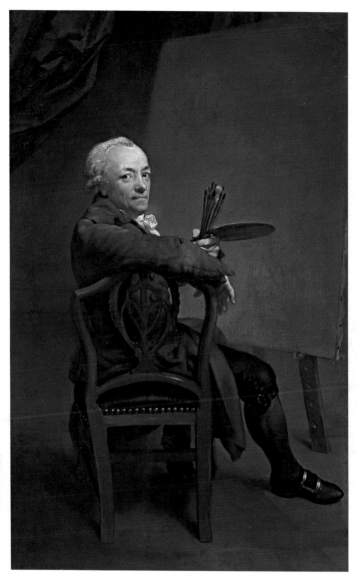

ANTON GRAFF (1736–1813)
Self-Portrait, 1794–5
Oil on canvas, 168 × 105 cm (66¼ × 41³⁄₈ in)
Gemäldegalerie, Dresden

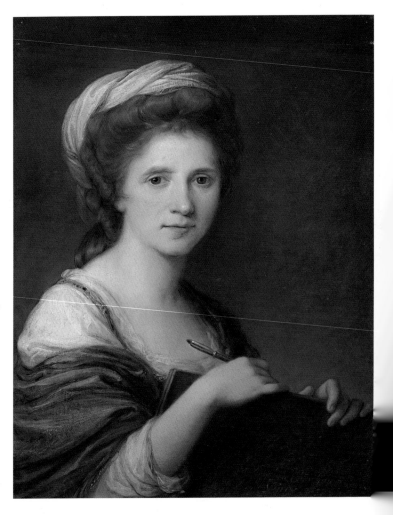

240

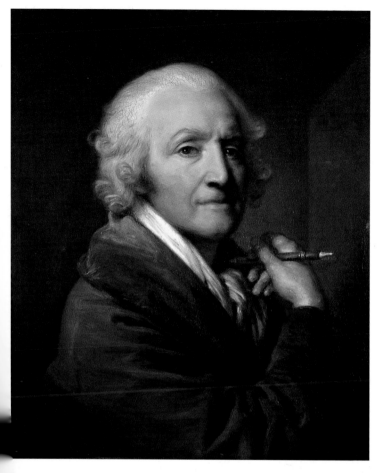

JEAN-BAPTISTE GREUZE (1725–1805)
Self-Portrait, c.1803
Oil on wood, 52.5 × 45.5 cm (20⁵⁄₈ × 17⁷⁄₈ in)
Musée des Beaux-Arts, Marseilles

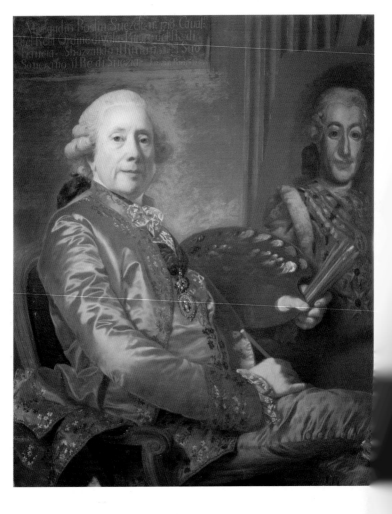

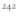

242

ALEXANDER ROSLIN (1718–93)
Self-Portrait, 1790
Oil on canvas, 103 × 81 cm (40⅝ × 31⅞ in)
Uffizi, Florence

ADÉLAIDE LABILLE-GUIARD (1749–1803)
Self-Portrait with Two Pupils, Mesdames Capet and Carreaud de Rosemond, 1785
Oil on canvas, 210.8 × 151.1 cm (83 × 59½ in)
Metropolitan Museum of Art, New York

JACQUES-LAURENT AGASSE (1767–1849)
Self-Portrait with Horse and Black Dog in a Landscape, 1790
Oil on canvas, 51.5 × 55 cm (20¼ × 21⅝ in)
Private collection

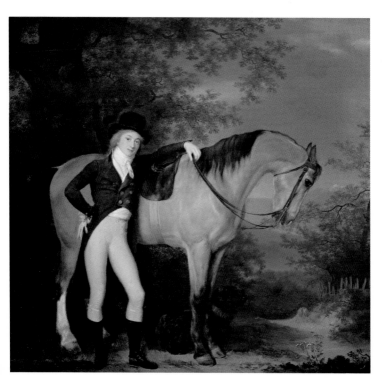

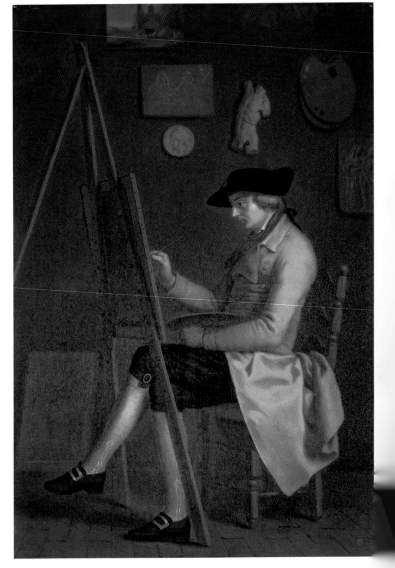

FRIEDRICH TISCHBEIN (1750–1812)
Self-Portrait at the Easel, 1785
Oil on wood, 50.8 × 36 cm (20 × 14¼ in)
Schlossmuseum, Weimar

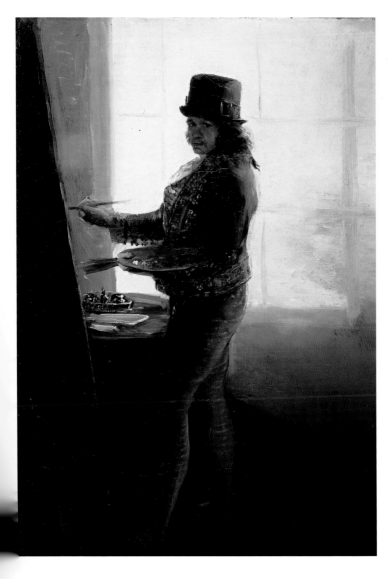

FRANCISCO GOYA (1746–1828)
Self-Portrait in the Studio, c.1791–2
Oil on canvas, 42 × 28 cm (16½ × 11 in)
Academia di San Fernando, Madrid

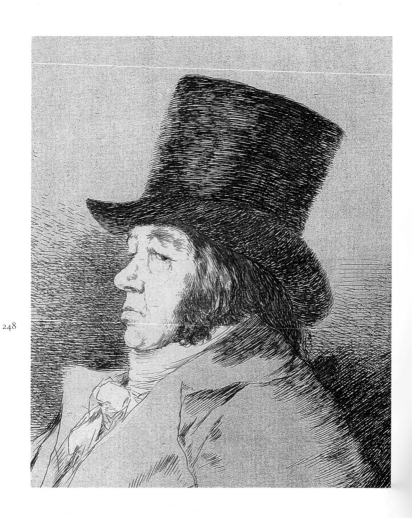

248

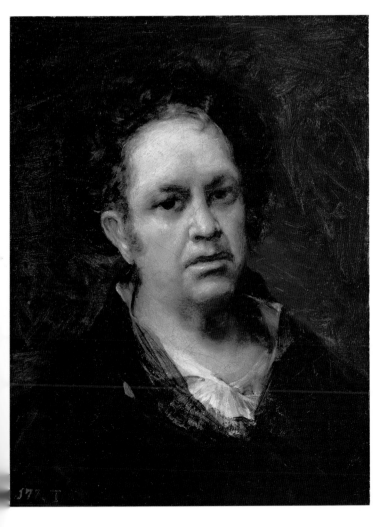

FRANCISCO GOYA (1746–1828)
*Self-Portrait, c.*1815
Oil on canvas, 46 × 35 cm (18⅛ × 13¾ in)
Prado, Madrid

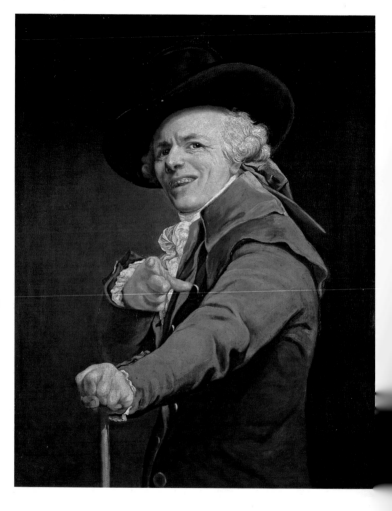

JOSEPH DUCREUX (1735–1802)
Self-Portrait as a Mocker, 1793
Oil on canvas, 55 × 46 cm (21³⁄₄ × 18¹⁄₈ in)
Louvre, Paris

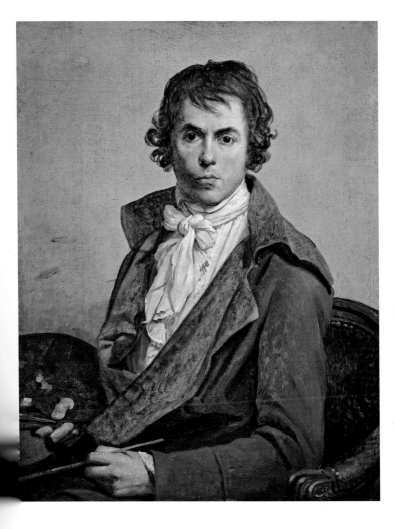

JACQUES-LOUIS DAVID (1748–1825)
Self-Portrait, 1794
Oil on canvas, 81 × 64 cm (31⁷⁄₈ × 25¼ in)
Louvre, Paris

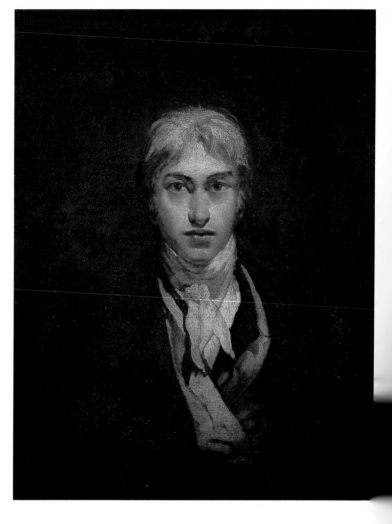

J M W TURNER (1775–1851)
Self-Portrait, 1798
Oil on canvas, 74.3 × 58.4 cm (29¼ × 23 in)
Tate Gallery, London

HN CONSTABLE (1776–1837)
lf-Portrait, c.1800
ncil and watercolour on paper, 24.8 × 19.4 cm (9³⁄₄ × 7⁵⁄₈ in)
tional Portrait Gallery, London

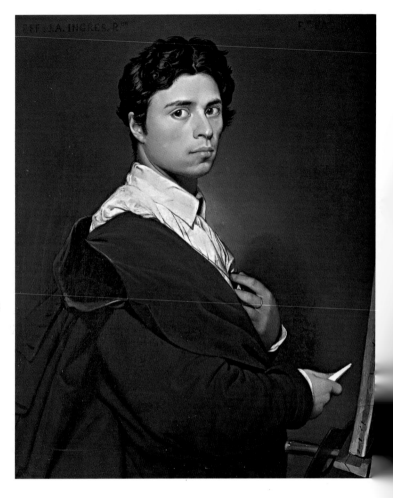

JEAN-AUGUSTE-DOMINIQUE INGRES (1780–1867)
Self-Portrait, 1804
Oil on canvas, 77 × 63 cm (30⅜ × 24⅞ in)
Musée Condé, Chantilly

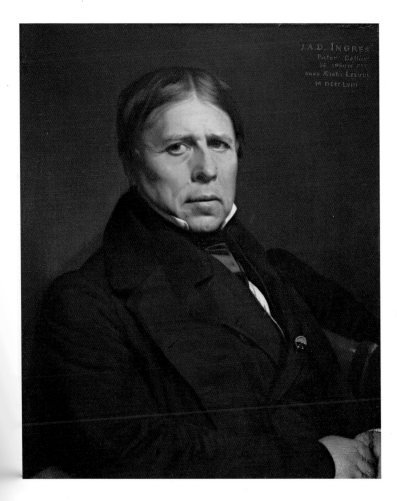

JEAN-AUGUSTE-DOMINIQUE INGRES (1780–1867)
Self-Portrait, 1858
Oil on canvas, 62 × 51 cm (24³/₈ × 20 in)
Uffizi, Florence

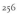256

CHARLES WILLSON PEALE (1741–1827)
Self-Portrait with Spectacles, c.1804
Oil on canvas, 66.3 × 56.4 cm (26⅛ × 22¼ in)
Pennsylvania Academy of the Fine Arts, Philadelphia

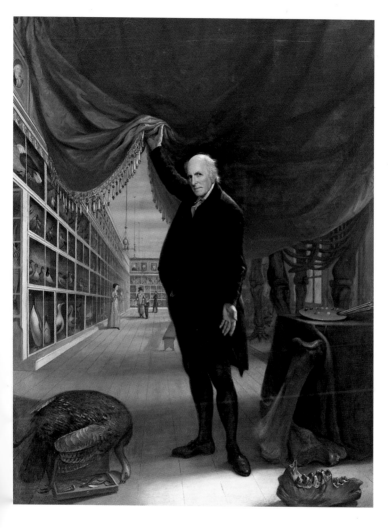

CHARLES WILLSON PEALE (1741–1827)
The Artist in his Museum, 1822
Oil on canvas, 263.2 × 202.6 cm (103¾ × 79⅞ in)
Pennsylvania Academy of the Fine Arts, Philadelphia

258

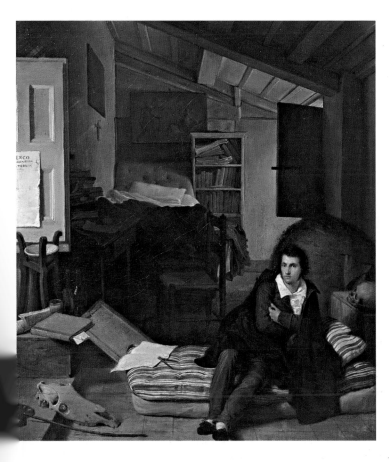

259

ƆMMASO MINARDI (1787–1871)
·lf-Portrait, c.1813
l on canvas, 37 × 33 cm (14⁵⁄₈ × 13 in)
ïzi, Florence

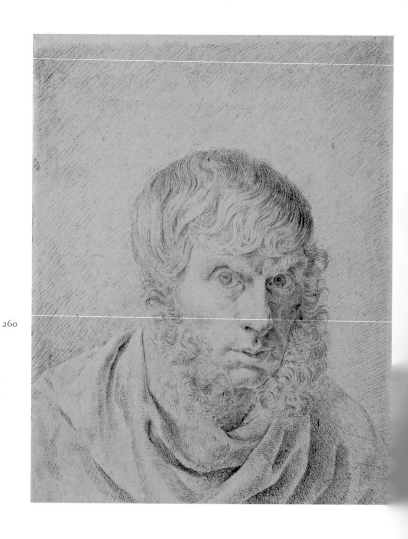

CASPAR DAVID FRIEDRICH (1774–1840)
Self-Portrait, 1810
Black chalk on paper, 22.9 × 18.2 cm (9 × 7⅛ in)
Kupferstichkabinett, Berlin

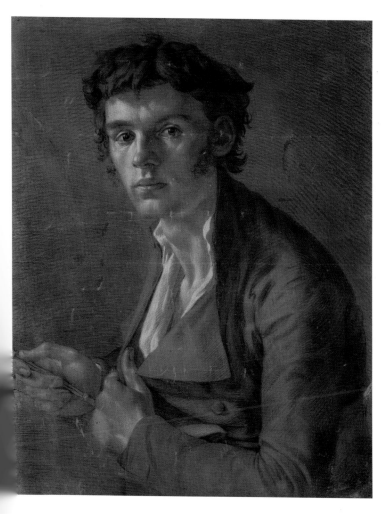

PHILIPP OTTO RUNGE (1777–1810)
*Self-Portrait, c.*1805
Black and white chalk on paper, 55.5 × 43.5 cm (21⁷⁄₈ × 17¹⁄₄ in)
Kunsthalle, Hamburg

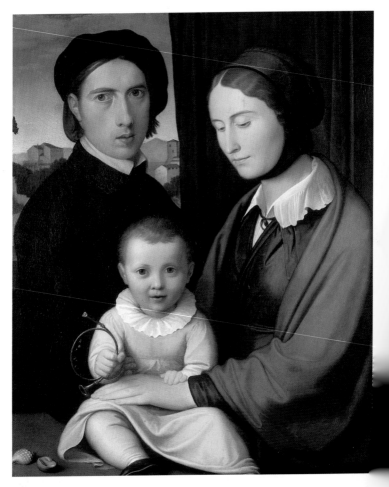

FRIEDRICH OVERBECK (1789–1869)
The Artist with his Family, c.1820–30
Oil on wood, 46.5 × 37 cm (18³⁄₈ × 14⁵⁄₈ in)
Museum für Kunst und Kulturgeschichte, Lübeck

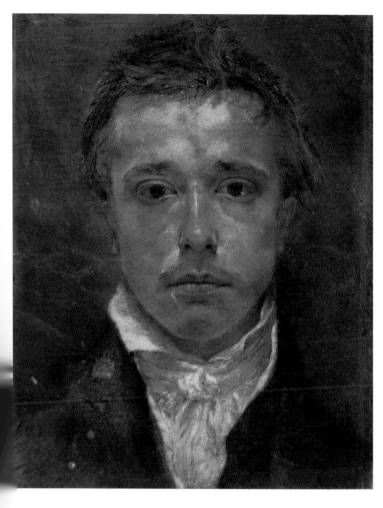

263

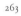

SAMUEL PALMER (1805–81)
Self-Portrait, *c.*1826
Black chalk heightened with white on buff paper, 29.2 × 22.8 cm (11½ × 9 in)
Ashmolean Museum, Oxford

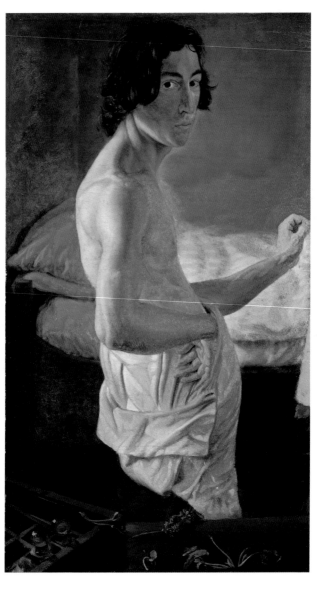

EMIL JANSSEN (1807–45)
Self-Portrait, c.1829
Oil on paper on canvas, 56.6 × 32.7 cm (22¼ × 12⅞ in)
Kunsthalle, Hamburg

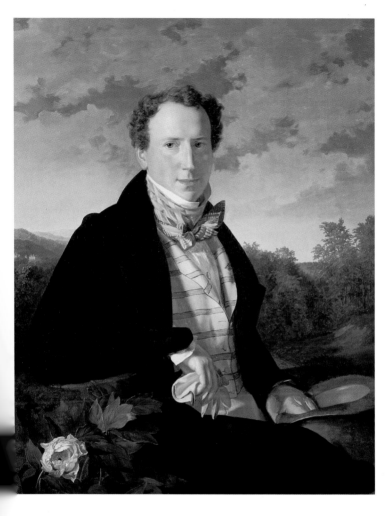

FERDINAND GEORG WALDMÜLLER (1793–1865)
Self-Portrait, 1828
Oil on canvas, 95 × 75.5 cm (37¹⁄₂ × 29³⁄₄ in)
Österreichische Galerie Belvedere, Vienna

266

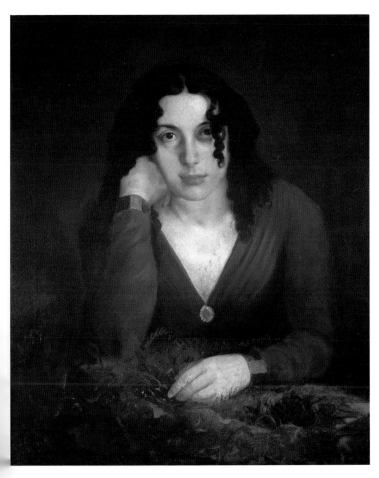

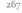

LILLY MARTIN SPENCER (1822–1902)
Self-Portrait, 1841
Oil on canvas, 76.1 × 64.7 cm (30 × 25½ in)
Ohio Historical Society, Columbus

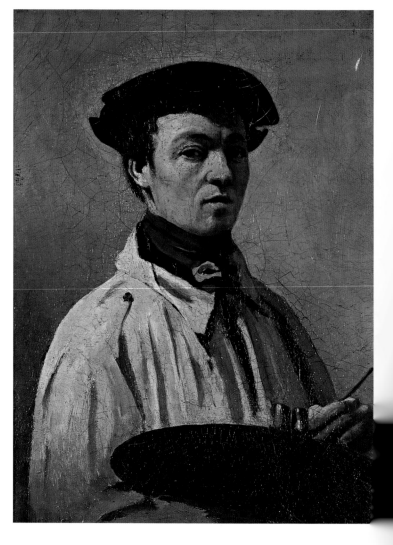

268

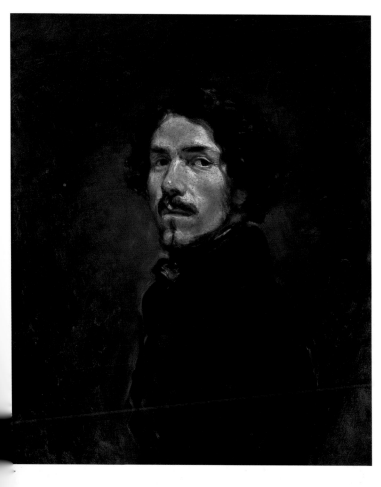

269

ᴜɢÈɴᴇ ᴅᴇʟᴀᴄʀᴏɪx (1798–1863)
*elf-Portrait, c.*1842
il on canvas, 66 × 54 cm (26 × 21¼ in)
ffizi, Florence

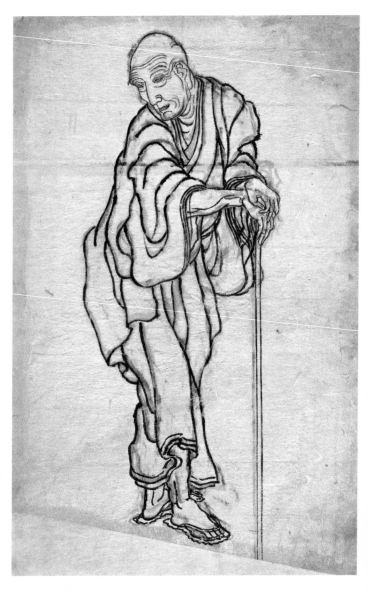

KATSUSHIKA HOKUSAI (1760–1849)
Self-Portrait as an Old Man, c.1845
Black ink and vermilion on paper, 37.2 × 23.7 cm (14⅝ × 9⅜ in)
Musée National des Arts Asiatiques Guimet, Paris

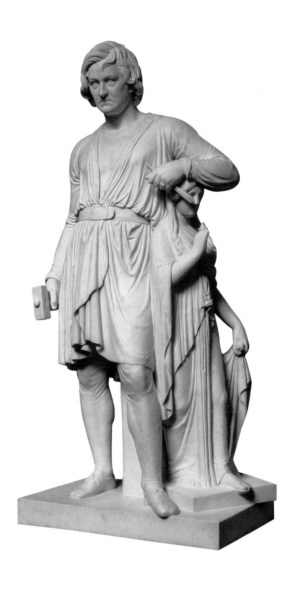

BERTEL THORVALDSEN (1768/70–1844)
...aning on the Statue of Hope: Self-Portrait, 1839
...arble version executed 1859, height 198 cm (78 in)
...horvaldsens Museum, Copenhagen

GUSTAVE COURBET (1819–77)
Self-Portrait: The Desperate Man, 1843
Oil on canvas, 45 × 54 cm (17³⁄₄ × 21¹⁄₄ in)
Nasjonalgalleriet, Oslo

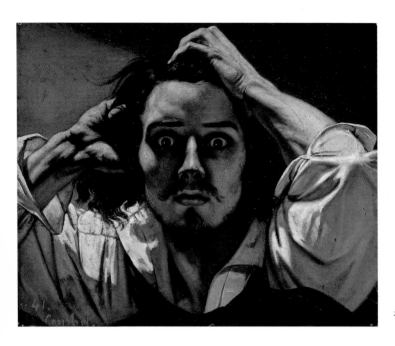

273

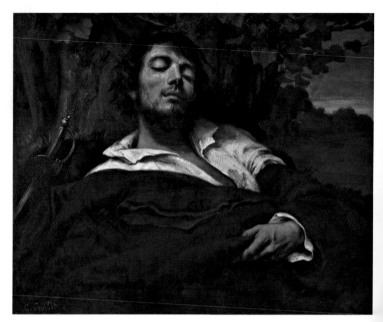

GUSTAVE COURBET (1819–77)
Self-Portrait: The Wounded Man, 1844–54
Oil on canvas, 81 × 97 cm (31⁷⁄₈ × 38¹⁄₄ in)
Musée d'Orsay, Paris

GUSTAVE COURBET (1819–77)
The Meeting, or *Bonjour, Monsieur Courbet*, 1854
Oil on canvas 129 × 149 cm (50⁵⁄₄ × 58⁵⁄₈ in)
Musée Fabre, Montpellier

DAVID OCTAVIUS HILL (1802–70)
*Self-Portrait, c.*1843
Calotype, 19.8 × 14.6 cm (7³⁄₄ × 5³⁄₄ in)

CHARLES DODGSON (LEWIS CARROLL) (1832–98)
Self-Portrait, 1856–60
Visiting card, albumen print, 9.1 × 5.7 cm (3⅝ × 2¼ in)

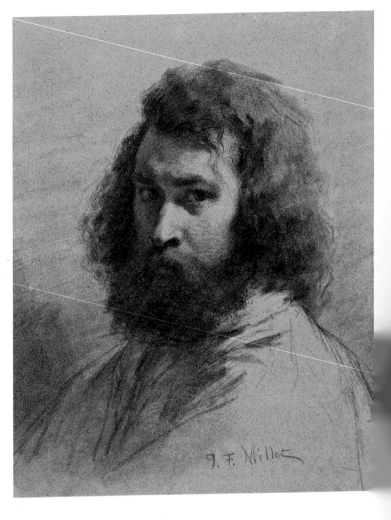

JEAN-FRANÇOIS MILLET (1814–75)
Self-Portrait, 1845–6
Pencil and black chalk on grey-blue paper, 56.2 × 45.6 cm (22⅛ × 18 in)
Louvre, Paris

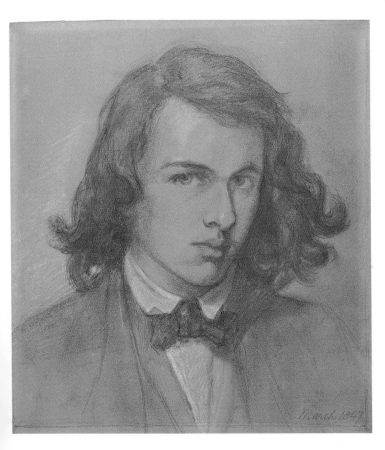

DANTE GABRIEL ROSSETTI (1828–82)
Self-Portrait, 1846
Pencil heightened with white on paper, 19.7 × 17.8 cm (7³⁄₄ × 7 in)
National Portrait Gallery, London

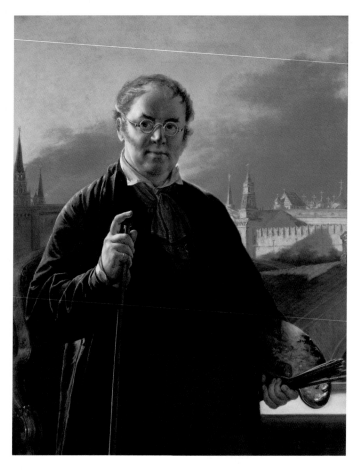

VASILY TROPININ (1776–1857)
Self-Portrait by a Window with a View on the Kremlin, 1846
Oil on canvas, 106 × 84.5 cm (41³⁄₄ × 33¹⁄₄ in)
Tret'yakov Gallery, Moscow

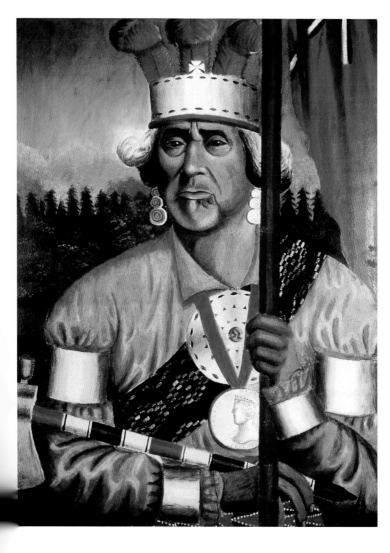

ZACHARIE VINCENT (TELARI-O-LIN) (1815–86)
Telari-o-lin, Huron Chief and Painter, c.1850
Oil and pencil on paper, 87 × 65 cm (34¼ × 25⅝ in)
Musée du Château Ramezay, Montreal

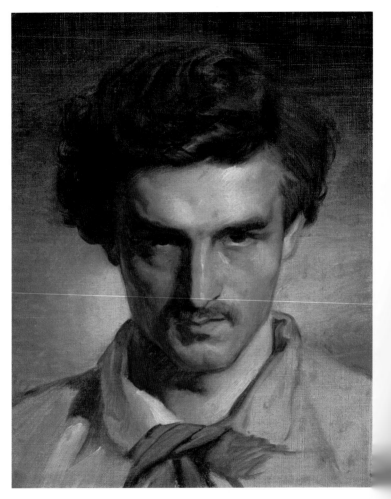

ANSELM FEUERBACH (1829–80)
Self-Portrait, c.1852
Oil on canvas, 42 × 33 cm (16½ × 13 in)
Staatliche Kunsthalle, Karlsruhe

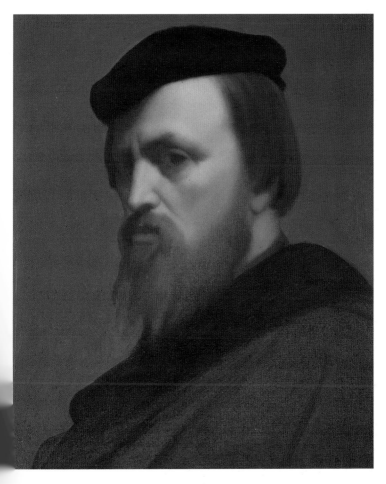

IPPOLYTE FLANDRIN (1809–64)
Self-Portrait, 1853
Oil on canvas, 44 × 36 cm (13³⁄₈ × 14¹⁄₄ in)
Uffizi, Florence

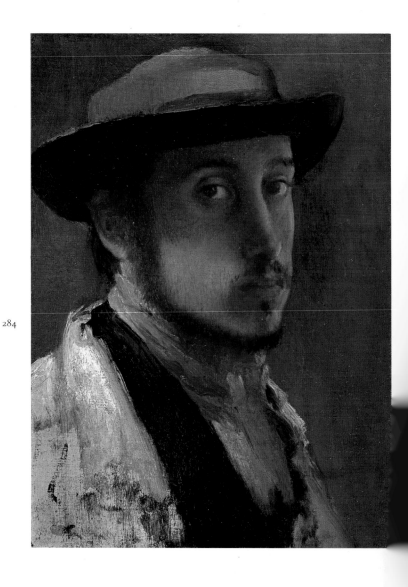

284

EDGAR DEGAS (1834–1917)
Self-Portrait, 1857
Oil on paper on canvas, 26 × 19 cm (10¼ × 7½ in)
Sterling and Francine Clark Art Institute, Williamstown, MA

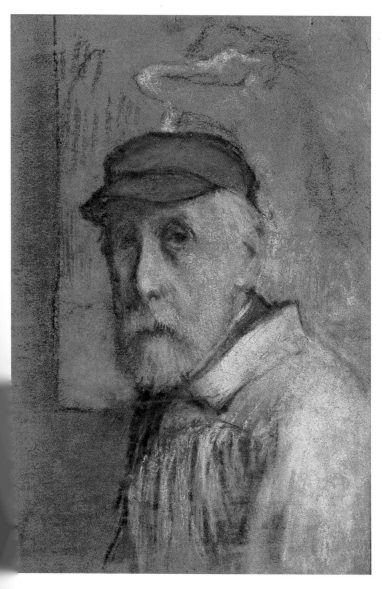

285

EDGAR DEGAS (1834–1917)
Self-Portrait, c.1895–1900
Pastel on paper, 47.5 × 32.5 cm (18³⁄₄ × 12³⁄₄ in)
Collection Rau, Zurich

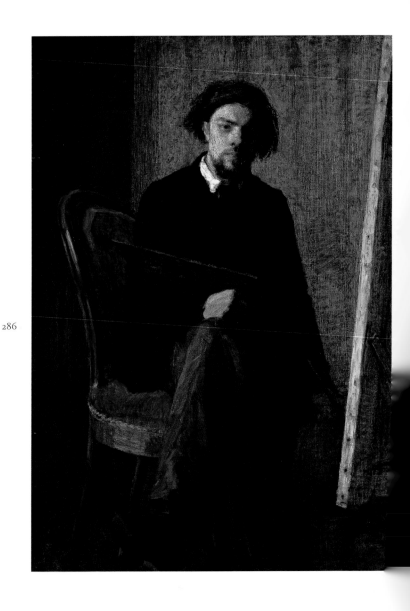

286

HENRI FANTIN-LATOUR (1836–1904)
Self-Portrait, 1858
Oil on canvas, 102.5 × 71.5 cm (40⁵⁄₈ × 28¹⁄₈ in)
Alte Nationalgalerie, Berlin

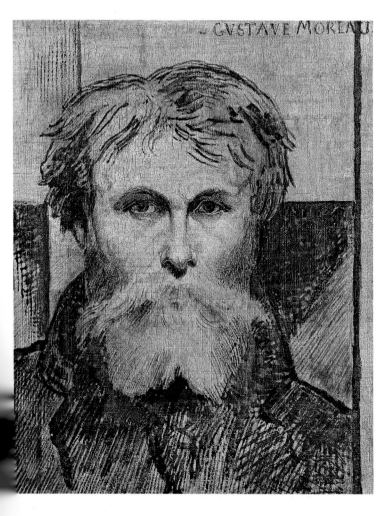

GVSTAVE MOREAU

GUSTAVE MOREAU (1826–98)
Self-Portrait, c.1870–5
Indian ink on canvas, 41 × 33 cm (16⅛ × 12½ in)
Musée Gustave Moreau, Paris

288

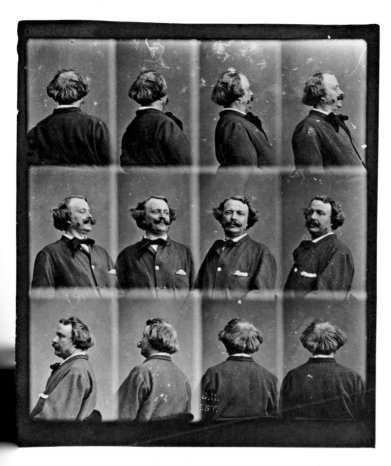

ADAR (1820–1910)
*elf-Portrait, Turning, c.*1865
bumen print, 14.6 × 13.3 cm (5¾ × 5¼ in)

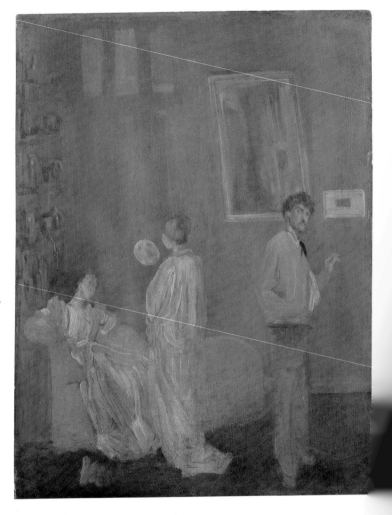

JAMES ABBOT MCNEILL WHISTLER (1834–1903)
The Artist's Studio, 1865
Oil on card, 62.2 × 46.3 cm (24⅝ × 18¼ in)
Hugh Lane Municipal Art Gallery, Dublin

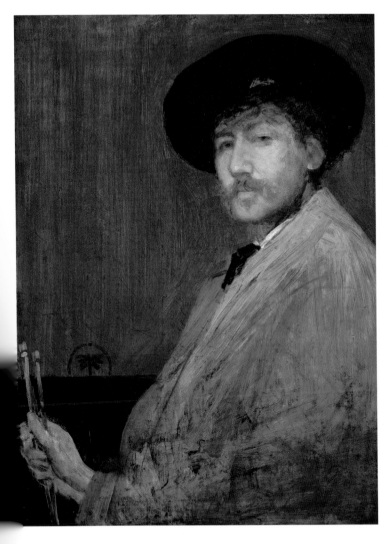

JAMES ABBOT MCNEILL WHISTLER (1834–1903)
Arrangement in Grey: Portrait of the Painter, 1872
Oil on canvas, 75 × 53.3 cm (29½ × 21 in)
Detroit Institute of Arts

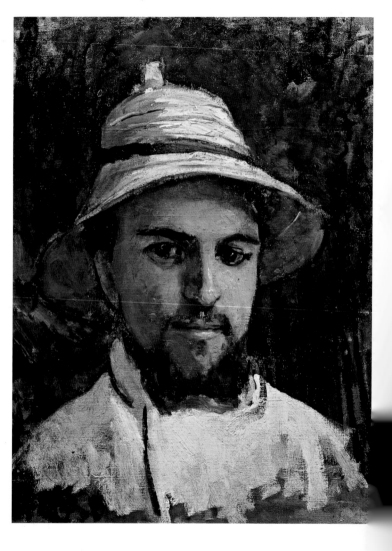

GUSTAVE CAILLEBOTTE (1848–94)
*Self-Portrait in Colonial Helmet, c.*1873–4
Oil on canvas, 47 × 32.7 cm (17³⁄₈ × 13 in)
Private collection

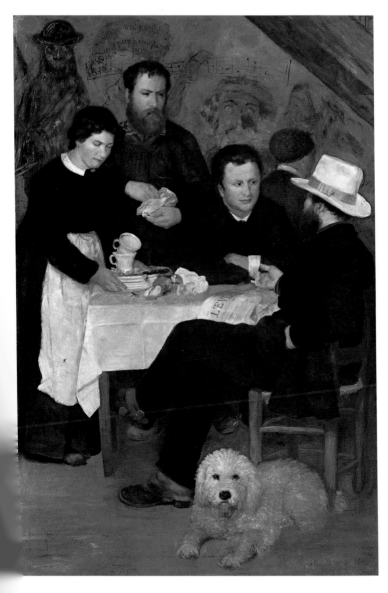

PIERRE AUGUSTE RENOIR (1841–1919)
At the Inn of Mother Anthony, 1866 (self-portrait, standing behind table)
Oil on canvas, 195 × 130 cm (76⁷⁄₈ × 51¹⁄₄ in)
Nationalmuseum, Stockholm

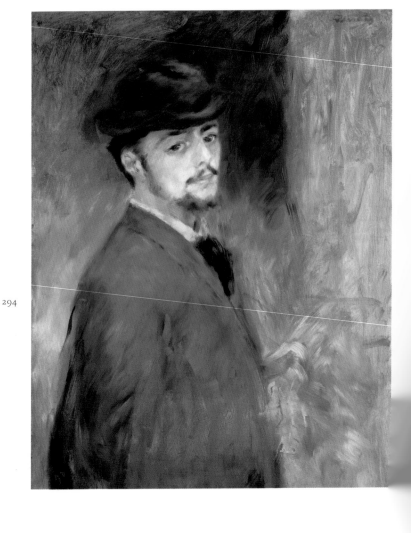

294

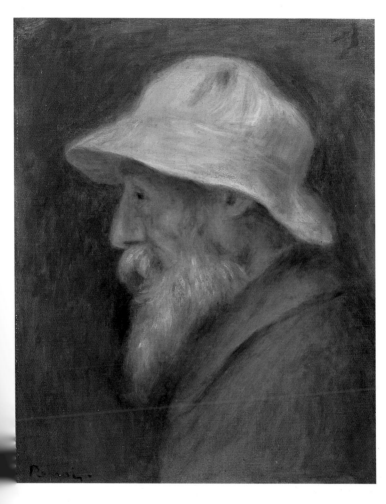

PIERRE AUGUSTE RENOIR (1841–1919)
Self-Portrait, 1910
Oil on canvas, 42 × 33 cm (16½ × 13 in)
Private collection

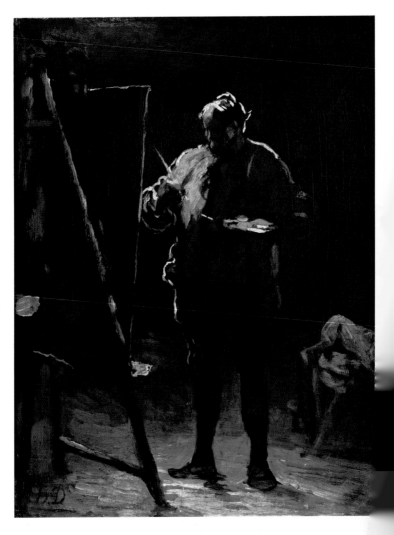

296

HONORÉ DAUMIER (1808–79)
The Painter before his Picture, 1870
Oil on wood, 33.5 × 26 cm (13¼ × 10¼ in)
Phillips Collection, Washington DC

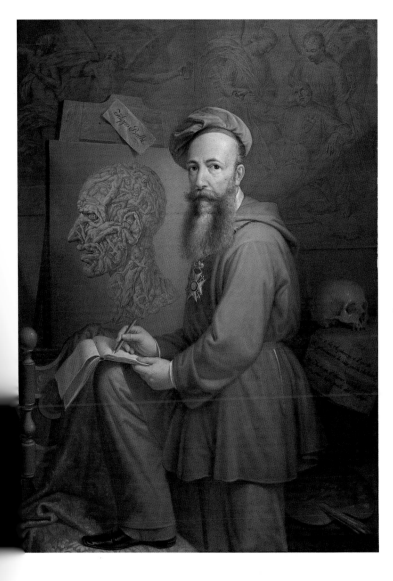

FILIPPO BALBI (1806–90)
Self-Portrait, 1873
Oil on canvas, 159 × 111 cm (62⅝ × 43¾ in)
Uffizi, Florence

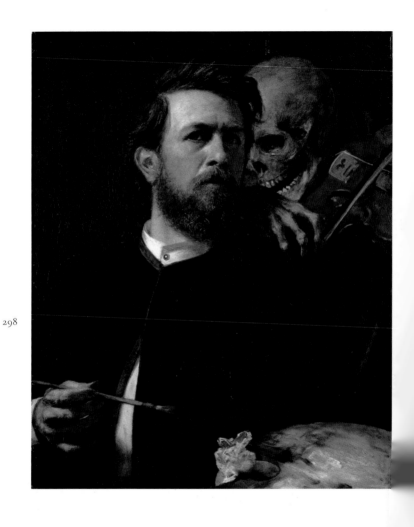

ARNOLD BÖCKLIN (1827–1901)
Self-Portrait with Death Playing the Violin, 1872
Oil on canvas, 75 × 61 cm (29½ × 24 in)
Neue Nationalgalerie, Berlin

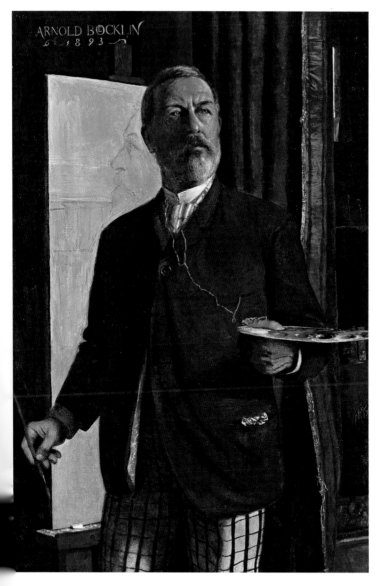

ARNOLD BÖCKLIN (1827–1901)
Self-Portrait in his Studio, 1893
Oil on canvas, 120.5 × 80.5 cm (47½ × 31¾ in)
Kunstmuseum, Basle

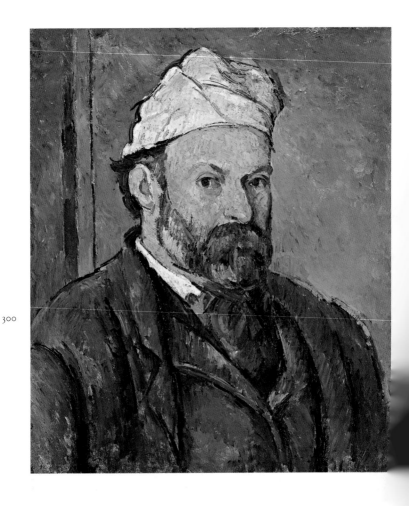

PAUL CÉZANNE (1839–1906)
Self-Portrait, 1875–7
Oil on canvas, 55.5 × 46 cm (21⁷⁄₈ × 18¹⁄₈ in)
Neue Pinakothek, Munich

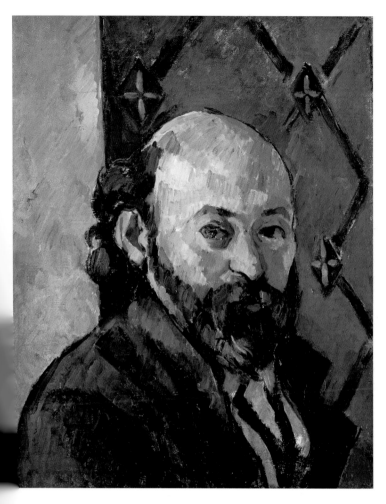

301

UL CÉZANNE (1839–1906)
f-Portrait, 1880–1
on canvas, 33.6 × 26 cm (13¼ × 10¼ in)
tional Gallery, London

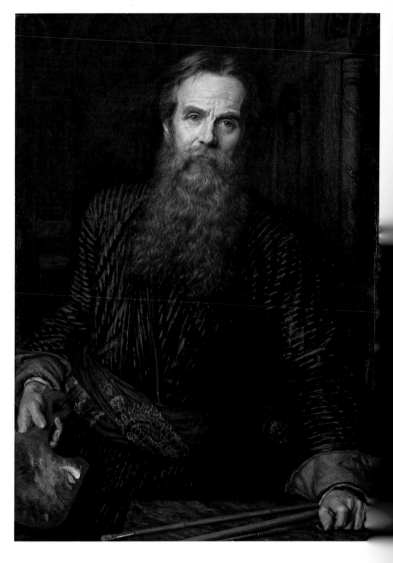

WILLIAM HOLMAN HUNT (1827–1910)
Self-Portrait, 1875
Oil on canvas, 103.5 × 73 cm (40³⁄₄ × 28³⁄₄ in)
Uffizi, Florence

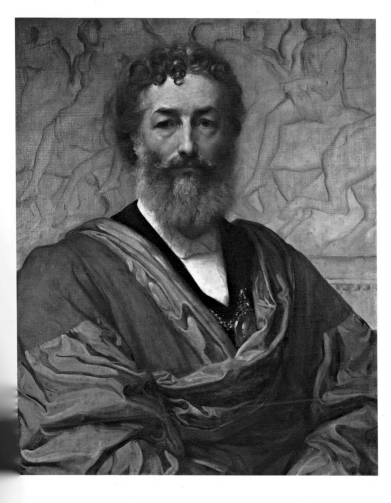

FREDERIC LEIGHTON (1830–96)
Self-Portrait, 1880
Oil on canvas, 76.5 × 64.1 cm (30¹⁄₈ × 25¹⁄₄ in)
Uffizi, Florence

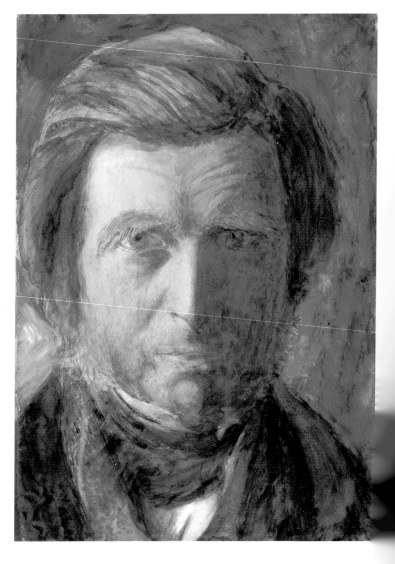

304

JOHN RUSKIN (1819–1900)
Self-Portrait in a Blue Neckcloth, 1873
Watercolour on paper, 35.3 × 25.3 cm (13 $\frac{7}{8}$ × 10 in)
Pierpont Morgan Library, New York

ADOLF VON MENZEL (1815–1905)
Self-Portrait, 1876–7
Pencil on paper, 14.9 × 17.2 cm (5⁷⁄₈ × 6³⁄₄ in)
Kupferstichkabinett, Berlin

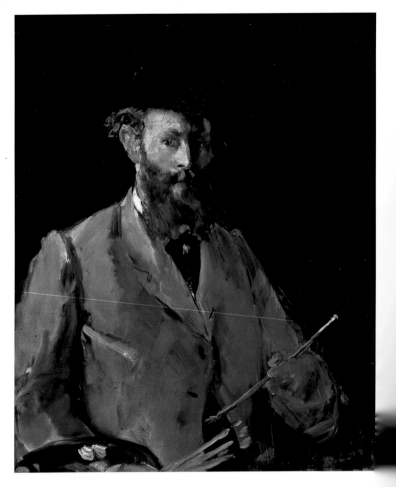

306

ÉDOUARD MANET (1832–83)
*Self-Portrait with Palette, c.*1879
Oil on canvas, 83 × 67 cm (32¼ × 26⅜ in)
Private collection

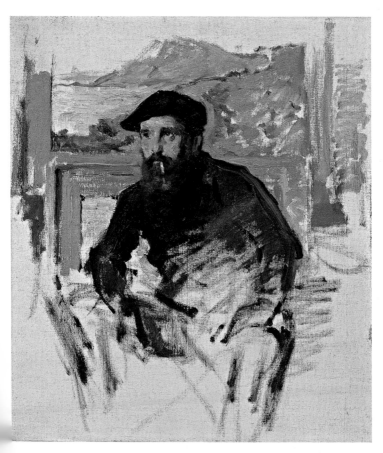

307

CLAUDE MONET (1840–1926)
Self-Portrait, c.1884
Oil on canvas, 52 × 48 cm (20½ × 18⅞ in)
Musée Marmottan, Paris

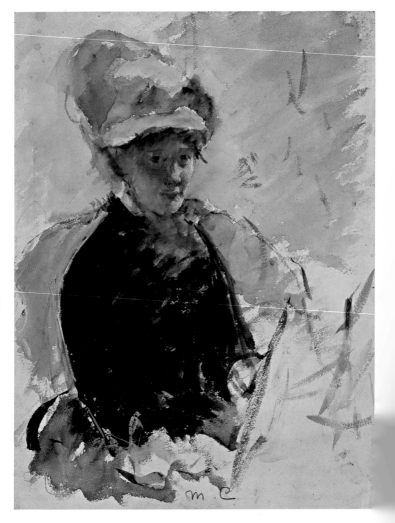

308

MARY CASSATT (1844–1926)
Self-Portrait, 1880
Watercolour on paper, 33 × 24.4 cm (13 × 9⅝ in)
National Portrait Gallery, Washington DC

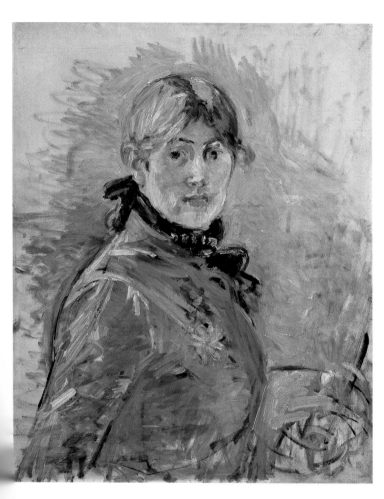

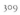

BERTHE MORISOT (1841–95)
Self-Portrait, 1885
Oil on canvas, 61 × 50 cm (24 × 17¾ in)
Musée Marmottan, Paris

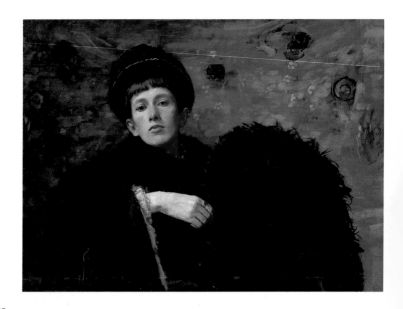

310

ELLEN DAY HALE (1855–1940)
Self-Portrait, 1885
Oil on canvas, 72.4 × 99.1 cm (28½ × 39 in)
Museum of Fine Arts, Boston

EUGÈNE CARRIÈRE (1849–1906)
Self-Portrait, 1890s
Oil on canvas, 45 × 37.3 cm (17¾ × 14¾ in)
Uffizi, Florence

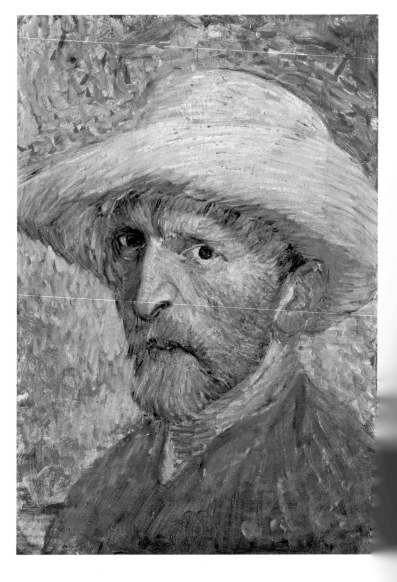

312

VINCENT VAN GOGH (1853–90)
Self-Portrait in a Straw Hat, 1887
Oil on canvas, 34 × 26.7 cm (13¹⁄₈ × 10¹⁄₂ in)
Detroit Institute of Arts

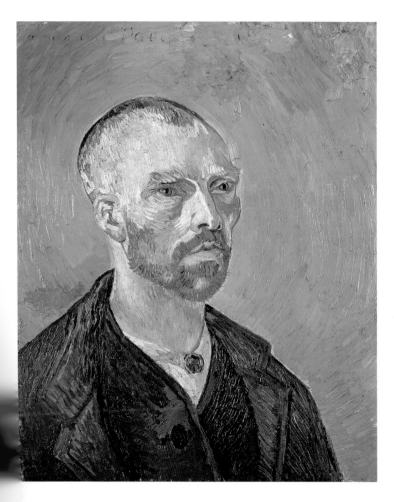

313

ɪɴᴄᴇɴᴛ ᴠᴀɴ ɢᴏɢʜ (1853–90)
elf-Portrait, 1888
ɪl on canvas, 59.5 × 48.3 cm (23½ × 19 in)
ᴐgg Art Museum, Cambridge, MA

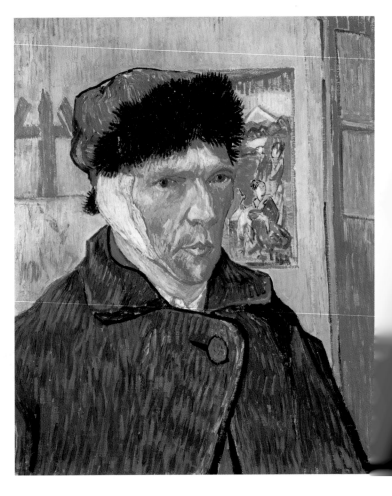

VINCENT VAN GOGH (1853–90)
Self-Portrait with Bandaged Ear, 1889
Oil on canvas, 60 × 49 cm (23⅝ × 19¼ in)
Courtauld Institute Galleries, London

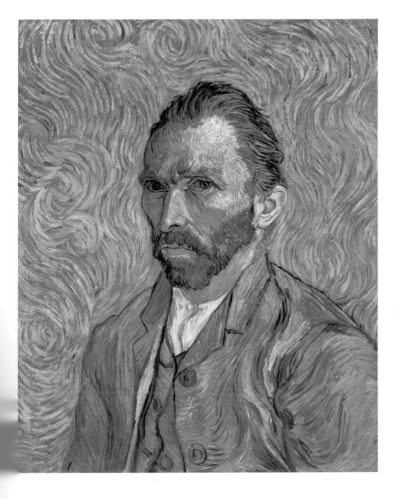

VINCENT VAN GOGH (1853–90)
Self-Portrait, 1889
Oil on canvas, 65 × 54 cm (25⁵⁄₈ × 21¹⁄₄ in)
Musée d'Orsay, Paris

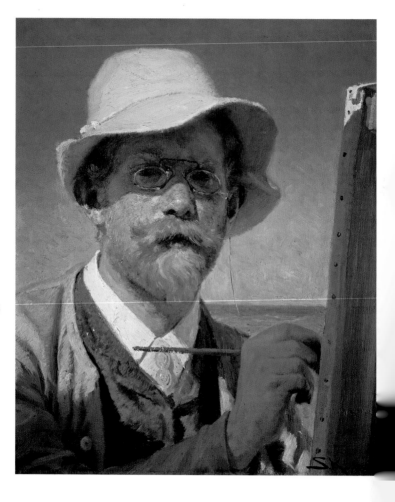

PEDER SEVERIN KRØYER (1851–1909)
Self-Portrait, 1888
Oil on canvas, 49 × 41 cm (19¼ × 16⅛ in)
Uffizi, Florence

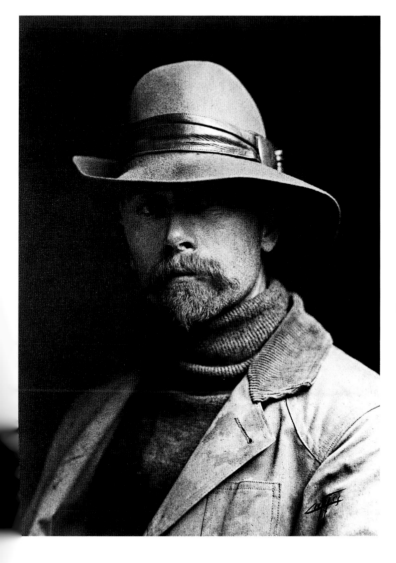

EDWARD SHERIFF CURTIS (1868–1952)
Self-Portrait, 1899
Gelatin silver print, 24.5 × 18 cm (10 × 7⅛ in)

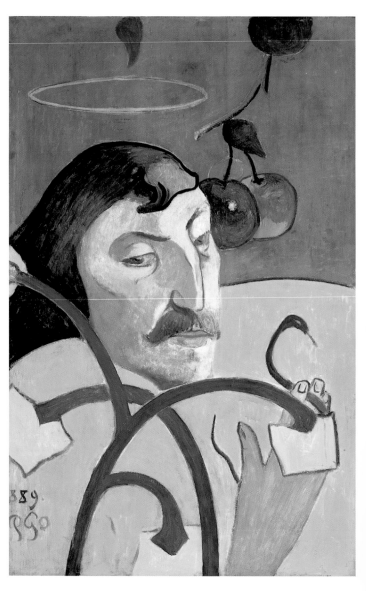

PAUL GAUGUIN (1848–1903)
Self-Portrait with Halo, 1889
Oil on wood, 79.2 × 52.3 cm (31¼ × 20¼ in)
National Gallery of Art, Washington DC

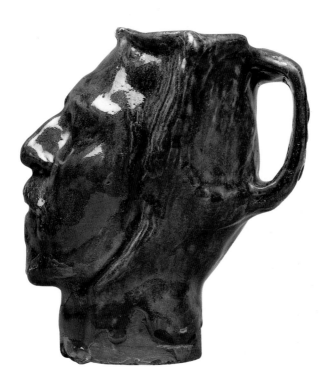

PAUL GAUGUIN (1848–1903)
Self-Portrait Jug, 1889
stoneware with coloured glazes, height 19.3 cm (7⁵⁄₈ in)
Kunstindustrimuseet, Copenhagen

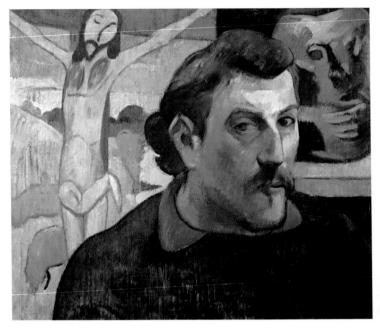

PAUL GAUGUIN (1848–1903)
Self-Portrait with Yellow Christ, 1889–90
Oil on canvas, 38 × 46 cm (15 × 18¹⁄₈ in)
Private collection

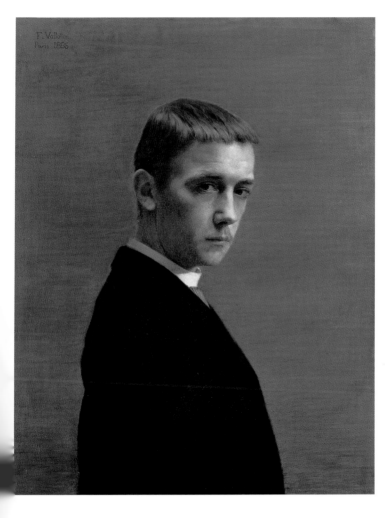

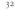

ÉLIX VALLOTTON (1865–1925)
Ion Portrait, 1885
il on canvas, 70 × 55 cm (27⁵/₈ × 21⁵/₈ in)
usée Cantonal des Beaux-Arts, Lausanne

ODILON REDON (1840–1916)
*Self-Portrait, c.*1888
Black chalk and charcoal on paper, 34.5 × 23.8 cm (13⅝ × 9⅜ in)
Gemeentemuseum, The Hague

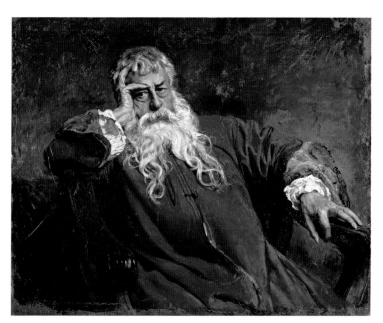

323

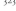

ERNEST MEISSONIER (1815–91)
Self-Portrait, 1889
Oil on canvas, 52 × 61 cm (20½ × 24 in)
Musée d'Orsay, Paris

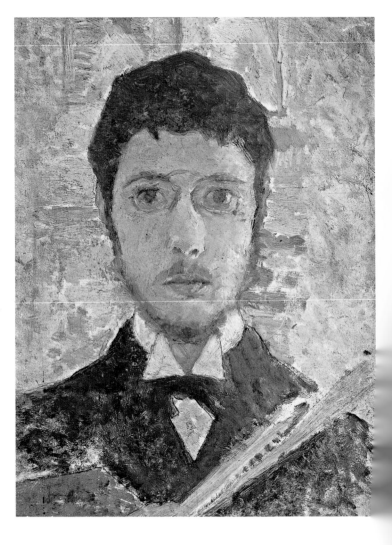

PIERRE BONNARD (1867–1947)
*Self-Portrait, c.*1889
Tempera on board, 21.5 × 15.8 cm (8½ × 6¼ in)
Private collection

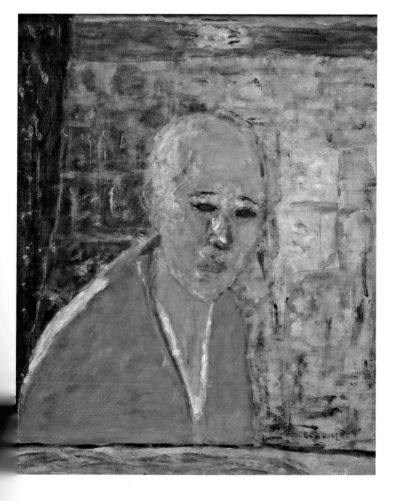

PIERRE BONNARD (1867–1947)
Self-Portrait, 1945
Oil on canvas, 56 × 46 cm (22⅛ × 18⅛ in)
Private collection

HENRI ROUSSEAU (1844–1910)
Self-Portrait, 1890
Oil on canvas, 143 × 110 cm (56³/₈ × 43³/₈ in)
National Gallery, Prague

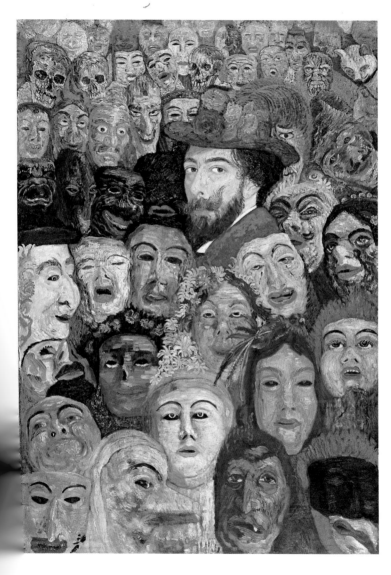

JAMES ENSOR (1860–1949)
Self-Portrait with Masks, 1899
Oil on canvas, 117 × 80 cm (46⅛ × 31½ in)
Menard Art Museum, Komaki, Japan

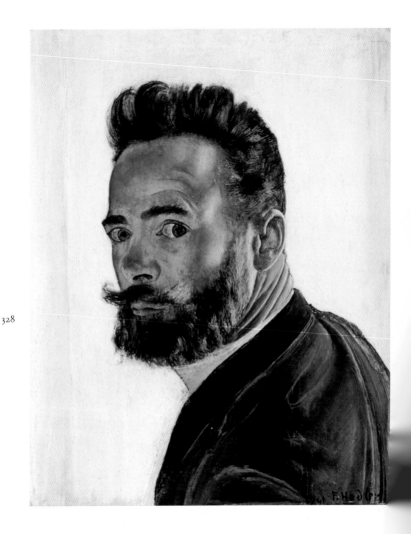

328

FERDINAND HODLER (1853–1918)
Self-Portrait, 1891
Oil on wood, 28.8 × 22.8 cm (11³/₈ × 9 in)
Musée d'Art et d'Histoire, Geneva

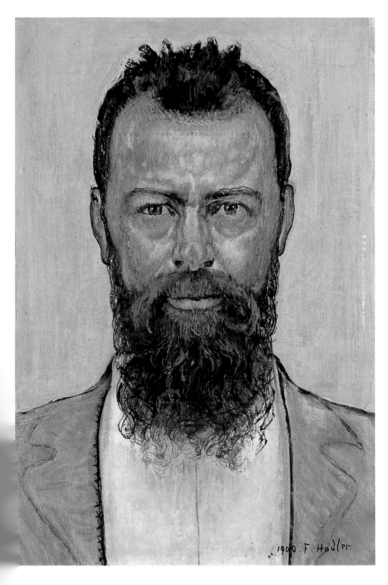

FERDINAND HODLER (1853–1918)
Self-Portrait, 1900
Oil on canvas, 41 × 26.6 cm (16⅛ × 10½ in)
Staatsgalerie, Stuttgart

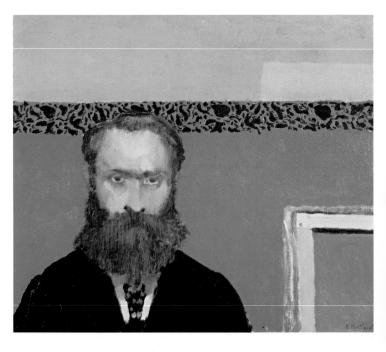

ÉDOUARD VUILLARD (1868–1940)
*Self-Portrait, c.*1892
Oil on canvas, 38.4 × 46.2 cm (15¹⁄₈ × 18¹⁄₄ in)
Private collection

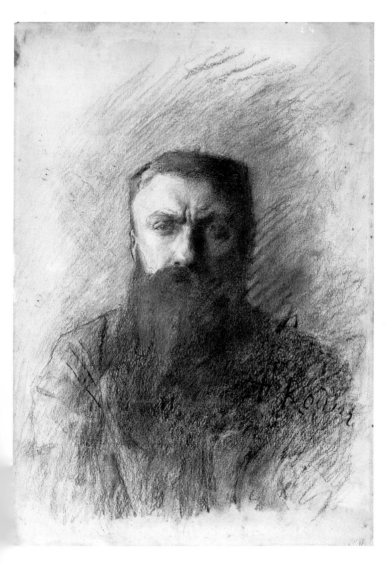

AUGUSTE RODIN (1840–1917)
Self-Portrait, 1898
Charcoal on paper, 42 × 29.8 cm (16½ × 11¾ in)
Musée Rodin, Paris

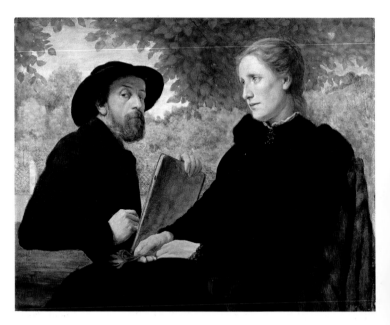

WILHELM STEINHAUSEN (1846–1924)
Portrait of the Artist with his Wife, 1892–3
Oil on board, 79.5 × 100 cm (31⅛ × 39⅛ in)
Wallraf-Richartz Museum, Cologne

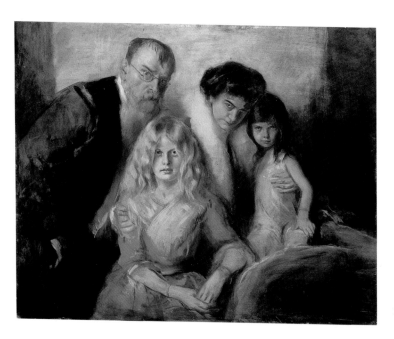

FRANZ VON LENBACH (1836–1904)
The Artist with his Wife and Daughters, 1903
Oil on board, 96.5 × 122 cm (38 × 48 in)
Städtische Galerie im Lenbachhaus, Munich

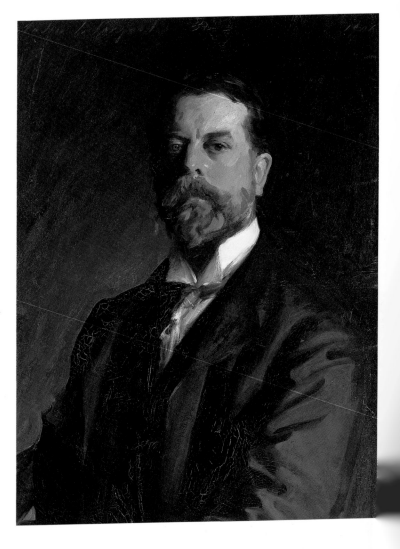

JOHN SINGER SARGENT (1856–1925)
Self-Portrait, 1907
Oil on canvas, 76.1 × 63.4 cm (30 × 25 in)
Uffizi, Florence

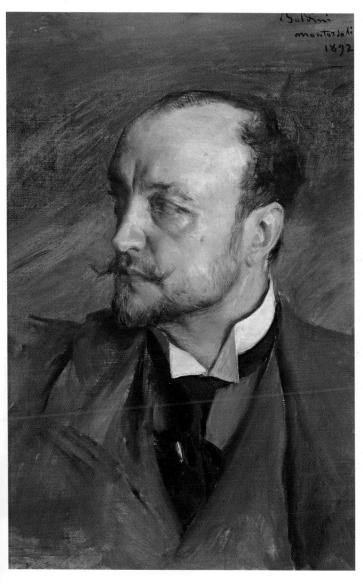

IOVANNI BOLDINI (1842–1931)
elf-Portrait, 1892
il on canvas, 57.5 × 40 cm (22⁵⁄₈ × 15³⁄₄ in)
ffizi, Florence

EDVARD MUNCH (1863–1944)
Self-Portrait with a Cigarette, 1895
Oil on canvas, 110.5 × 85.5 cm (43$\frac{1}{2}$ × 33$\frac{5}{8}$ in)
Nasjonalgalleriet, Oslo

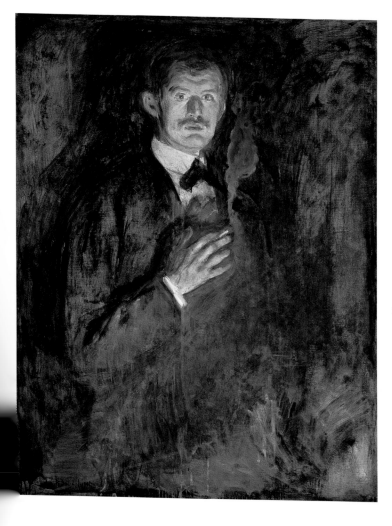

337

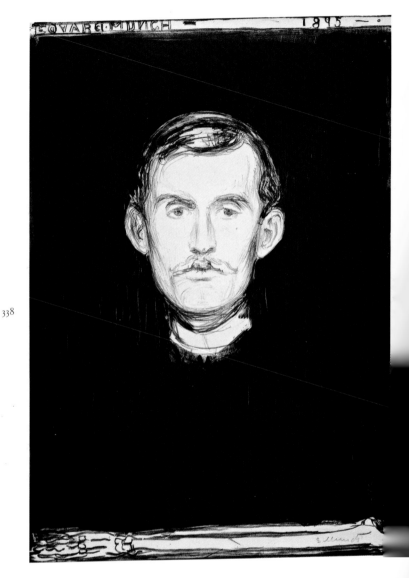

338

EDVARD MUNCH (1863–1944)
Self-Portrait with Skeleton Arm, 1895
Lithograph, 45.5 × 31.7 cm (18 × 12½ in)

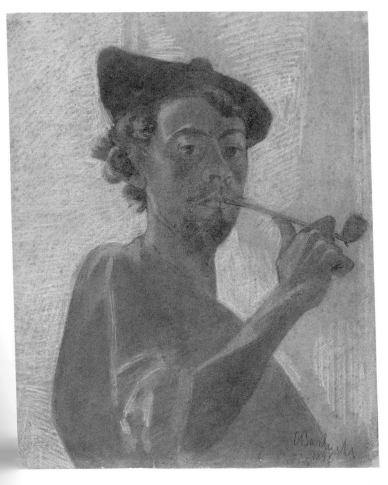

ERNST BARLACH (1870–1938)
Self-Portrait with Beret and Clay Pipe, 1895
Charcoal with white heightening on paper, 55.3 × 45.5 cm (21³⁄₄ × 17⁷⁄₈ in)
Ernst Barlach Stiftung, Güstrow

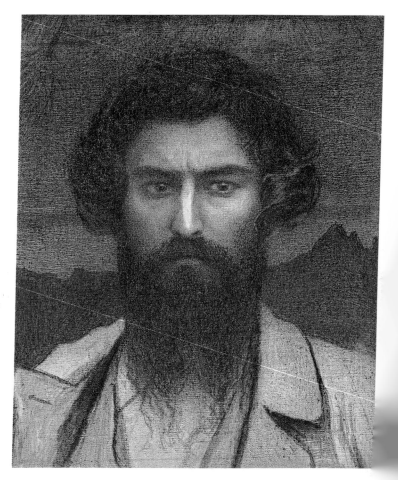

340

GIOVANNI SEGANTINI (1858–99)
Self-Portrait, 1895
Charcoal with gold dust and chalk on canvas, 59 × 50 cm (23¼ × 19¼ in)
Segantini Museum, St Moritz

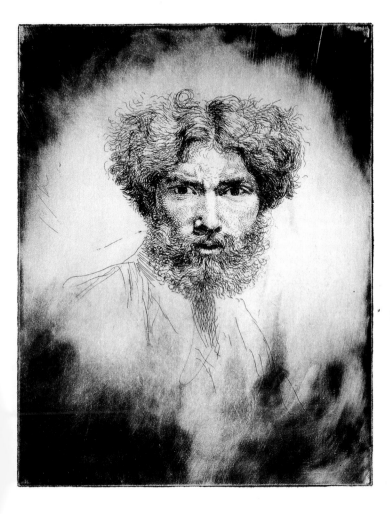

AUGUSTUS JOHN (1878–1961)
Portrait of the Artist: Tête Farouche, c.1902–6
Etching, 21.2 × 17 cm (8³⁄₈ × 6³⁄₄ in)

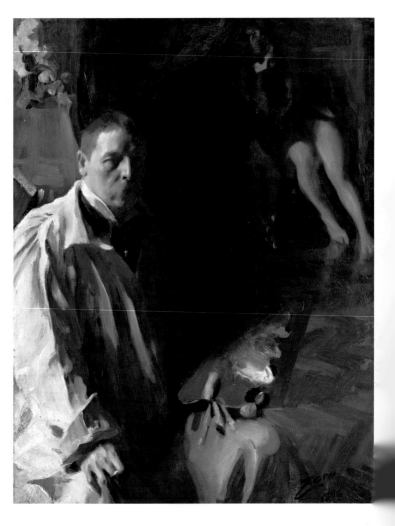

ANDERS ZORN (1860–1920)
Self-Portrait with Model, 1896
Oil on canvas, 117 × 94 cm (46$\frac{1}{8}$ × 37 in)
Nationalmuseum, Stockholm

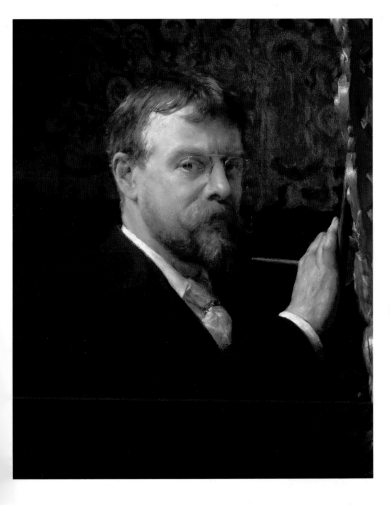

LAWRENCE ALMA-TADEMA (1836–1912)
Self-Portrait, 1896
Oil on canvas, 65.7 × 52.8 cm (25⁷⁄₈ × 20¹⁄₄ in)
Uffizi, Florence

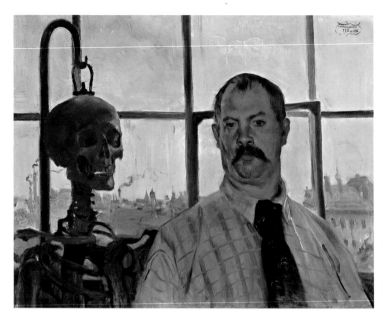

344

LOVIS CORINTH (1858–1925)
Self-Portrait with Skeleton, 1896
Oil on canvas, 66 × 86 cm (26 × 33⁷⁄₈ in)
Städtische Galerie, Munich

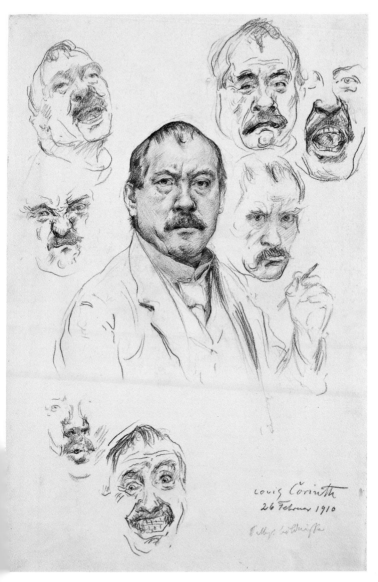

LOVIS CORINTH (1858–1925)
Self-Portrait with Seven Studies of Expressions, 1910
Pencil on paper, 51.5 × 34 cm (20¼ × 13⅜ in)
Kunsthalle, Bremen

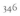

EDWARD STEICHEN (1879–1973)
Self-Portrait, 1898
Platinum print, 19.2 × 8.3 cm (8 × 3¼ in)

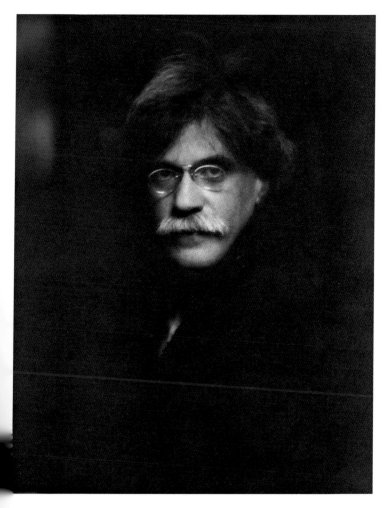

ALFRED STIEGLITZ (1864–1946)
Self-Portrait, 1907
Platinum print, 24.5 × 19.5 cm (9⁵⁄₈ × 7⁵⁄₈ in)

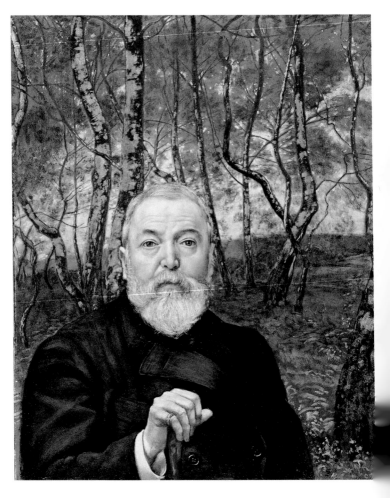

HANS THOMA (1839–1924)
Self-Portrait before a Birch Wood, 1899
Oil on canvas, 94 × 75.5 cm (37 × 29³⁄₄ in)
Städelsches Kunstinstitut, Frankfurt am Main

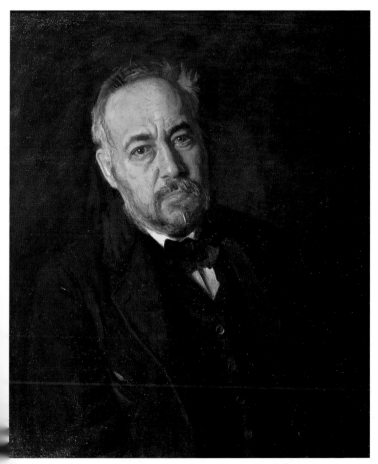

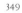

THOMAS EAKINS (1844–1916)
Self-Portrait, 1902
Oil on canvas on board, 76.2 × 63.5 cm (30 × 25 in)
National Academy of Design, New York

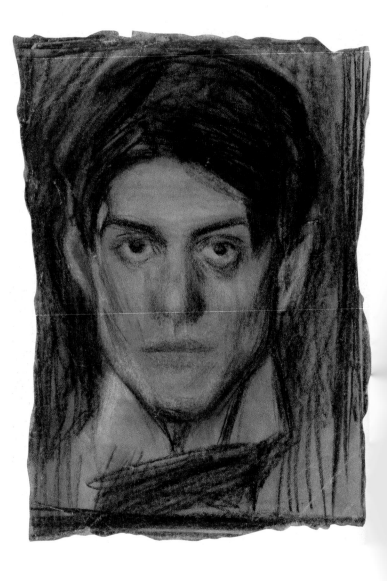

PABLO PICASSO (1881–1973)
Self-Portrait, 1899–1900
Charcoal on paper, 22.5 × 16.5 cm (8⅞ × 6½ in)
Museu Picasso, Barcelona

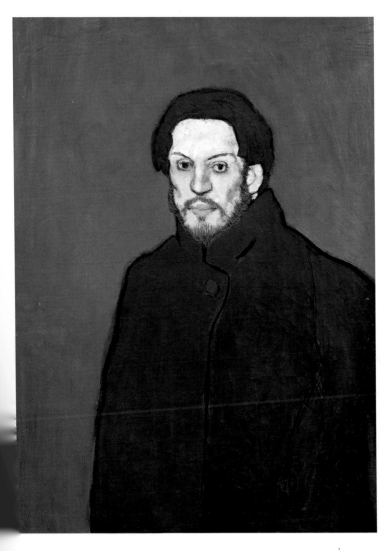

PABLO PICASSO (1881–1973)
Self-Portrait with Cloak, 1901
Oil on canvas, 81 × 60 cm (31⅞ × 23⅝ in)
Musée Picasso, Paris

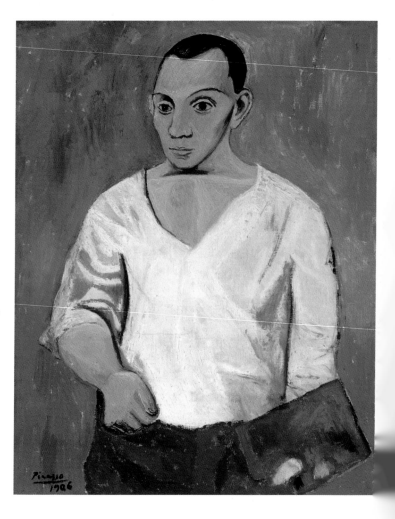

PABLO PICASSO (1881–1973)
Self-Portrait with Palette, 1906
Oil on canvas, 92 × 73 cm (36¼ × 28¾ in)
Philadelphia Museum of Art

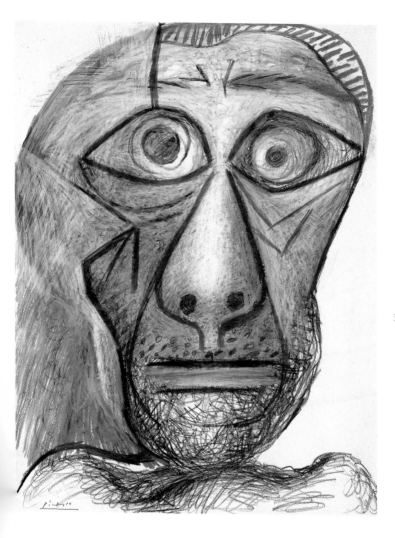

PABLO PICASSO (1881–1973)
Self-Portrait, 1972
Wax crayon on paper, 65.7 × 50.5 cm (25⁷⁄₈ × 20 in)
Private collection

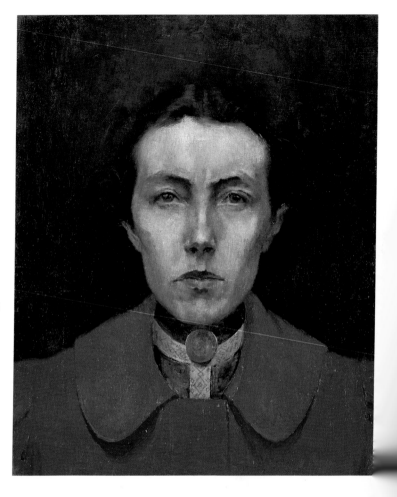

354

AURÉLIA DE SOUSA (1869–1922)
Self-Portrait, 1900
Oil on canvas, 45.6 × 36.4 cm (18 × 14⅛ in)
Museu Nacional de Soares dos Reis, Oporto

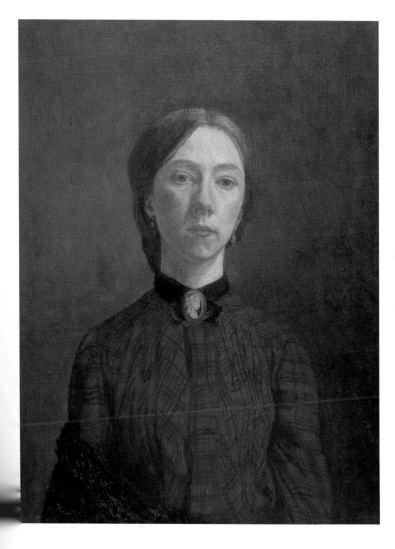

GWEN JOHN (1876–1939)
Self-Portrait, 1902
Oil on canvas, 44.8 × 34.9 cm (17⁵⁄₈ × 13³⁄₄ in)
Tate Gallery, London

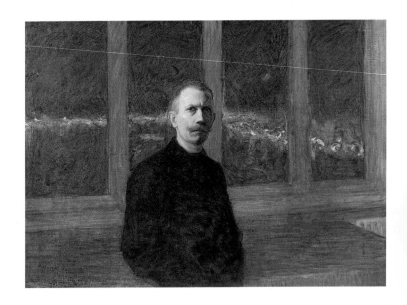

356

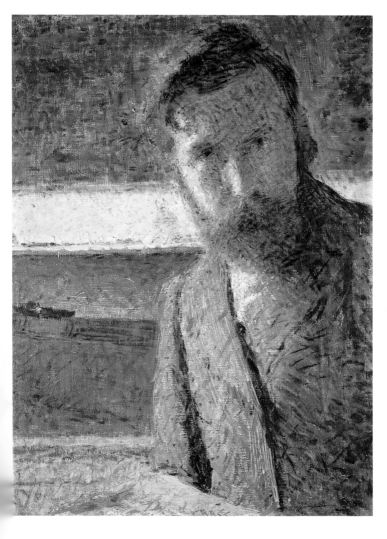

GIACOMO BALLA (1871–1958)
Self-Portrait, 1902
Oil on canvas, 59 × 43 cm (23¼ × 16⅞ in)
Banca d'Italia, Rome

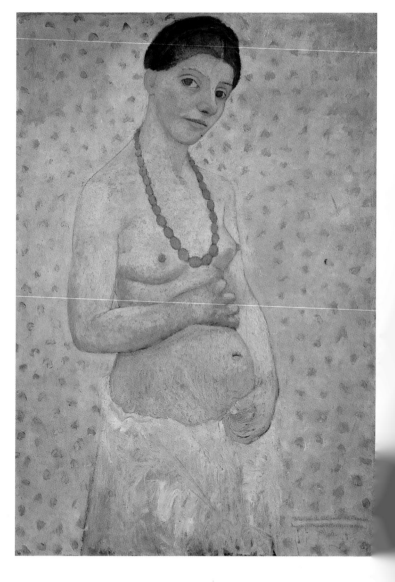

PAULA MODERSOHN-BECKER (1876–1907)
Self-Portrait on my Sixth Wedding Anniversary, 1906
Oil distemper on board, 101.8 × 70 cm (40⅛ × 27½ in)
Paula Modersohn-Becker Museum, Bremen

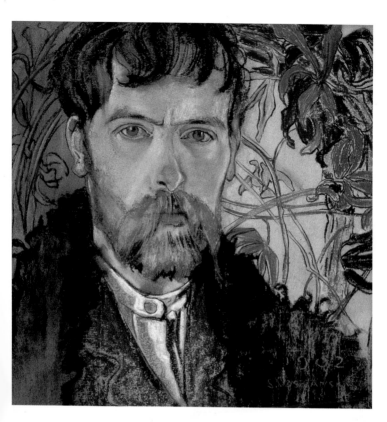

STANISLAW WYSPIAŃSKI (1869–1907)
Self-Portrait, 1902
Pastel on paper, 38 × 38 cm (15 × 15 in)
National Museum, Warsaw

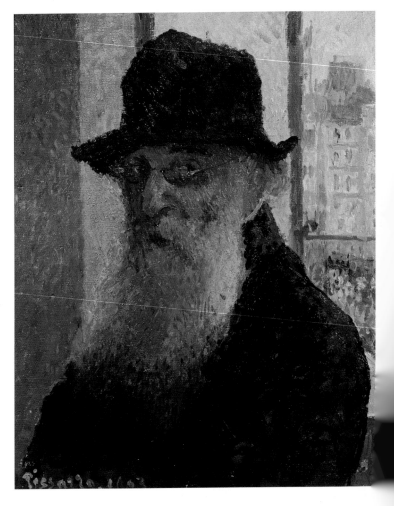

360

CAMILLE PISSARRO (1830–1903)
Self-Portrait, 1903
Oil on canvas, 41 × 33.3 cm (16¹⁄₈ × 13¹⁄₈ in)
Tate Gallery, London

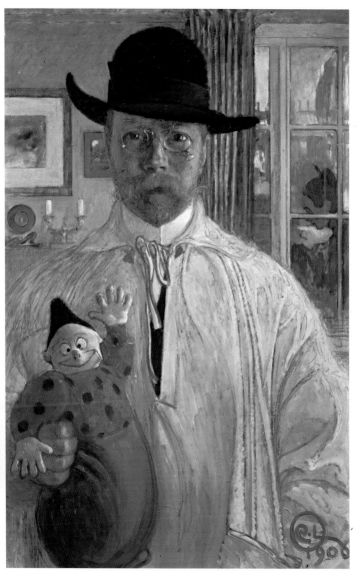

CARL OLAF LARSSON (1853–1919)
Self-Portrait, 1906
Oil on canvas, 95.5 × 61.5 cm (37⁵/₈ × 24¹/₄ in)
Uffizi, Florence

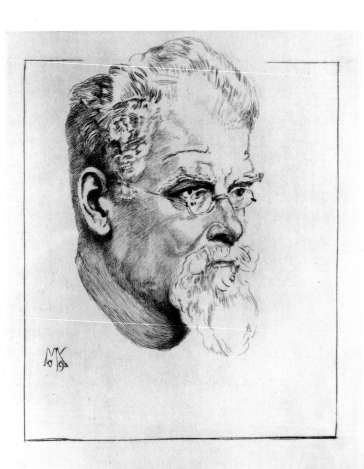

MAX KLINGER (1857–1920)
Self-Portrait, 1909
Etching, 32.5 × 21 cm (12³⁄₄ × 8¹⁄₄ in)

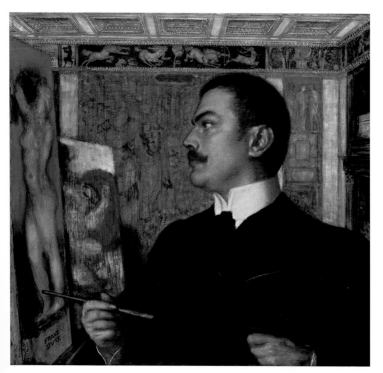

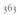

FRANZ VON STUCK (1863–1928)
Self-Portrait at the Easel, 1905
Oil on wood, 72.5 × 76 cm (28⁵⁄₈ × 30 in)
Neue Nationalgalerie, Berlin

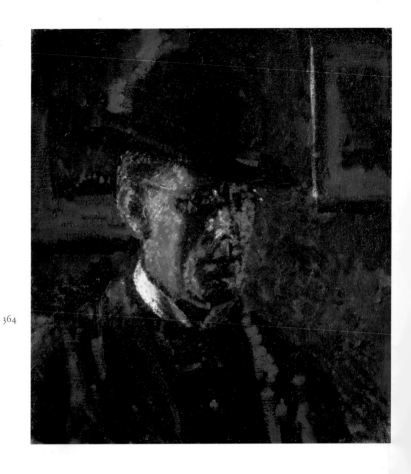

364

WALTER SICKERT (1860–1942)
The Juvenile Lead: Self-Portrait, 1907
Oil on canvas, 51 × 45.8 cm (20¹⁄₈ × 18 in)
Southampton City Art Gallery

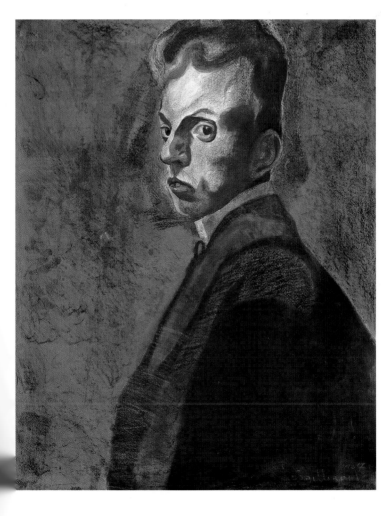

LÉON SPILLIAERT (1881–1946)
Self-Portrait, 1907
Watercolour and pastel on paper, 75.3 × 60 cm (29⅝ × 23⅝ in)
Private collection

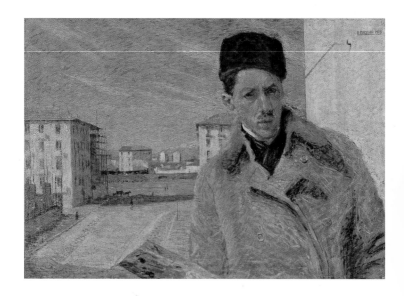

366

UMBERTO BOCCIONI (1882–1916)
Self-Portrait, 1908
Oil on canvas, 70 × 100 cm (27⅝ × 39⅜ in)
Brera, Milan

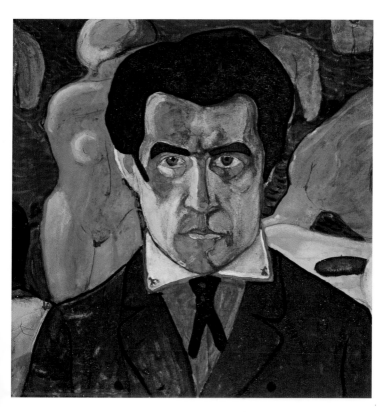

KAZIMIR MALEVICH (1878–1935)
Self-Portrait, 1908
Gouache on paper, 27 × 26.8 cm (10⅝ × 10½ in)
Tret'yakov Gallery, Moscow

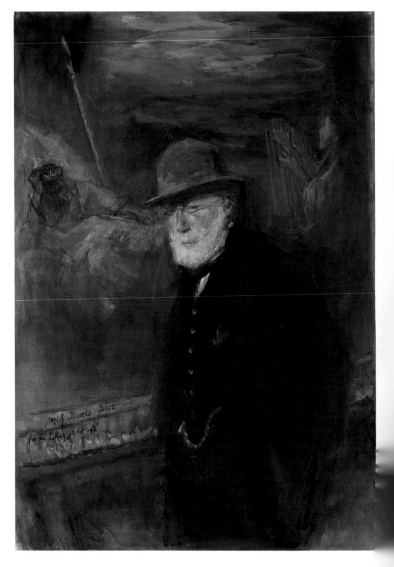

JOSEPH ISRAELS (1824–1911)
Self-Portrait, 1908
Watercolour and gouache on paper, 78.7 × 54.3 cm (31 × 21³⁄₈ in)
Toledo Museum of Art, Ohio

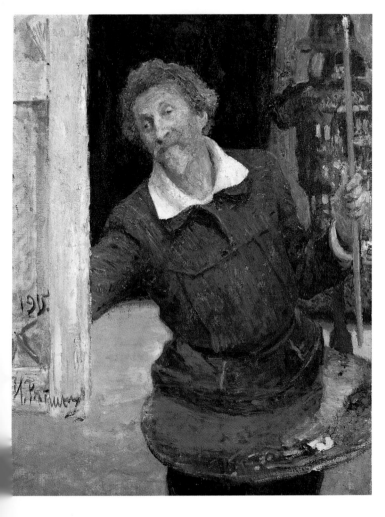

ILYA YEFIMOVICH REPIN (1844–1930)
Self-Portrait, 1915
Oil on canvas, 125 × 94 cm (49¹₄ × 37 in)
National Gallery, Prague

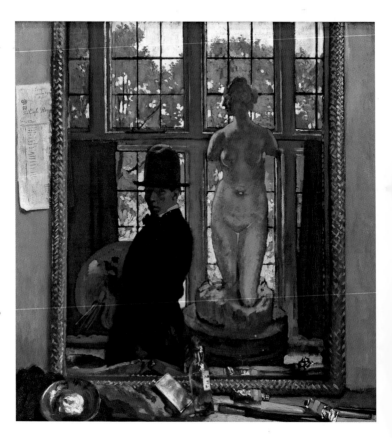

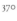

WILLIAM ORPEN (1878–1931)
Myself and Venus, c.1908
Oil on canvas, 91.4 × 86.7 cm (36 × 34⅛ in)
Carnegie Museum of Art, Pittsburgh

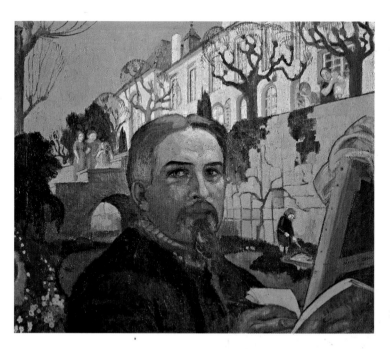

MAURICE DENIS (1870–1943)
Self-Portrait, 1916
Oil on canvas, 68 × 80 cm (26³⁄₄ × 31¹⁄₂ in)
Uffizi, Florence

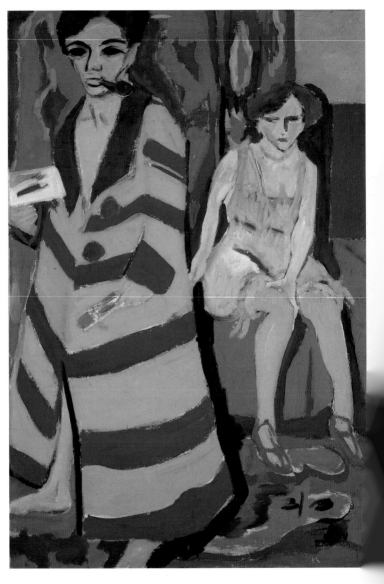

ERNST LUDWIG KIRCHNER (1880–1938)
*Self-Portrait with Model, c.*1910
Oil on canvas, 149.7 × 100 cm (59 × 39³⁄₈ in)
Kunsthalle, Hamburg

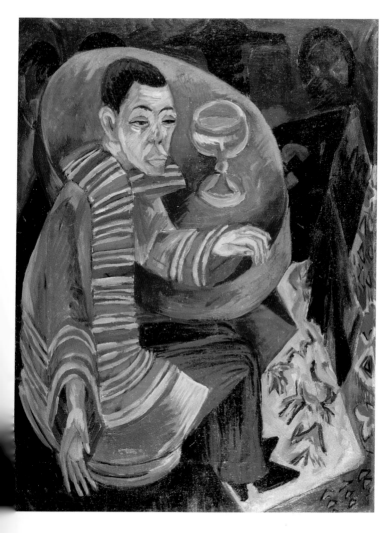

373

ERNST LUDWIG KIRCHNER (1880–1938)
The Drinker (Self-Portrait), 1915
Oil on canvas, 118 × 88 cm (46½ × 34⅝ in)
Germanisches Nationalmuseum, Nuremberg

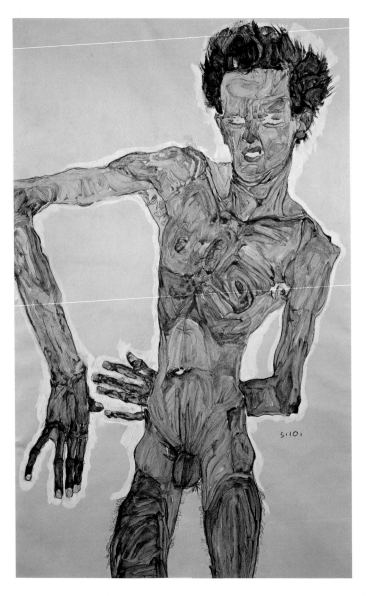

374

EGON SCHIELE (1890–1918)
Nude Self-Portrait, Grimacing, 1910
Gouache, watercolour and pencil heightened with white on paper, 55.8 × 36.9 cm (22 × 14½ ³⁄₄
Graphische Sammlung Albertina, Vienna

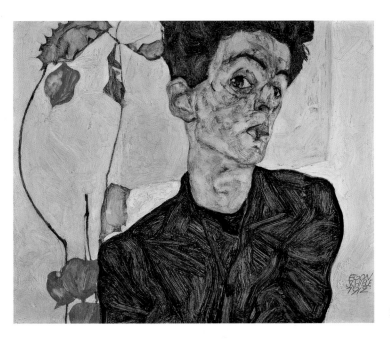

EGON SCHIELE (1890–1918)
Self-Portrait with Chinese Lantern Fruit, 1912
Oil and body paint on wood, 32.2 × 39.8 cm (12³/₄ × 15³/₄ in)
Private collection

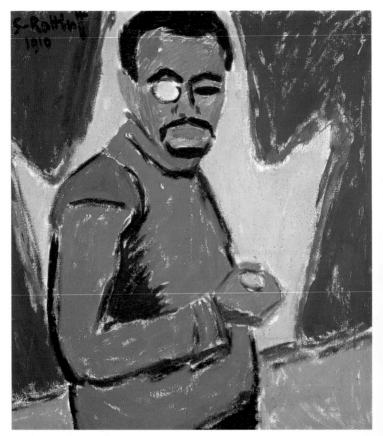

376

KARL SCHMIDT-ROTTLUFF (1884–1976)
Self-Portrait with Monocle, 1910
Oil on canvas, 84 × 76.5 cm (32¹⁄₈ × 30¹⁄₈ in)
Neue Nationalgalerie, Berlin

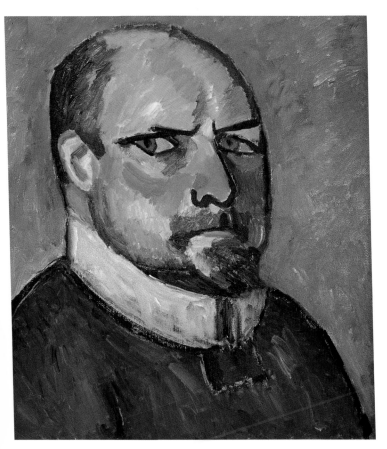

ALEXEI JAWLENSKY (1864–1941)
Self-Portrait, 1911
Oil on board, 55 × 51 cm (21⅝ × 20⅛ in)
Private collection

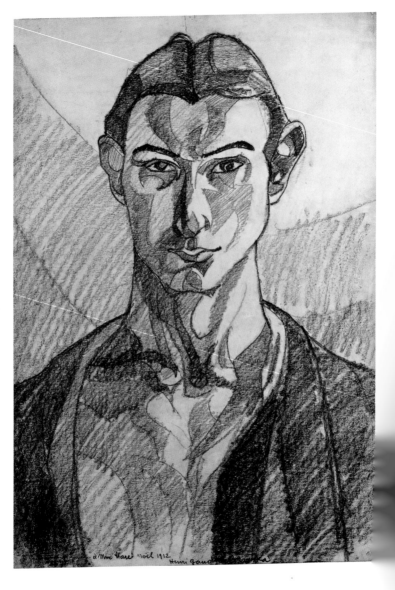

HENRI GAUDIER-BRZESKA (1891–1915)
Self-Portrait, 1912
Pencil on paper, 55.9 × 39.4 cm (22 × 15½ in)
National Portrait Gallery, London

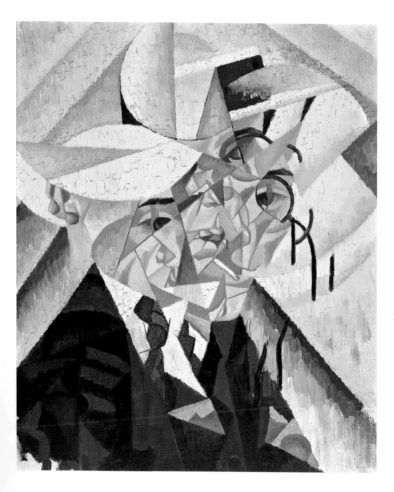

GINO SEVERINI (1883–1966)
Self-Portrait (My Rhythm), 1912
Oil on canvas, 54 × 45 cm (21 × 17¾ in)
Private collection

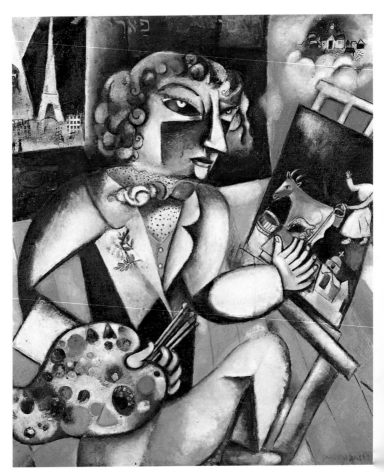

MARC CHAGALL (1887–1985)
*Self-Portrait with Seven Fingers, c.*1912–13
Oil on canvas, 126 × 107 cm (49⅝ × 42⅛ in)
Stedelijk Museum, Amsterdam

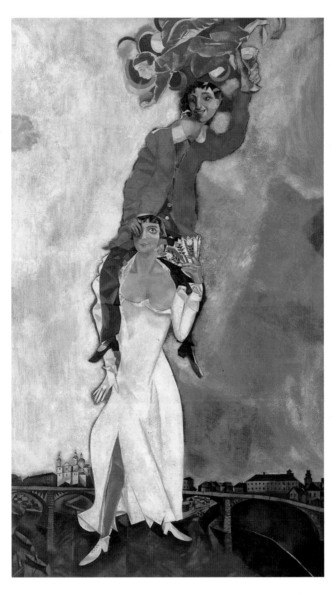

MARC CHAGALL (1887–1985)
*Double Portrait with Wineglass, c.*1917–18
oil on canvas, 235 × 137 cm (92½ × 54 in)
Musée National d'Art Moderne, Paris

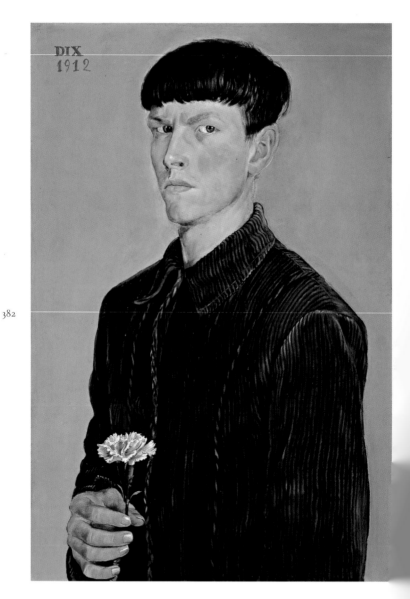

382

OTTO DIX (1891–1969)
Self-Portrait, 1912
Oil and tempera on wood, 73.6 × 49.5 cm (29 × 19½ in)
Detroit Institute of Arts

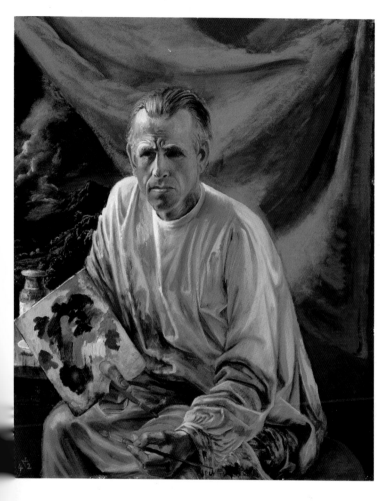

OTTO DIX (1891–1969)
Self-Portrait with a Palette in front of a Red Curtain, 1942
Oil on wood, 100 × 80 cm (39³⁄₈ × 31¹⁄₂ in)
Private collection

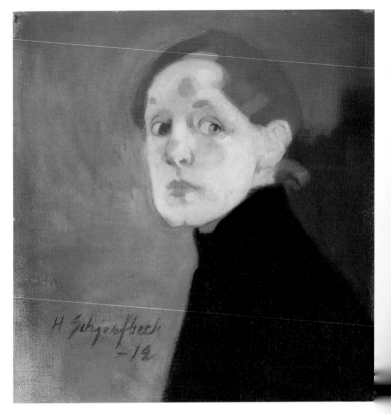

384

HÉLÈNE SCHJERFBECK (1862–1946)
Self-Portrait, 1912
Oil on canvas, 43 × 42 cm (16⅞ × 16½ in)
Private collection

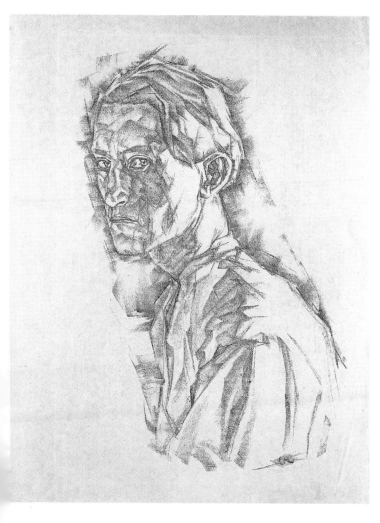

385

JOSEF ALBERS (1888–1976)
Self-Portrait, c.1917
Lithograph, 47 × 30.5 cm (18½ × 12 in)

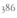

WALTER CRANE (1845–1915)
Self-Portrait, 1912
Oil on canvas, 91 × 68.5 cm (35⅞ × 27 in)
Uffizi, Florence

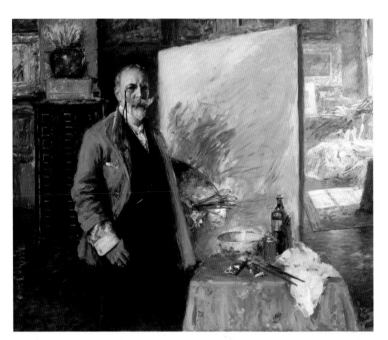

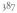

WILLIAM MERRITT CHASE (1849–1916)
Self-Portrait, 1916
Oil on canvas, 134.5 × 159.8 cm (53 × 63 in)
Richmond Art Museum, Indiana

BORIS KUSTODIEV (1878–1927)
Self-Portrait, 1912
Tempera on board, 100 × 85 cm (39³⁄₈ × 33¹⁄₂ in)
Uffizi, Florence

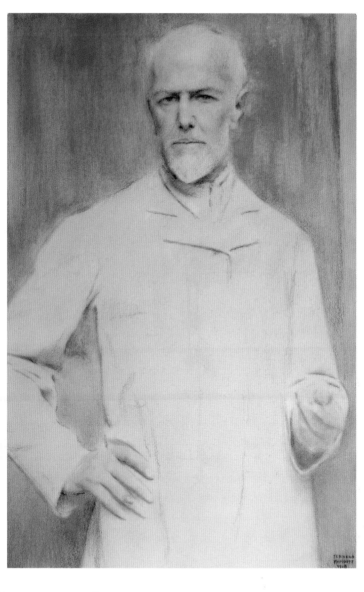

389

FERNAND KHNOPFF (1885–1921)
Self-Portrait, 1918
Pastel on paper, 64 × 41 cm (25¼ × 16⅛ in)
Uffizi, Florence

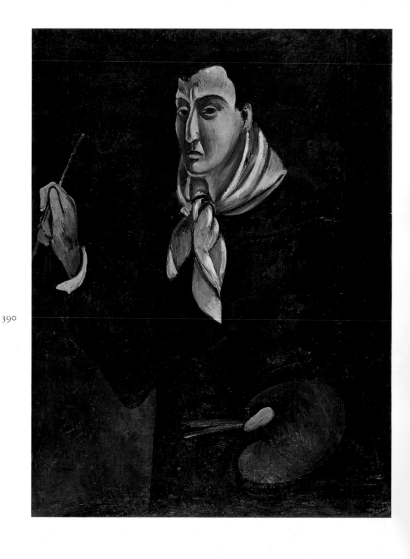

ANDRÉ DERAIN (1880–1954)
*Self-Portrait, c.*1912
Oil on canvas, 116 × 90 cm (45³/₄ × 35¹/₂ in)
Minneapolis Institute of Arts

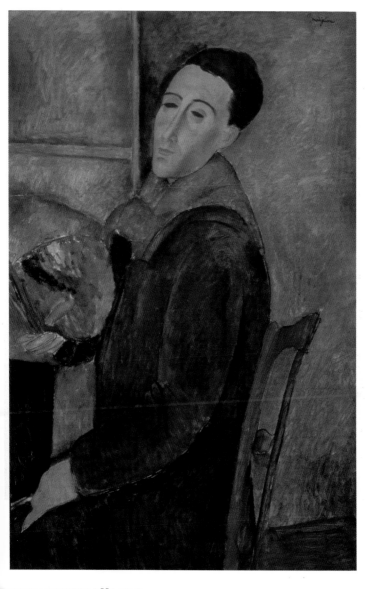

AMEDEO MODIGLIANI (1884–1920)
Self-Portrait, 1919
Oil on canvas, 100 × 65 cm (39³⁄₈ × 25⁵⁄₈ in)
Museum of Contemporary Art, University of São Paulo, Brazil

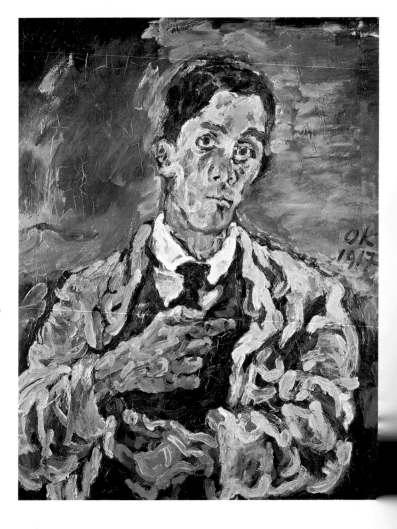

OSKAR KOKOSCHKA (1886–1980)
Self-Portrait, 1917
Oil on canvas, 79 × 62 cm (31⅛ × 24⅜ in)
Von der Heydt-Museum, Wuppertal

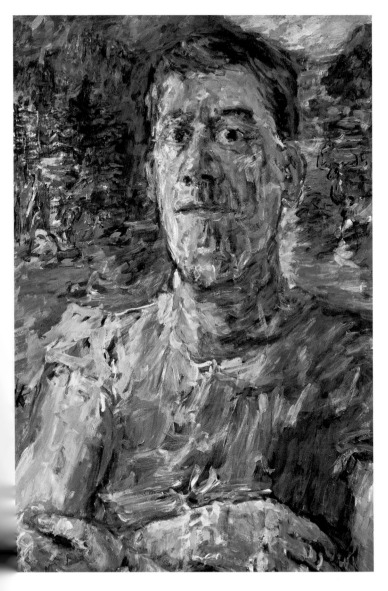

OSKAR KOKOSCHKA (1886–1980)
Portrait of a 'Degenerate Artist', 1937
Oil on canvas, 110 × 85 cm (43¼ × 33½ in)
Scottish National Gallery of Modern Art, Edinburgh

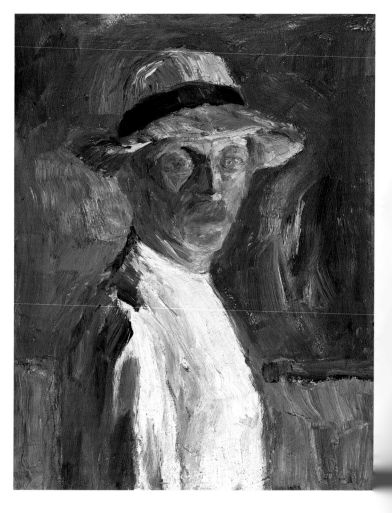

EMIL NOLDE (1867–1956)
Self-Portrait, 1917
Oil on plywood, 83.5 × 65 cm (32⁷⁄₈ × 25⁵⁄₈ in)
Nolde-Stiftung, Seebüll

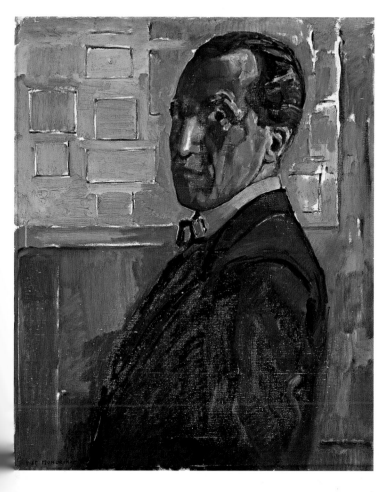

PIET MONDRIAN (1872–1944)
Self-Portrait, 1918
Oil on canvas, 88 × 77 cm (34⅝ × 30⅜ in)
Gemeentemuseum, The Hague

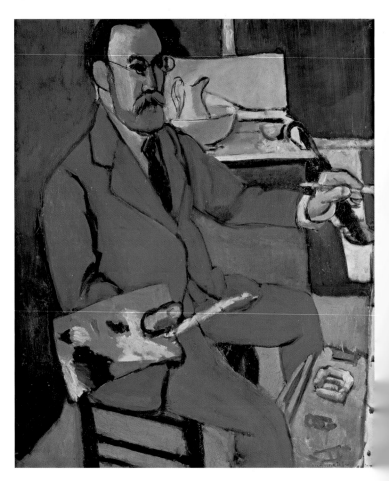

HENRI MATISSE (1869–1954)
Self-Portrait, 1918
Oil on canvas, 65 × 54 cm (25⅝ × 21¼ in)
Musée Matisse, Le Cateau

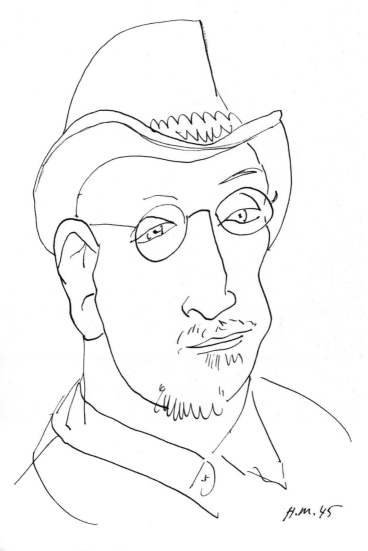

H.M. 45

HENRI MATISSE (1869–1954)
Self-Portrait in a Straw Hat, 1945
Pen and black ink on paper, 40.1 × 26 cm (15³⁄₄ × 10¹⁄₄ in)
Private collection

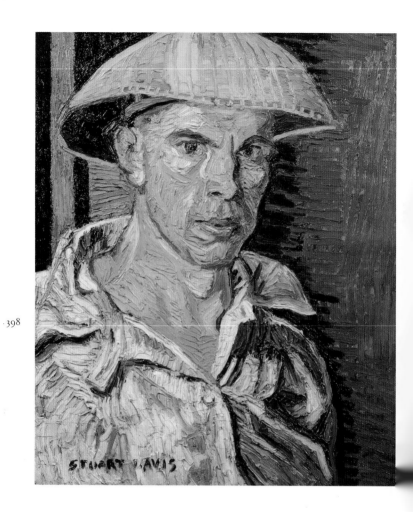

STUART DAVIS (1894–1964)
Self Portrait (Chinese Hat), 1919
Oil on canvas, 59 × 48.8 cm (23¹⁄₄ × 19¹⁄₄ in)
Private collection

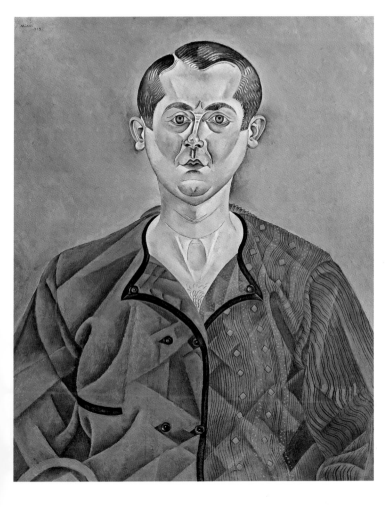

399

JOAN MIRÓ (1893–1983)
Self-Portrait (Young Man in a Red Shirt), 1919
Oil on canvas, 73 × 60 cm (28³⁄₄ × 23⁵⁄₈ in)
Musée Picasso, Paris

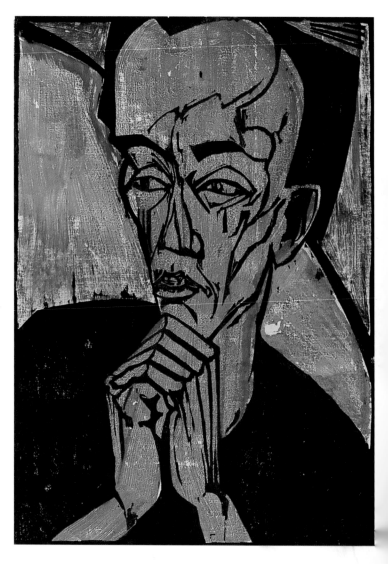

ERICH HECKEL (1883–1970)
Self-Portrait, 1919
Woodcut, 46.1 × 32.3 cm (18¼ × 12¾ in)

PAUL KLEE (1879–1940)
Lost in Thought, 1919
Pencil on paper on board, 27 × 19.7 cm (10⁵⁄₈ × 7³⁄₄ in)
Norton Simon Museum, Pasadena

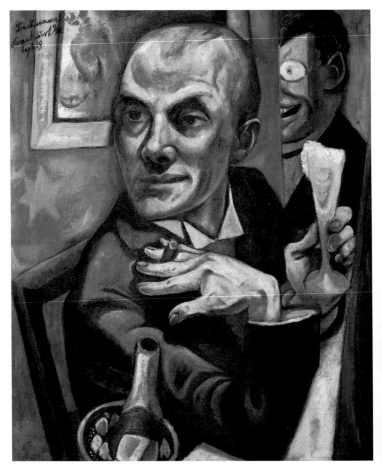

MAX BECKMANN (1884–1950)
Self-Portrait with a Glass of Champagne, 1919
Oil on canvas, 95 × 55.5 cm (37$\frac{1}{2}$ × 21$\frac{7}{8}$ in)
Private collection

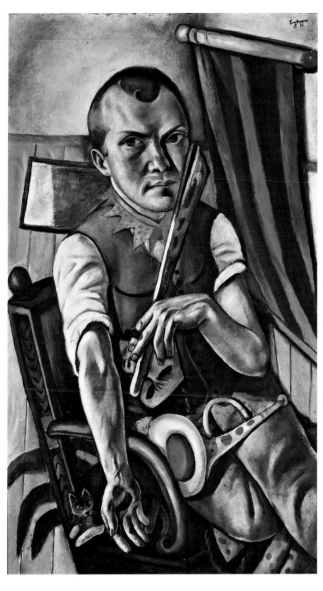

MAX BECKMANN (1884–1950)
Self-Portrait as a Clown, 1921
Oil on canvas, 100 × 59 cm (39³⁄₈ × 23¹⁄₄ in)
Von der Heydt-Museum, Wuppertal

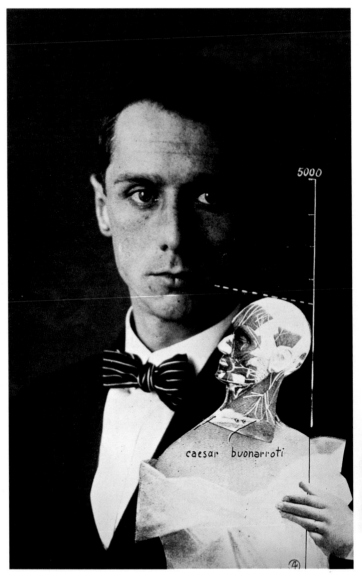

MAX ERNST (1891–1976)
Self-Portrait, 1920
Collage, drawing and photograph, 17.6 × 11.5 cm (6⁷⁄₈ × 4¹⁄₂ in)
Private collection

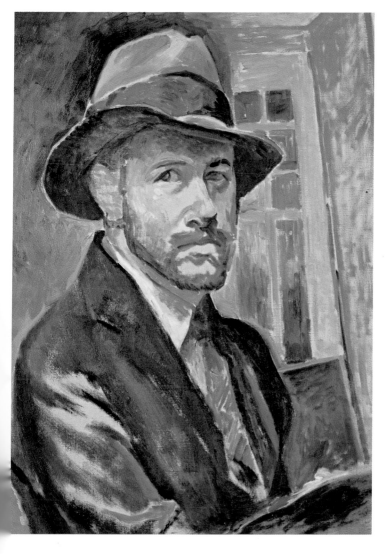

MARK TOBEY (1890–1976)
*Self-Portrait, c.*1930
Oil on canvas, 61 × 45.1 cm (24 × 17³⁄₄ in)
National Portrait Gallery, Washington DC

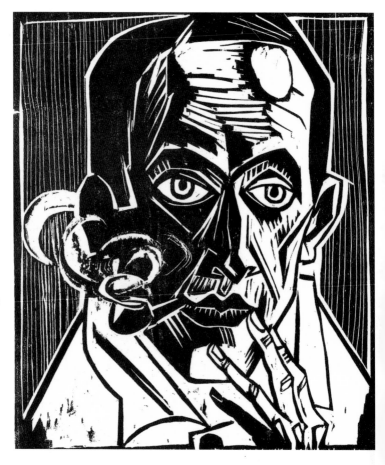

MAX PECHSTEIN (1881–1955)
Self-Portrait, 1920
Woodcut, 34 × 28 cm (13³⁄₈ × 11 in)

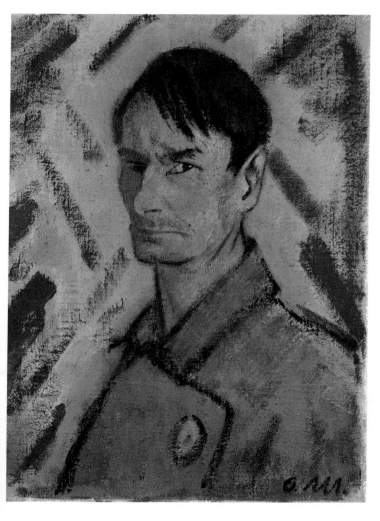

OTTO MÜLLER (1874–1930)
Self-Portrait, 1921
Watercolour on canvas, 71 × 54.7 cm (28 × 21½ in)
Staatsgalerie in der Kunsthalle, Augsburg

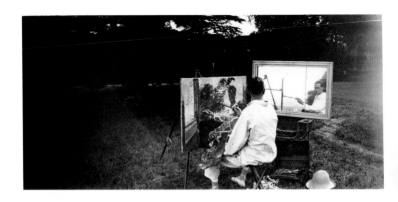

408

JAQUES-HENRI LARTIGUE (1894–1986)
Self-Portrait, Rouzat, 1923
Gelatin silver print, 28 × 13.5 cm (11 × 5$^{1}/_{4}$ in)

ALBERTO GIACOMETTI (1901–66)
Self-Portrait, 1921
Oil on canvas, 82.5 × 69.5 cm (32½ × 27⅜ in)
Kunsthaus, Zurich

THOMAS HART BENTON (1889–1975)
Self-Portrait with Rita, 1922
Oil on canvas, 125.6 × 101.5 cm (49½ × 40 in)
National Portrait Gallery, Washington DC

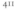

411

ROMAINE BROOKS (1874–1970)
Self-Portrait, 1923
Oil on canvas, 117.5 × 68.5 cm (46³⁄₈ × 27 in)
National Gallery of Art, Washington DC

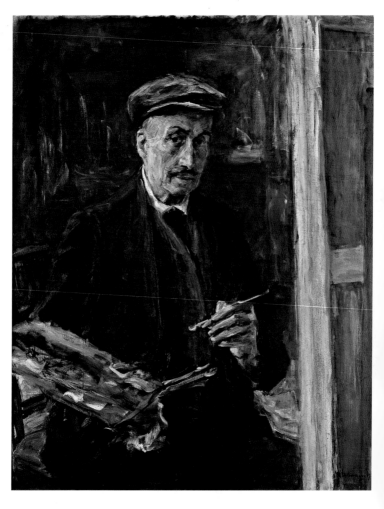

MAX LIEBERMANN (1847–1935)
Self-Portrait with Cap, 1925
Oil on canvas, 112 × 89 cm (44⅛ × 35⅛ in)
Neue Nationalgalerie, Berlin

CHAIM SOUTINE (1893–1943)
*Grotesque: Self-Portrait, c.*1922–3
Oil on canvas, 81 × 45 cm (31⁷⁄₈ × 17³⁄₄ in)
Musée d'Art Moderne de la Ville de Paris

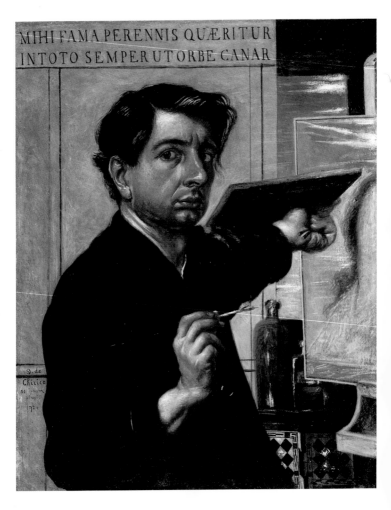

MIHI FAMA PERENNIS QUÆRITUR
INTOTO SEMPER UT ORBE CANAR

GIORGIO DE CHIRICO (1888–1978)
Self-Portrait with Palette, 1924
Tempera on canvas, 76 × 61 cm (29⅞ × 24 in)
Kunstmuseum, Winterthur

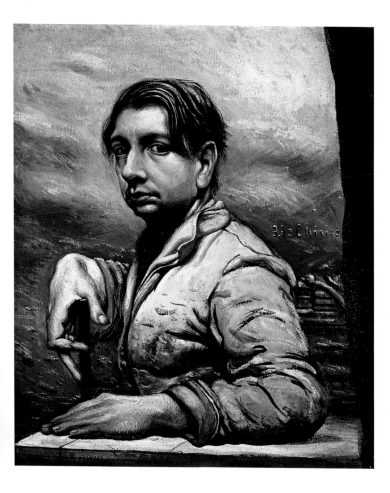

415

416

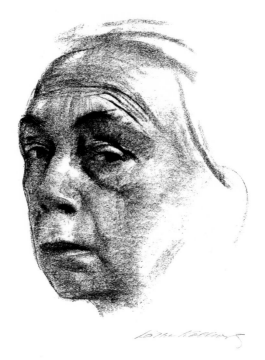

KÄTHE KOLLWITZ (1867–1945)
Self-Portrait, 1924
Lithograph, 29 × 22.5 cm ($11^{3}/_{8}$ × $8^{7}/_{8}$ in)

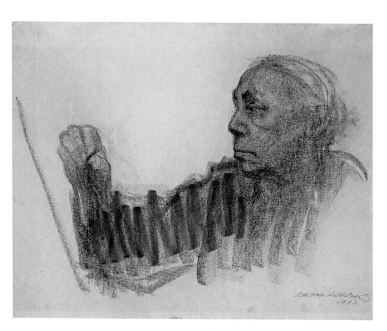

KÄTHE KOLLWITZ (1867–1945)
Self-Portrait in Profile, Drawing, 1933
Charcoal on paper, 47.7 × 63.5 cm (18³⁄₄ × 25 in)
National Gallery of Art, Washington DC

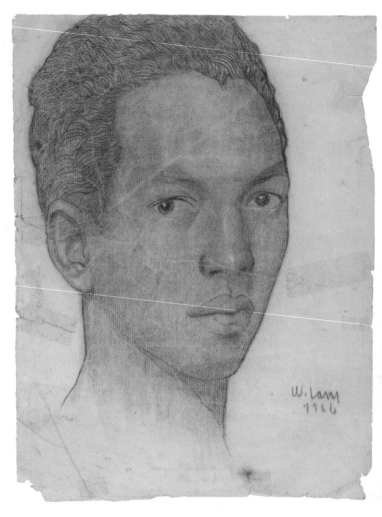

WIFREDO LAM (1902–82)
Self-Portrait, 1924
Bistre on paper, 31.4 × 23.7 cm (12¹/₈ × 9³/₈ in)
Private collection

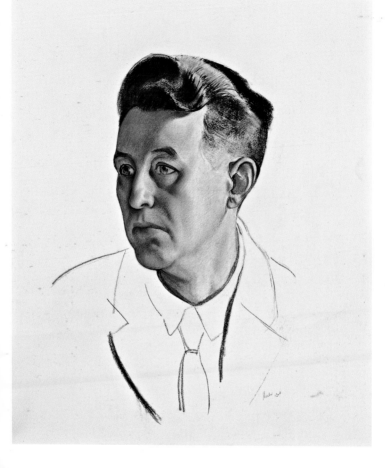

CHARLES SHEELER (1883–1965)
Self-Portrait, 1924
Pastel on paper, 58.4 × 48.2 cm (23 × 19 in)
National Portrait Gallery, Washington DC

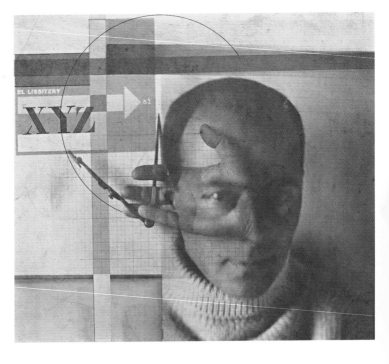

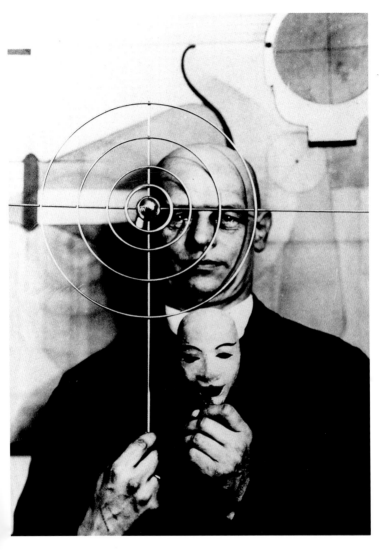

OSKAR SCHLEMMER (1888–1943)
Self-Portrait with Mask and Co-ordinate Grid System (Sun) in Front of Mythical Figure, 1931
Black and white photograph (original lost)

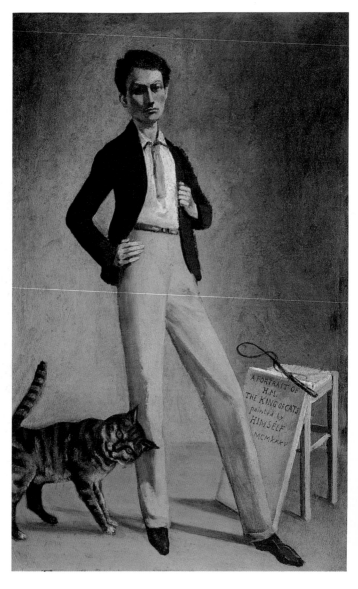

BALTHUS (1908–97)
The King of Cats, 1935
Oil on canvas, 71 × 48 cm (28 × 19 in)
Private collection

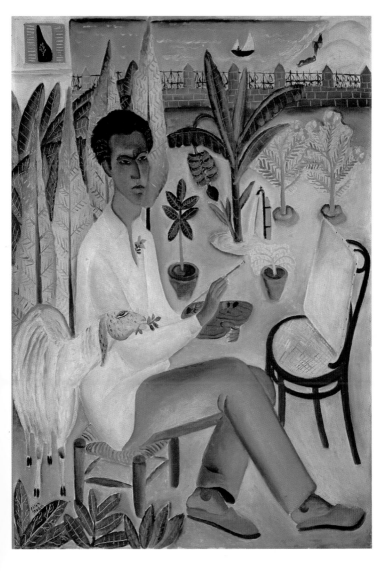

REUVEN RUBIN (1893–1974)
Self-Portrait, 1924
Oil on canvas on board, 90.8 × 63.5 cm (35¼ × 25 in)
Private collection

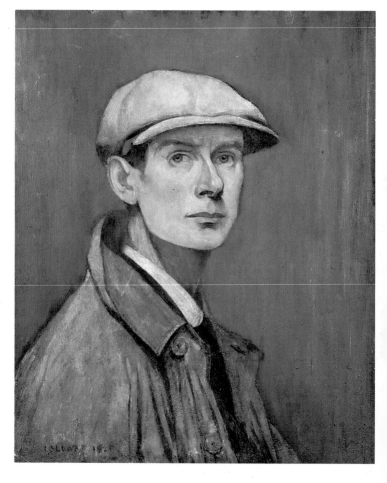

424

LS LOWRY (1887–1976)
Self-Portrait, 1925
Oil on board, 57.2 × 47.2 cm (22^1/$_2$ × 18^5/$_8$ in)
City of Salford Art Gallery

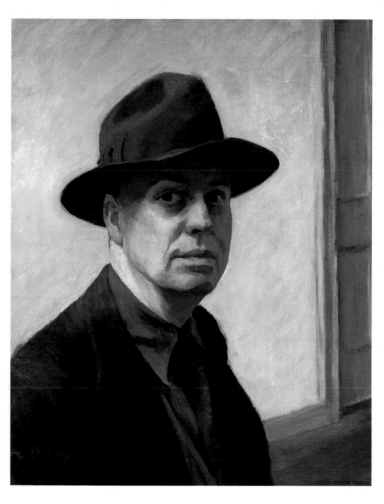

425

EDWARD HOPPER (1882–1967)
Self-Portrait, 1925–30
Oil on canvas, 63.4 × 51.7 cm (25 × 20⅛ in)
Whitney Museum of American Art, New York

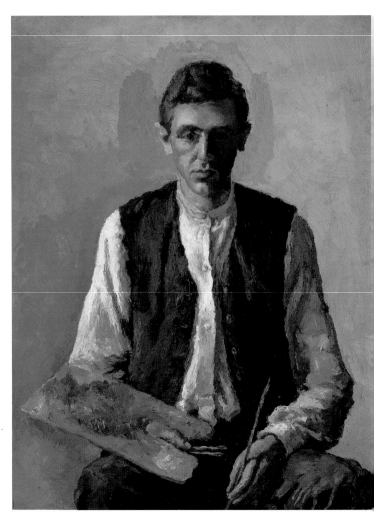

426

GIORGIO MORANDI (1890–1964)
Self-Portrait, 1925
Oil on canvas, 63 × 48.5 cm (24$^7/_8$ × 19$^1/_8$ in)
Magnani-Rocca Collection, Mamiano di Parma

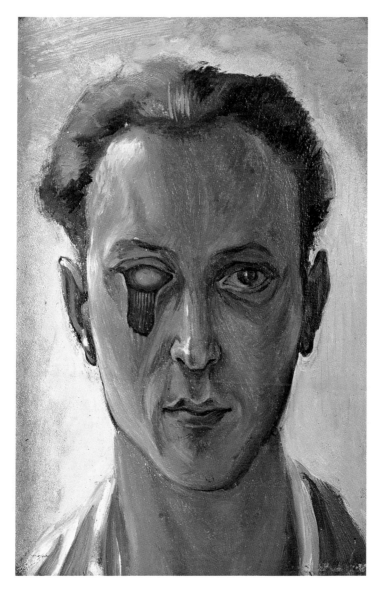

VICTOR BRAUNER (1903–66)
Self-Portrait, 1931
Oil on wood, 22 × 16.2 cm (8⁵⁄₈ × 6³⁄₈ in)
Musée National d'Art Moderne, Paris

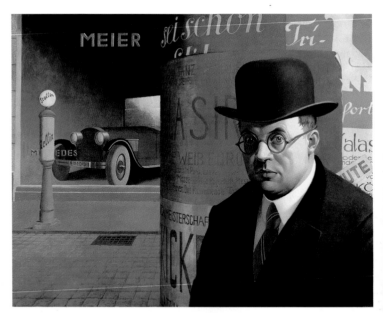

428

GEORG SCHOLZ (1890–1945)
Self-Portrait, 1926
Oil on board, 60 × 78 cm (23⅝ × 30¾ in)
Kunsthalle, Karlsruhe

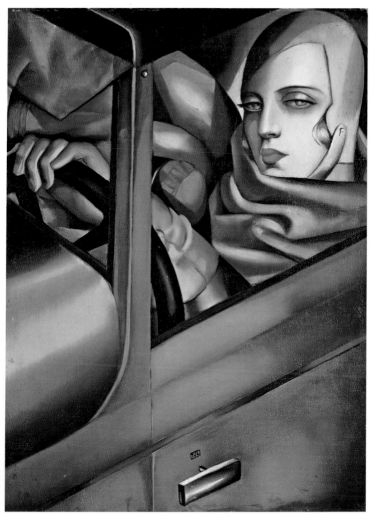

429

TAMARA DE LEMPICKA (1898–1980)
Self-Portrait in the Bugatti, 1932
Oil on canvas, 35 × 26 cm (13³⁄₄ × 10¹⁄₄ in)
Private collection

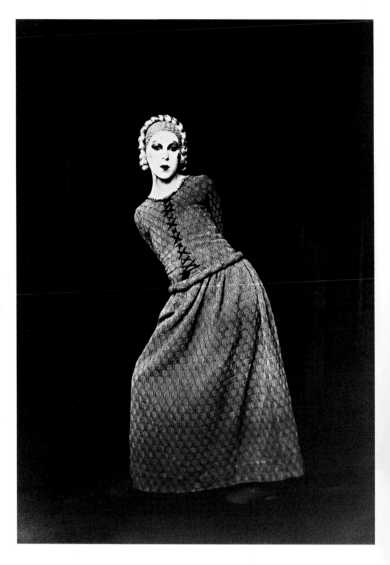

430

CLAUDE CAHUN (1894–1954)
*Self-Portrait (in Barbe Bleu Costume), c.*1929
Black and white photograph, 11 × 9 cm (4³/₈ × 3¹/₂ in)

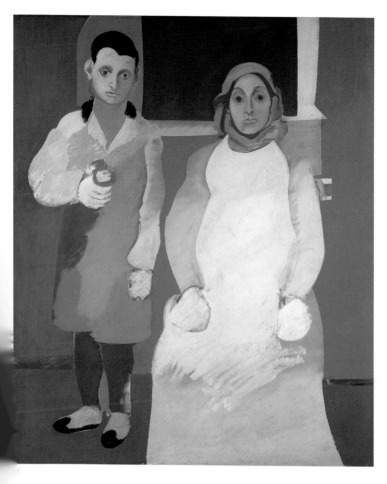

ARSHILE GORKY (1904–48)
The Artist and his Mother, 1926–36
Oil on canvas, 152.4 × 127 cm (60 × 50 in)
Whitney Museum of American Art, New York

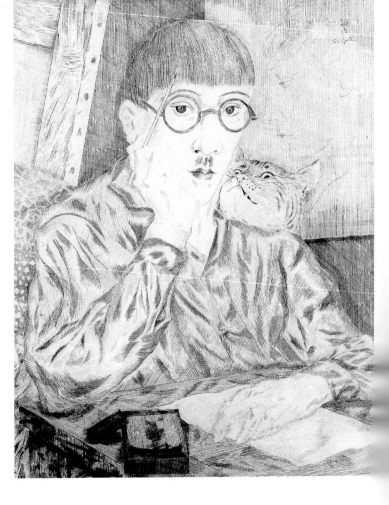

TSUGOUHARU FOUJITA (1886–1968)
Self-Portrait, 1927
Drypoint, 45.5 × 35 cm (17⅞ × 13¾ in)

433

ᴱᴵC GILL (1882–1940)
Self-Portrait, 1927
Wood engraving, 17.5 × 12 cm (6⁷⁄₈ × 4³⁄₄ in)

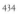

434

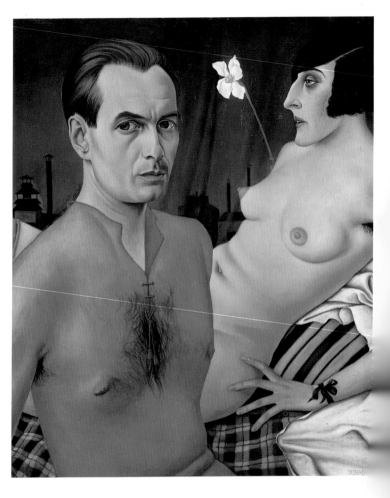

CHRISTIAN SCHAD (1894–1982)
Self-Portrait, 1927
Oil on wood, 76 × 61.5 cm (30 × 24¼ in)
Private collection

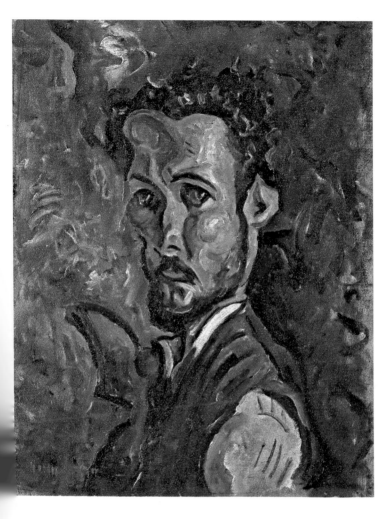

435

WILLIAM H JOHNSON (1901–70)
Self-Portrait, 1929
Oil on canvas, 59 × 46.3 cm (23¼ × 18¼ in)
National Museum of American Art, Washington DC

CHRISTOPHER WOOD (1901–30)
Self-Portrait, 1927
Oil on canvas, 130 × 97 cm (51¼ × 38¼ in)
Kettle's Yard, Cambridge

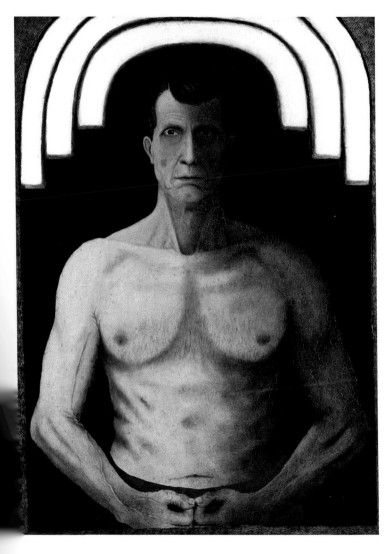

JOHN KANE (1860–1934)
Self-Portrait, 1929
oil on canvas on board, 91.8 × 68.9 cm (36¹⁄₈ × 27¹⁄₈ in)
Museum of Modern Art, New York

438

WALKER EVANS (1903–75)
Self-Portraits, Juan-les-Pins, France, 1927
Four gelatin silver prints, each 6.1 × 3.7 cm (2³⁄₈ × 1¹⁄₂ in)

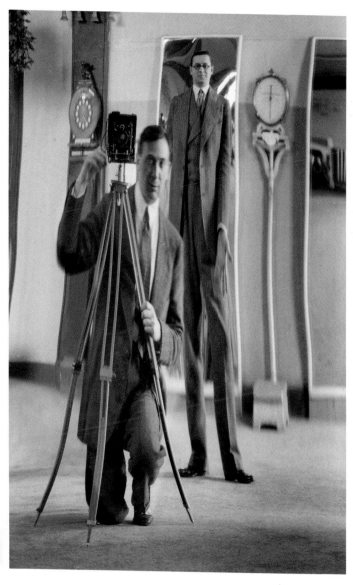

439

NDRÉ KERTÉSZ (1894–1985)
elf-Portrait with Carlo Rim, 1930
elatin silver print, 22.9 × 15.6 cm (9 × 6¹/₈ in)

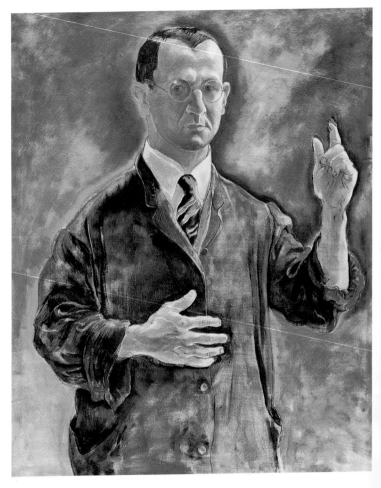

GEORGE GROSZ (1893–1959)
Self-Portrait as Warner, 1927
Oil on canvas, 98 × 79 cm (38⅝ × 31⅛ in)
Berlinische Galerie, Berlin

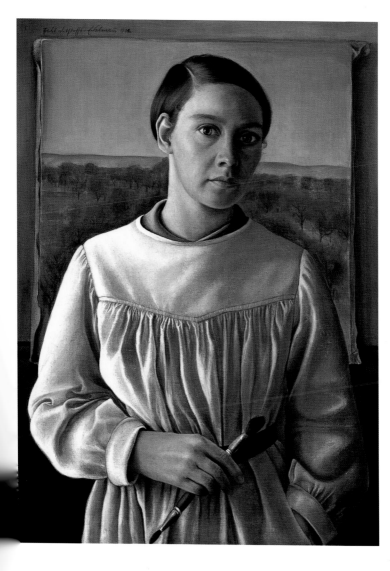

RIDEL DETHLEFFS-EDELMANN (1899–1982)
Self-Portrait, 1932
Oil on canvas, 74 × 55 cm (29^1/$_8$ × 21^5/$_8$ in)
Kunsthalle, Augsburg

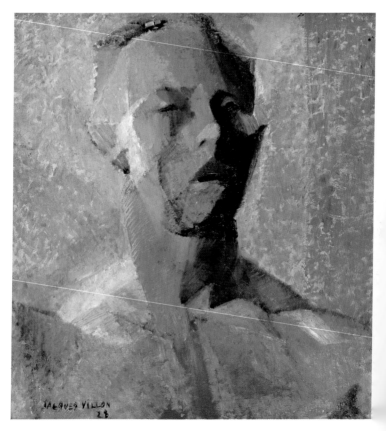

442

JACQUES VILLON (1875–1963)
Self-Portrait, 1928
Oil on board, 55 × 45.5 cm (21⁵⁄₈ × 17⁷⁄₈ in)
Musée Malraux, Le Havre

443

AVID BOMBERG (1890–1957)
ouble Self-Portrait, 1937
harcoal on paper, 46 × 63.5 cm (18 × 25 in)
rivate collection

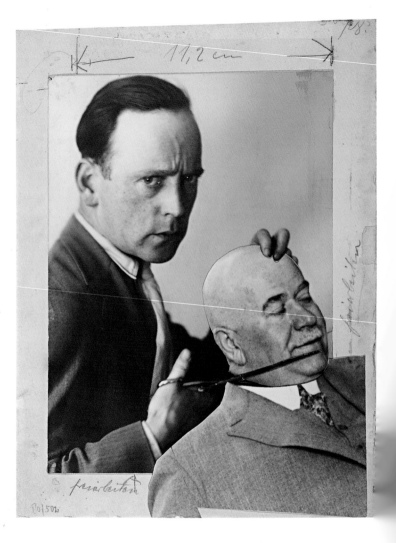

444

JOHN HEARTFIELD (1891–1968)
John Heartfield and Police Commissioner Zörgiebel, 1929
Photomontage, 28 × 21 cm (11 × 8¼ in)
Stiftung Archiv der Akademie der Künste, Berlin

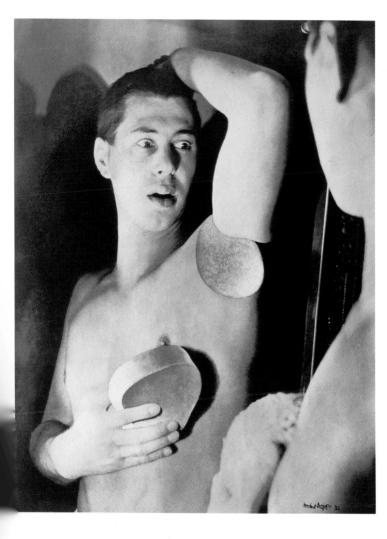

445

HERBERT BAYER (1900–85)
Self-Portrait, 1932
Gelatin silver print, 38.5 × 29.4 cm (15¹⁄₈ × 11¹⁄₂ in)

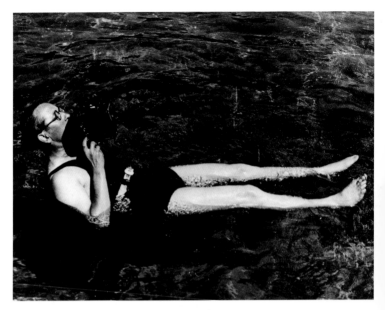

446

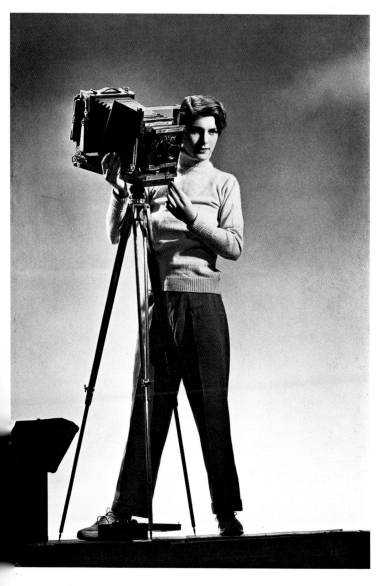

MARGARET BOURKE WHITE (1904–71)
Self-Portrait with Camera, c.1933
Gelatin silver print, 32.3 × 22.8 cm (12³⁄₄ × 9 in)

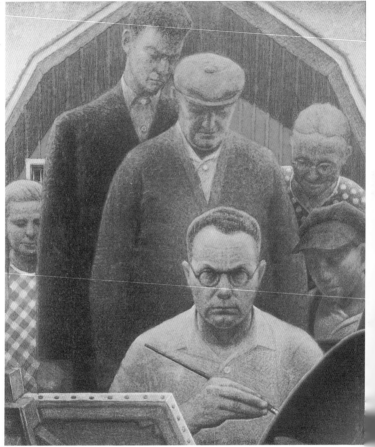

448

GRANT WOOD (1891–1942)
Return from Bohemia, 1935
Pastel on paper, 62.9 × 50.8 cm (23³⁄₄ × 20 in)
Davenport Museum of Art, Iowa

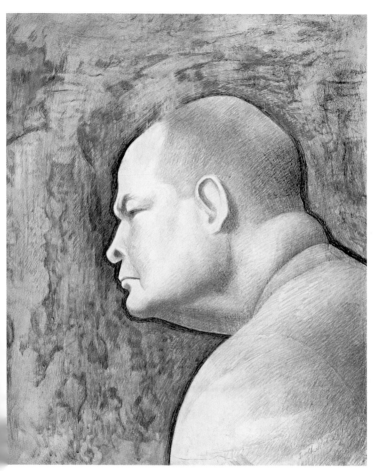

449

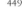

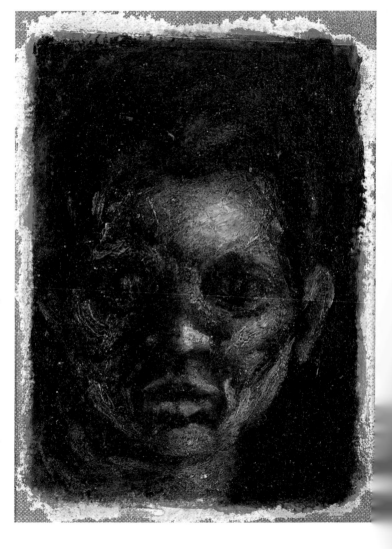

JACKSON POLLOCK (1912–56)
*Self-Portrait, c.*1930–3
Oil on canvas, 18.4 × 13.3 cm (7¼ × 5¼ in)
Private collection

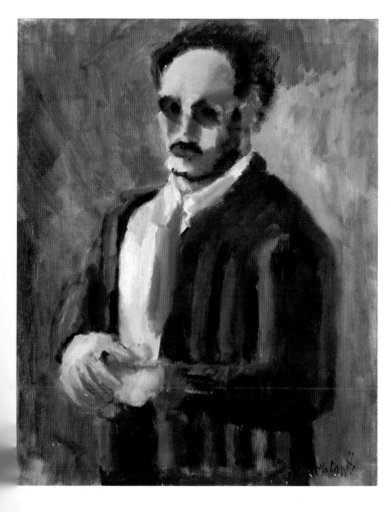

MARK ROTHKO (1903–70)
Self-Portrait, 1936
Oil on canvas, 81.9 × 65.4 cm (32¼ × 25¾ in)
Collection of Christopher Rothko

MAN RAY (1890–1976)
Self-Portrait, 1933
Cast bronze, glass and wood, 35.5 × 21.1 × 13.7 cm (14 × 8¼ × 5⅜ in)
National Museum of American Art, Washington DC

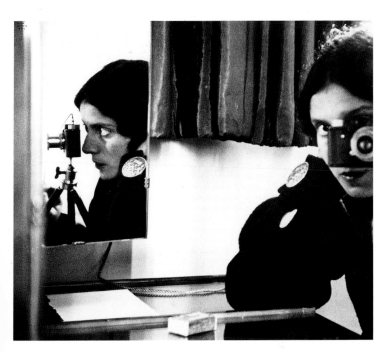

453

ILSE BING (1899–1998)
Self-Portrait with Mirrors, 1931
Gelatin silver print, 26.6 × 29.8 cm (10½ × 11¾ in)

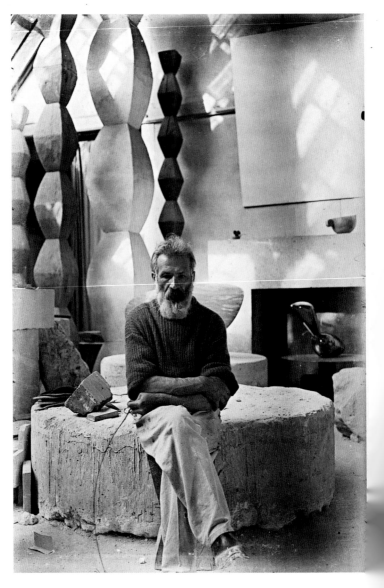

454

CONSTANTIN BRANCUSI (1876–1957)
Self-Portrait in the Workshop, c.1933–4
Silver gelatin print, 12 × 9 cm (4³⁄₄ × 3¹⁄₂ in)

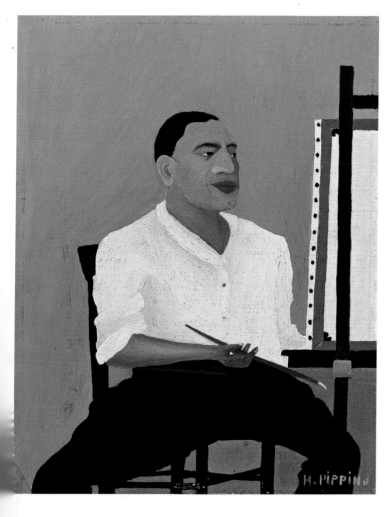

HORACE PIPPIN (1888–1946)
Self-Portrait, 1941
Oil on canvas on board, 35.5 × 27.9 cm (14 × 11 in)
Albright-Knox Art Gallery, Buffalo

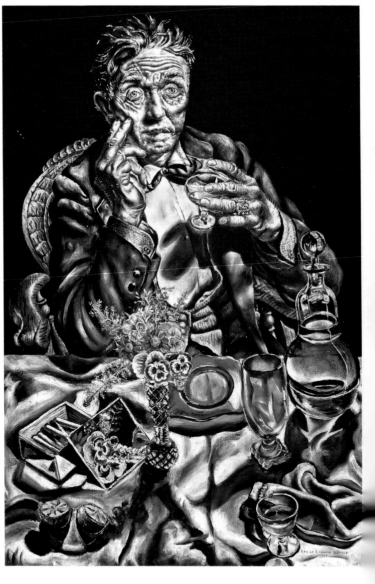

IVAN ALBRIGHT (1897–1983)
Self-Portrait, 1935
Oil on canvas, 77 × 50.6 cm (30¼ × 19⅞ in)
Art Institute of Chicago

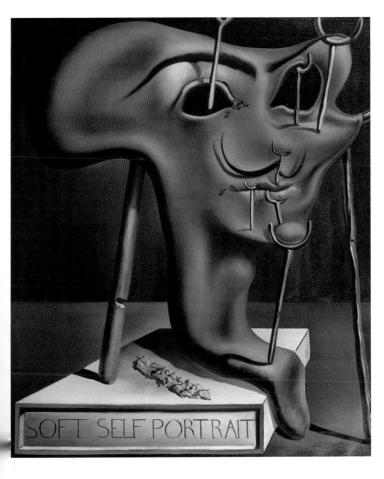

SALVADOR DALÍ (1904–89)
Soft Self-Portrait with Fried Bacon, 1941
oil on canvas, 61.3 × 50.8 cm (24⅛ × 20 in)
Fundación Gala-Salvador-Dalí, Figueras

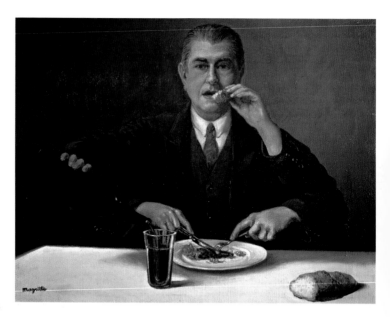

458

RENÉ MAGRITTE (1898–1967)
The Wizard, 1951
Oil on canvas, 35 × 46 cm (13³⁄₄ × 18¹⁄₈ in)
Private collection

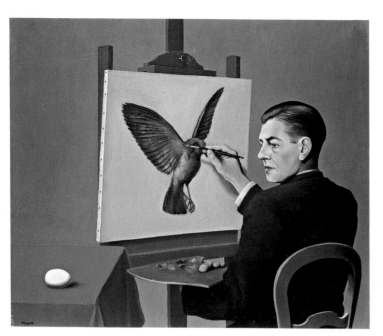

459

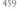

ené magritte (1898–1967)
a Clairvoyance, 1936
il on canvas, 54.2 × 65 cm (21³⁄₈ × 25⁵⁄₈ in)
rivate collection

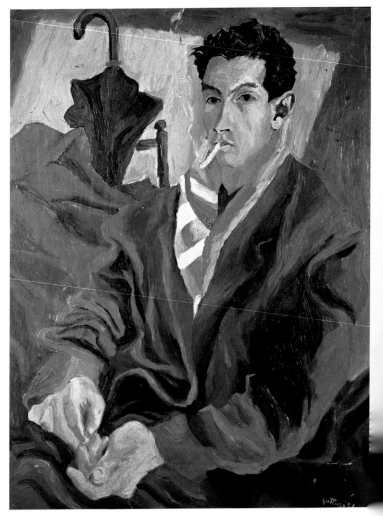

RENATO GUTTUSO (1912–87)
Self-Portrait with Umbrella and Scarf, 1936
Oil on board, 71 × 55 cm (28 × 21⅝ in)
Private collection

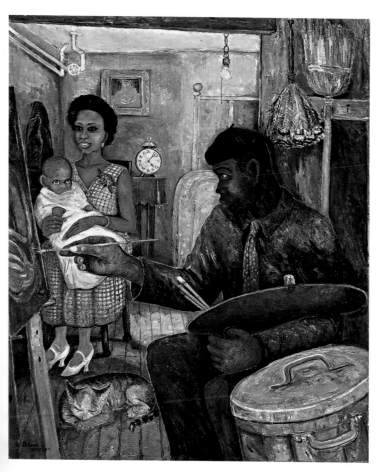

PALMER HAYDEN (1893–1973)
*The Janitor who Paints, c.*1937
Oil on canvas, 99.3 × 83.4 cm (39⅛ × 32⅞ in)
National Museum of American Art, Washington DC

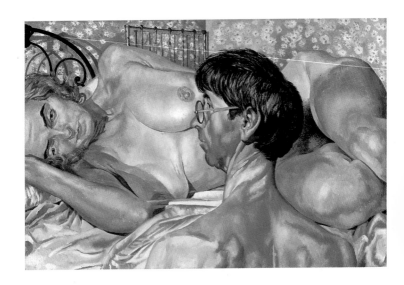

462

STANLEY SPENCER (1891–1959)
Self-Portrait with Patricia Preece, 1936
Oil on canvas, 61 × 91.2 cm (24 × 36 in)
Fitzwilliam Museum, Cambridge

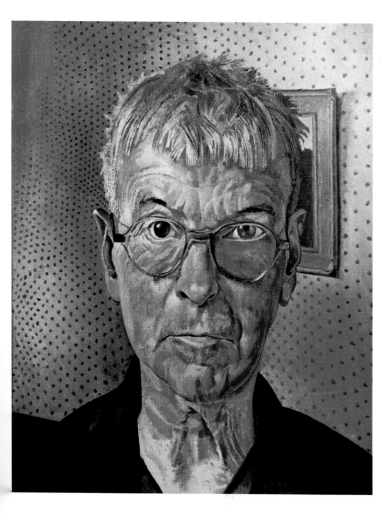

STANLEY SPENCER (1891–1959)
Self-Portrait, 1959
Oil on canvas, 51 × 40.6 cm (20 × 16 in)
Tate Gallery, London

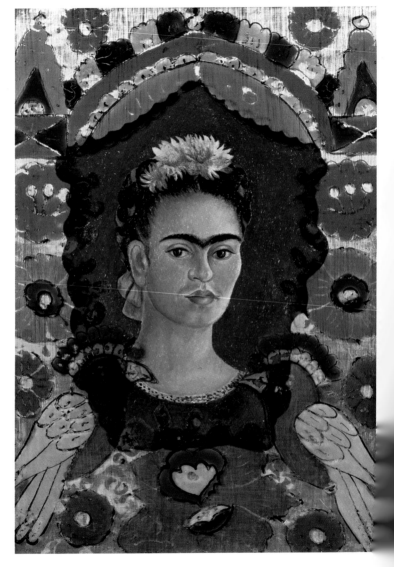

464

FRIDA KAHLO (1907–54)
*Self-Portrait, c.*1938
Oil on aluminium and glass, 29.2 × 21.6 cm (11$\frac{1}{2}$ × 8$\frac{1}{2}$ in)
Musée National d'Art Moderne, Paris

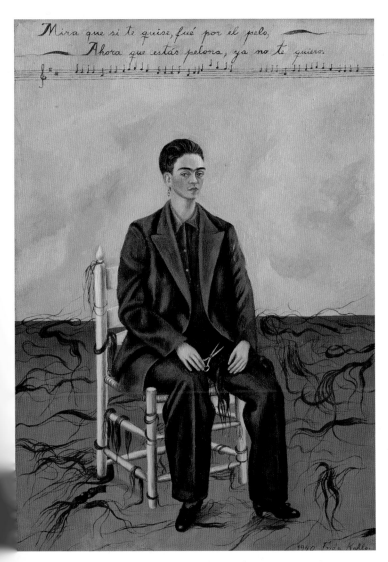

FRIDA KAHLO (1907–54)
Self-Portrait with Cropped Hair, 1940
Oil on canvas, 40 × 28 cm (15¾ × 11 in)
Museum of Modern Art, New York

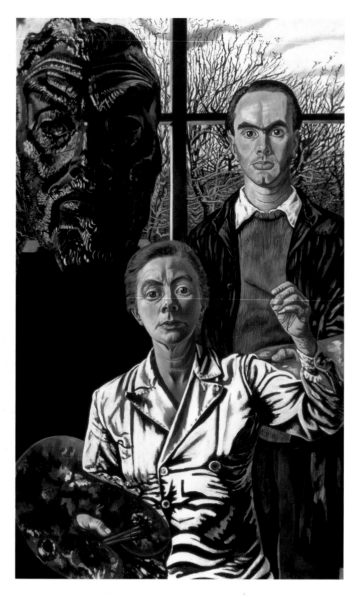

CHARLEY TOOROP (1894–1955)
Three Generations, 1941–50
Oil on canvas, 200 × 121 cm (78³⁄₄ × 47⁵⁄₈ in)
Museum Boymans–Van Beuningen, Rotterdam

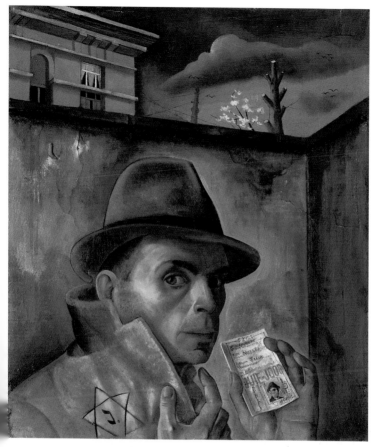

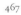

FELIX NUSSBAUM (1904–44)
Self-Portrait with Jewish Identity Card, 1943
Oil on canvas, 56 × 49 cm (22 × 19¼ in).
Kulturgeschichtliches Museum, Osnabrück

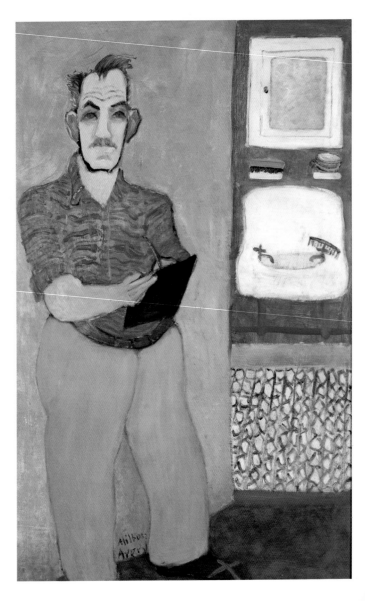

MILTON AVERY (1893–1965)
Self-Portrait, 1941
Oil on canvas, 137 × 86.3 cm (54 × 34 in)
Private collection

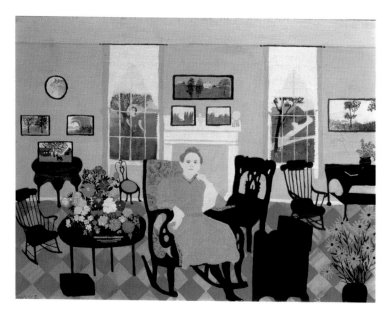

469

ANNA (GRANDMA) MOSES (1860–1961)
In The Studio, 1944
Oil on board, 18 × 23.5 cm (7¹⁄₈ × 9¹⁄₄ in)
Private collection

MAURITS CORNELIUS ESCHER (1898–1972)
Self-Portrait in a Shaving Mirror, 1943
'Scratch' drawing in brown lithographic crayon, 24.9 × 25.6 cm (9¾ × 10 in)
Gemeentemuseum, The Hague

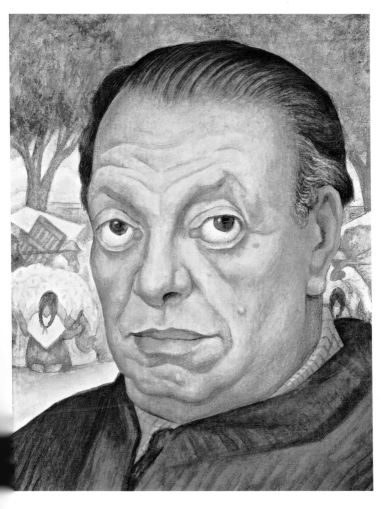

DIEGO RIVERA (1886–1957)
Self-Portrait, 1949
Tempera on canvas, 31.1 × 25.1 cm (12¼ × 9⅞ in)
Private collection

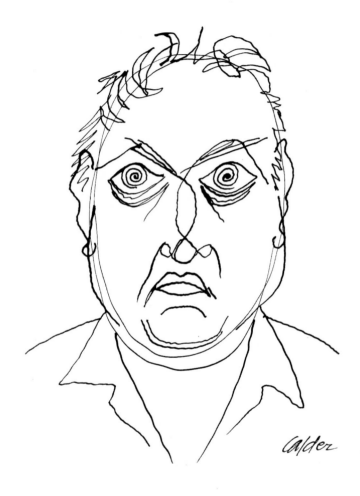

472

ALEXANDER CALDER (1898–1976)
Self-Portrait, c.1944
Pen and ink on paper, 36.8 × 29.2 cm (14¹⁄₂ × 11¹⁄₂ in)
Private collection

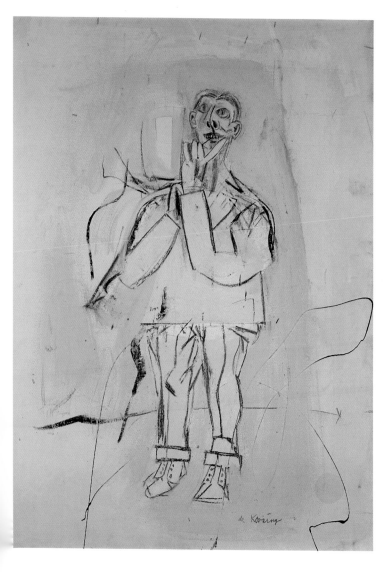

WILLEM DE KOONING (1904–97)
Self-Portrait, 1947
Oil on board, 64.7 × 46.9 cm (25½ × 18½ in)
Private collection

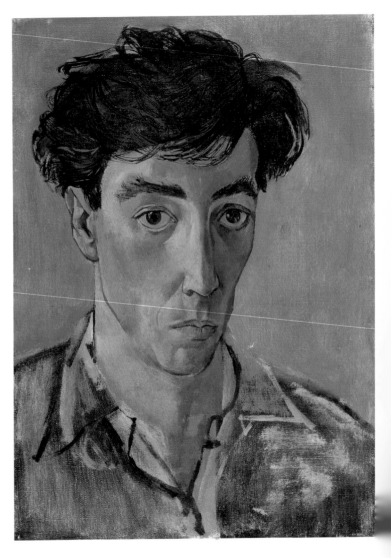

JOHN MINTON (1917–57)
*Self-Portrait, c.*1953
Oil on canvas, 35.6 × 25.4 cm (14 × 10 in)
National Portrait Gallery, London

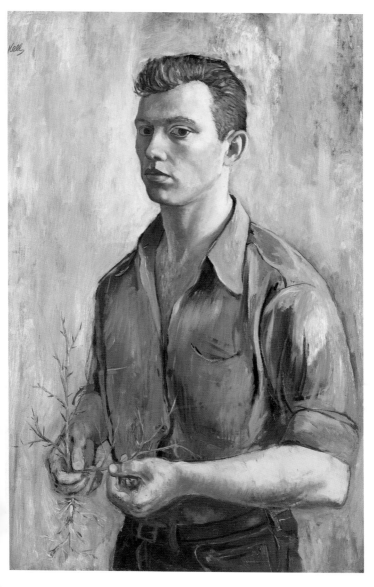

ELLSWORTH KELLY (1923–)
Self-Portrait with Thorns, 1947
Oil on wood, 90.8 × 60.6 cm (35³⁄₄ × 23⁷⁄₈ in)
San Francisco Museum of Modern Art

ANGUS MCBEAN (1904–90)
Self-Portrait, 1947
Gelatin silver print, 28.8 × 23.4 cm (11³⁄₈ × 9¹⁄₄ in)

WEEGEE (ARTHUR FELLIG) (1899–1968)
Self-Portrait as a Talent Scout, c.1950–2
Gelatin silver print, 35.5 × 29.9 cm (14 × 11 in)

ANDREW WYETH (1917–)
The Revenant, 1949
Tempera on wood, 30 × 20 cm (11³⁄₄ × 7⁷⁄₈ in)
New Britain Museum of American Art, Connecticut

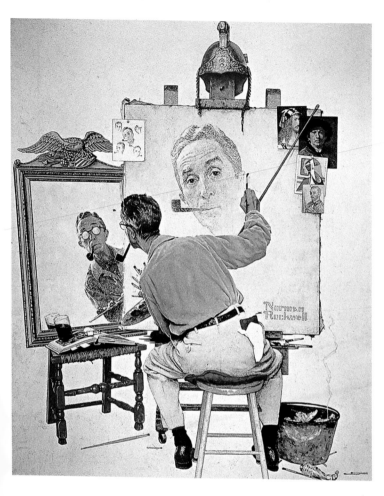

479

NORMAN ROCKWELL (1894–1978)
Triple Self-Portrait, 1960
Oil on canvas, 114.2 × 88.8 cm (45 × 35 in)
Rockwell Family Trust

VANESSA BELL (1879–1961)
*Self-Portrait, c.*1958
Oil on canvas, 47.7 × 38.7 cm (18¾ × 15¼ in)
Charleston, Firle, East Sussex

GRAHAM SUTHERLAND (1903–80)
Self-Portrait, 1977
Oil on canvas, 52.7 × 50.2 cm (20¾ × 19¾ in)
National Portrait Gallery, London

482

MARCEL DUCHAMP (1887–1968)
With my Tongue in my Cheek, 1959
Plaster on pencil and paper, 25 × 15 × 5.1 cm (9⁷/₈ × 5⁷/₈ × 2 in)
Musée National d'Art Moderne, Paris

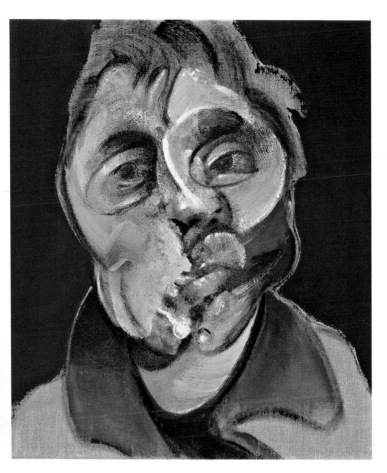

FRANCIS BACON (1909–92)
Self-Portrait, 1969
Oil on canvas, 35.5 × 30.5 cm (14 × 12 in)
Private collection

484

ALBERTO GIACOMETTI (1901–66)
Self-Portrait, 1960
Pencil on paper, 50 × 32 cm (19$\frac{3}{4}$ × 12$\frac{5}{8}$ in)
Private collection

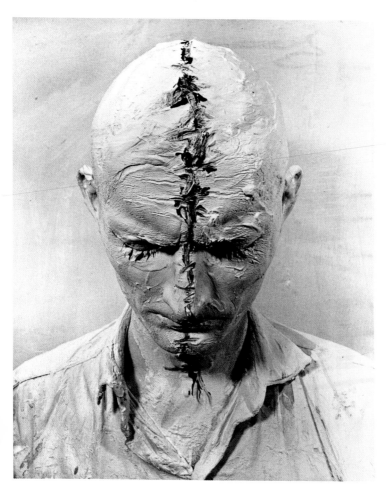

485

GÜNTER BRUS (1938–)
Self-Portrait, 1964
Gelatin silver print, 50 × 40 cm (19$\frac{1}{2}$ × 15$\frac{3}{4}$ in)

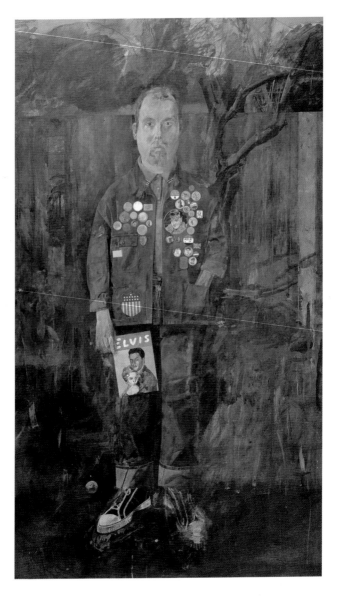

PETER BLAKE (1932–)
Self-Portrait with Badges, 1961
Oil on board, 172.7 × 120.6 cm (68 × 47½ in)
Tate Gallery, London

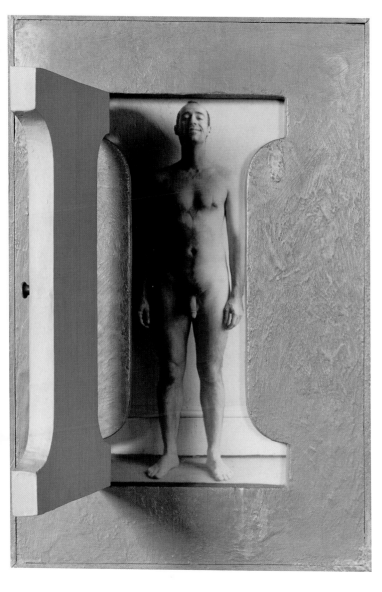

ROBERT MORRIS (1931–)
I-Box, 1962
Painted plywood cabinet, sculptmetal and photograph, 48 × 33 × 4 cm (18⅞ × 13 × 1⅝ in)
Solomon R Guggenheim Museum, New York

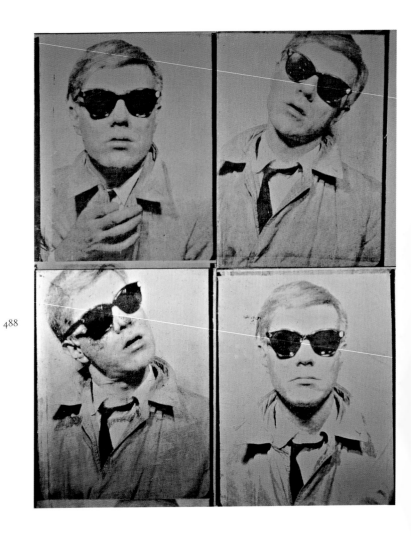

488

ANDY WARHOL (1928–87)
Self-Portrait, 1964
Silkscreen ink on synthetic polymer paint on canvas, 4 panels, each 50.8 × 40.6 cm (20 × 16 in)
Private collection

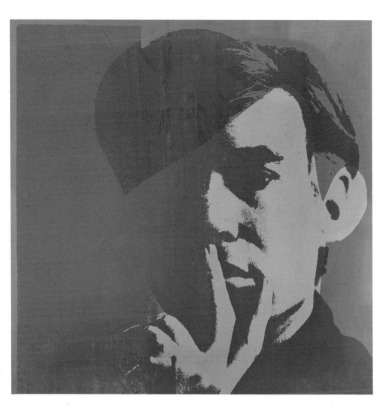

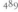

ANDY WARHOL (1928–87)
Self-Portrait, 1967
Acrylic on canvas, 182.8 × 182.8 cm (72 × 72 in)
Staatsgalerie Moderner Kunst, Munich

JASPER JOHNS (1930–)
Souvenir 2, 1964
Oil and collage on canvas with objects, 73 × 53.3 cm (28³⁄₄ × 21 in)
Private collection

LEE FRIEDLANDER (1934–)
Route 9W, New York, 1969
Gelatin silver print, 27.9 × 35.6 cm (11 × 14 in)

LUCIAN FREUD (1922–)
Reflection with Two Children (Self-Portrait), 1965
Oil on canvas, 91.5 × 91.5 cm (36 × 36 in)
Museo Thyssen-Bornemisza, Madrid

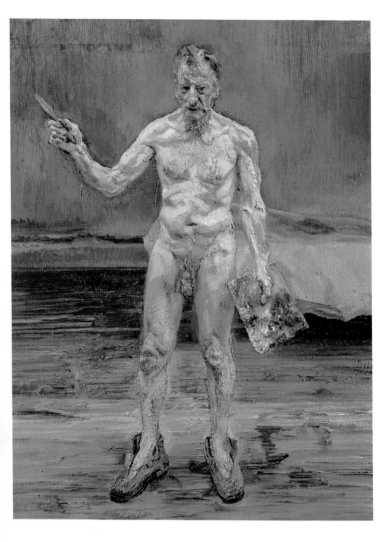

LUCIAN FREUD (1922–)
Painter Working, Reflection, 1993
Oil on canvas, 101.3 × 81.7 cm (40 × 32¼ in)
Private collection

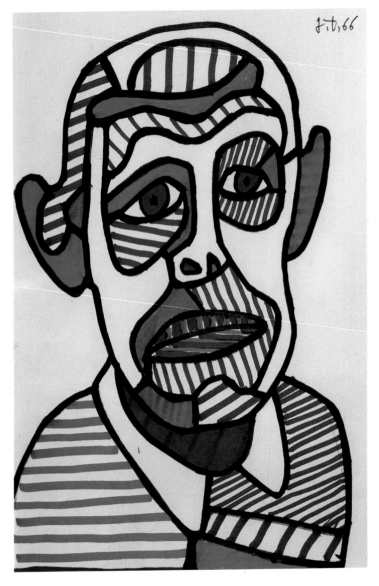

494

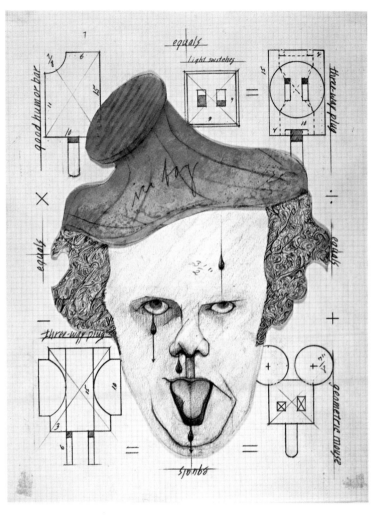

CLAES OLDENBURG (1929–)
Symbolic Self-Portrait with Equals, 1969
Ink, watercolour, pencil, spray enamel and colour stencil, 28 × 21 cm (11 × 8¼ in)
Moderna Museet, Stockholm

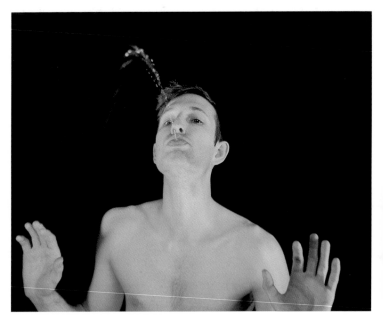

496

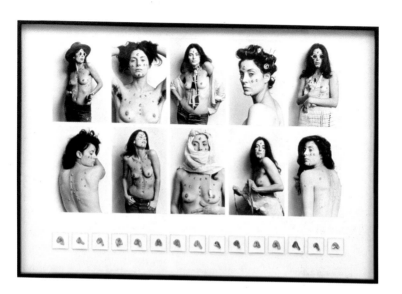

HANNAH WILKE (1940–93)
SOS Starification Object Series, 1974–82
Black and white photographs and gum sculptures, 104.1 × 147.3 cm (41 × 58 in)
Private collection

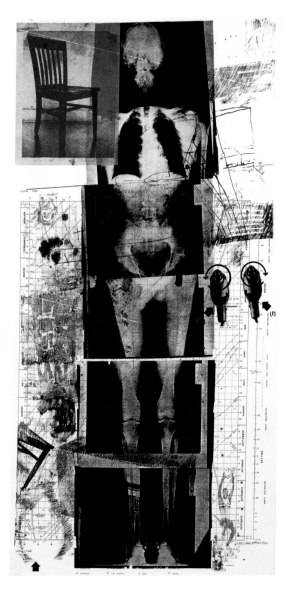

ROBERT RAUSCHENBERG (1925–)
Booster, 1967
Lithograph and silkscreen, 72 × 36 cm (28³/₈ × 14¹/₄ in)

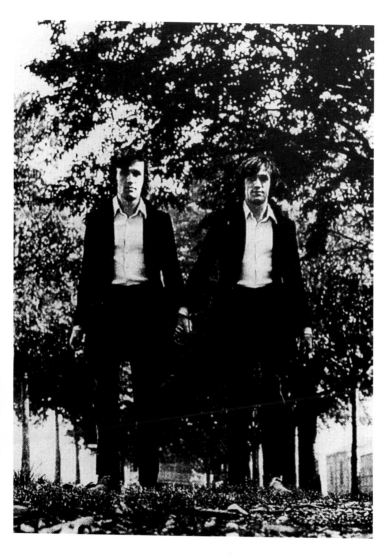

499

ALIGHIERO BOETTI (1940–94)
Gemelli (Twins), 1968
Postcard made from a black and white photograph, 16.5 × 12 cm (6$^1/_2$ × 4$^3/_4$ in)

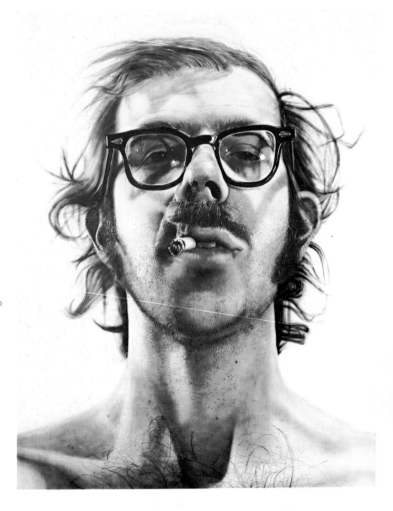

CHUCK CLOSE (1940–)
Big Self-Portrait, 1967–8
Acrylic on canvas, 273.1 × 212.1 cm (107¹⁄₂ × 83¹⁄₂ in)
Walker Art Center, Minneapolis

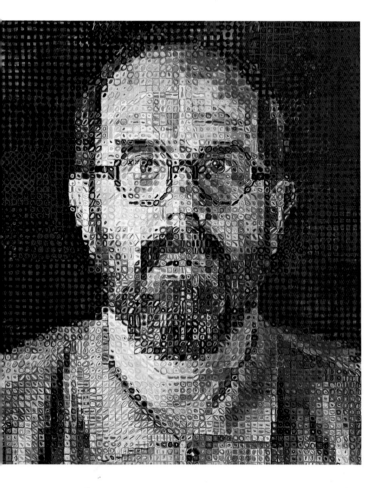

501

CHUCK CLOSE (1940–)
Self-Portrait, 1991
Oil on canvas, 254 × 213.4 cm (100 × 84 in)
Collection Paine Webber Group Inc., New York

PIETRO ANNIGONI (1910–88)
Self-Portrait, 1971
Tempera on wood, 80 × 60 cm (31$^{1}/_{2}$ × 23$^{5}/_{8}$ in)
Uffizi, Florence

503

GEORGE TOOKER (1920–)
Self-Portrait, 1969
Tempera on wood, 60.9 × 49.5 cm (24 × 19½ in)
National Academy of Design, New York

504

GIUSEPPE PENONE (1947–)
To Reverse One's Eyes, 1970
Black and white photograph, 18 × 13 cm (7 × 5⅛ in)

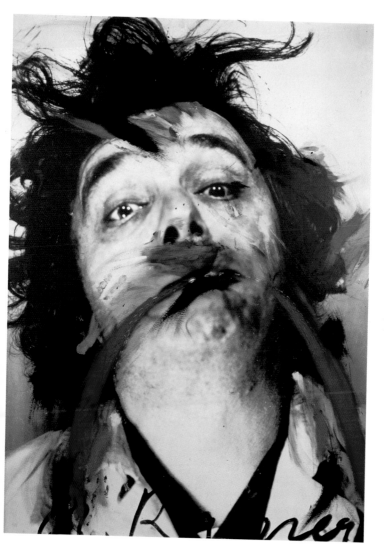

505

ARNULF RAINER (1929–)
Angst, 1969–73
Oil on photograph, 120 × 88 cm (47¼ × 34¼ in)
Private collection

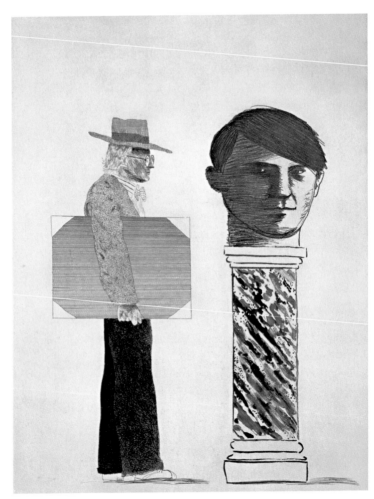

506

DAVID HOCKNEY (1937–)
The Student – Homage to Picasso, 1973
Etching, 68.5 × 53.3 cm (27 × 21 in)

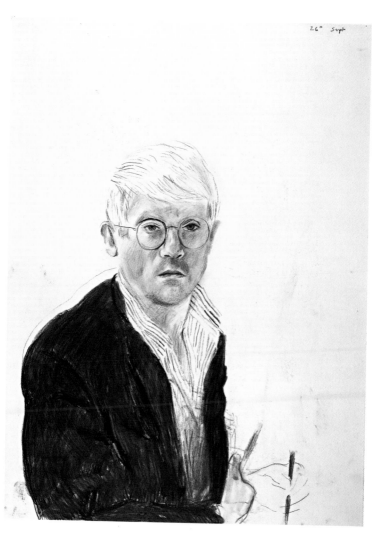

26" Sept

507

DAVID HOCKNEY (1937–)
Self-Portrait, 26th September 1983
Charcoal on paper, 76.2 × 57.2 cm (30 × 22½ in)
Collection of the artist

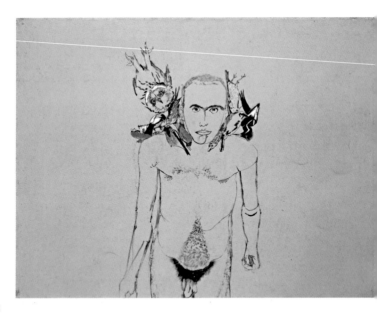

508

FRANCESCO CLEMENTE (1952–)
Self-Portrait: The First, 1979
Gouache, watercolour and ink on paper mounted on canvas, 111.8 × 147.3 cm (44 × 58 in)
Private collection

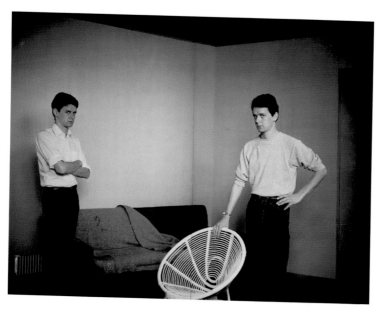

509

JEFF WALL (1946–)
Double Self-Portrait, 1979
Transparency and lightbox, 172 × 229 cm (67¾ × 90¼ in)
Art Gallery of Ontario, Toronto

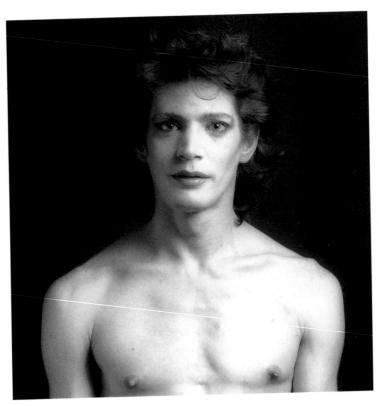

ROBERT MAPPLETHORPE (1946–89)
Self-Portrait, 1980
Gelatin silver print, 50.7 × 40.5 cm (20 × 16 in)

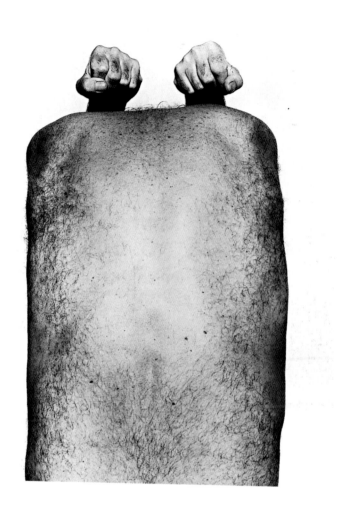

511

JOHN COPLANS (1920–)
Self-Portrait (Back with Arms Above), 1984
Gelatin silver print, 60.9 × 50.7 cm (24 × 20 in)

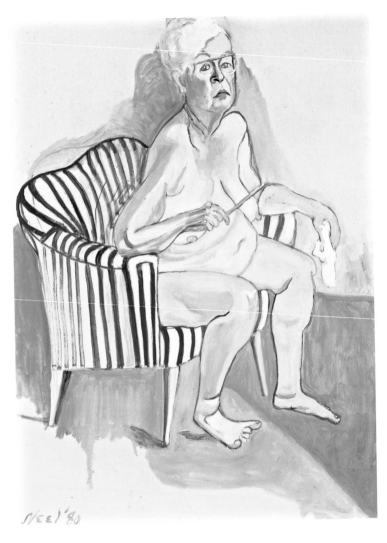

ALICE NEEL (1900–84)
Self-Portrait, 1980
Oil on canvas, 137.1 × 101.6 cm (54 × 40 in)
National Portrait Gallery, Washington DC

513

NAN GOLDIN (1953–)
Nan One Month after Being Battered, 1984
Cibachrome print, 68.5 × 101.5 cm (27⁵/₈ × 40 in)

Self-Portrait Exaggerating My Negroid Features

© Adrian Piper
6/22/81

ADRIAN PIPER (1948–)
Self-Portrait Exaggerating My Negroid Features, 1981
Pencil on paper, 25.4 × 20.3 cm (10 × 8 in)
Collection of the artist

FRANCISCO TOLEDO (1940–)
Self-Portrait XIX, 1999
Aquatint, 32.5 × 24.5 cm (12¼ × 9⅝ in)

516

JEAN-MICHEL BASQUIAT (1960–88)
Self-Portrait as a Heel – Part Two, 1982
Acrylic and oil paintstick on canvas, 243.8 × 154.9 cm (96 × 61 in)
Private collection

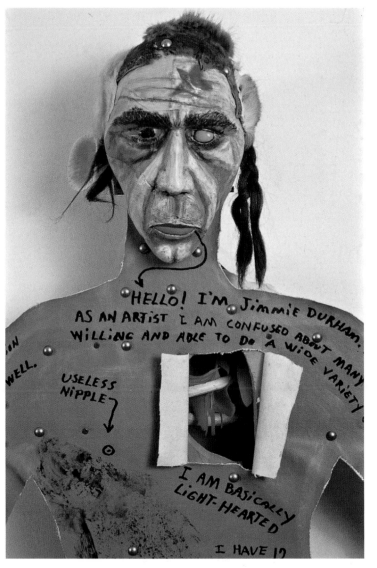

JIMMIE DURHAM (1940–)
Self-Portrait (JD 56), 1987 (detail)
Canvas, wood and mixed media, dimensions of whole 182.7 × 91.3 × 30.6 cm (72 × 36 × 12 in)
Private collection

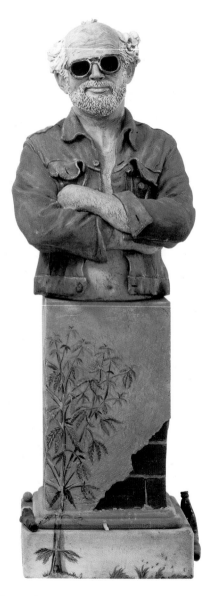

ROBERT ARNESON (1930–92)
California Artist, 1982
Stoneware with glazes, 173.4 × 69.9 × 51.5 cm (68$^1/_4$ × 27$^1/_2$ × 20$^1/_4$ in)
San Francisco Museum of Modern Art

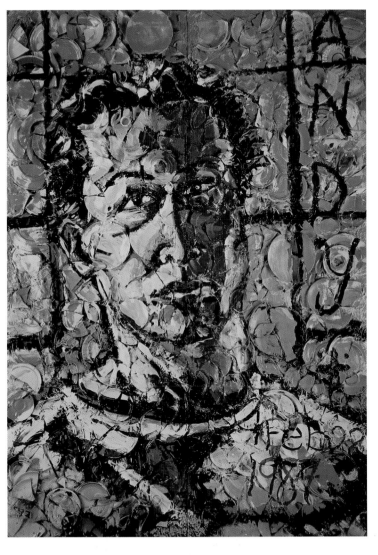

JULIAN SCHNABEL (1951–)
Self-Portrait in Andy's Shadow, 1987
Oil, bondo and plates on wood, 261.3 × 182.6 cm (103 × 72 in)
The Eli and Edythe L Broad Collection, Santa Monica

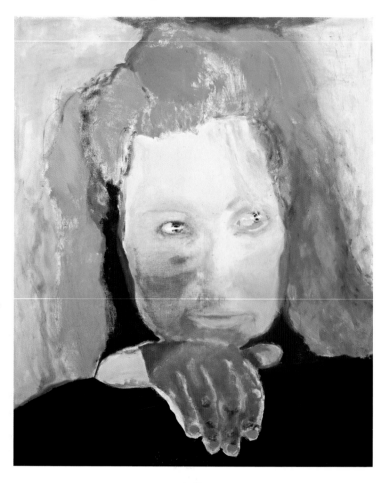

MARLENE DUMAS (1953–)
Evil is Banal, 1984
Oil on canvas, 125 × 105 cm (49¹⁄₄ × 41³⁄₈ in)
Stedelijk Van Abbemuseum, Eindhoven

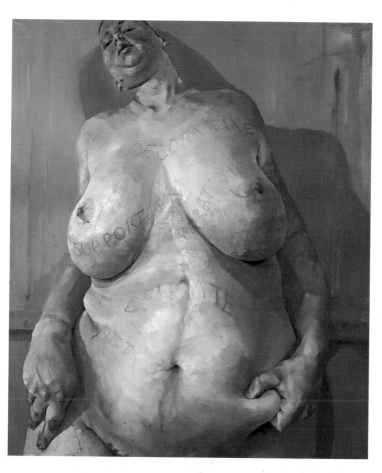

JENNY SAVILLE (1970–)
Branded, 1992
Oil on canvas, 213.5 × 183 cm (84 × 72 in)
Saatchi Gallery, London

522

CINDY SHERMAN (1954–)
Untitled, 1989
Colour photograph, 135.7 × 102.1 cm (53½ × 40¼ in)

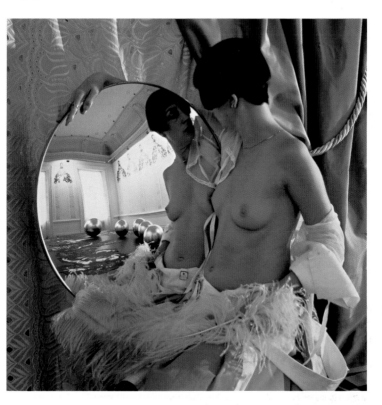

523

HELEN CHADWICK (1953–96)
Vanity, 1986
Cibachrome print

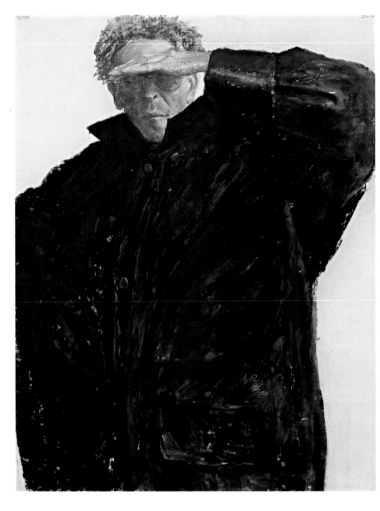

AVIGDOR ARIKHA (1929–)
Self-Portrait in a Raincoat, Peering, 1988
Pastel on emery paper, 70.5 × 55.5 cm (27³⁄₄ × 21⁷⁄₈ in)
Private collection

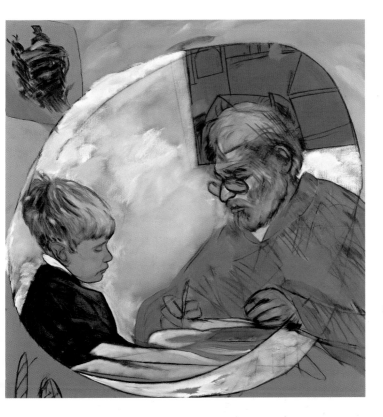

525

R B KITAJ (1932–)
I and Thou, 1990–2
Oil on canvas, 122.6 × 122.6 cm (48¼ × 48¼ in)
Private collection

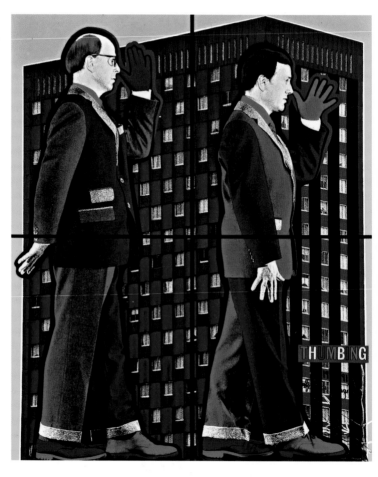

GILBERT AND GEORGE (1943–; 1942–)
Thumbing, 1991
Photopiece, 169 × 142 cm (66⅝ × 56 in)

527

YASUMASA MORIMURA (1951–)
'Doublannage' (Dancer I), 1989
Colour photograph, 240 × 120 cm (94$\frac{1}{2}$ × 47$\frac{1}{4}$ in)

528

529

MARC QUINN (1964–)
Self, 1991
Blood, stainless steel, perspex and refrigeration equipment, dimensions including pedestal
208 × 63 × 63 cm (82 × 25 × 25 in)
Saatchi Gallery, London

GILLIAN WEARING (1963–)
Dancing in Peckham, 1994
Video still
Edition of 10

SHIRIN NESHAT (1957–)
Seeking Martyrdom, 1995
Black and white photograph and ink, 152.5 × 101.5 cm (60 × 40 in)
Private collection

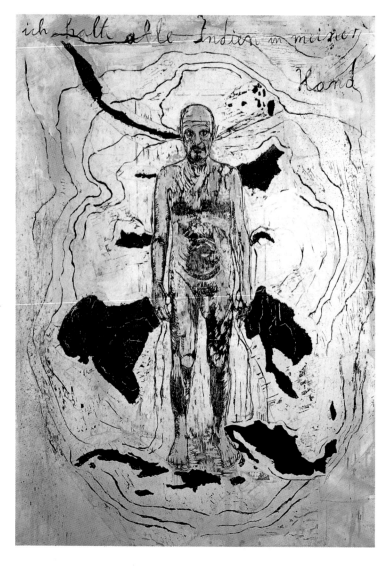

ANSELM KIEFER (1945–)
I Hold All Indias in my Hand, 1996
Woodcut, shellac and acrylic on canvas, 300 × 200 cm (118¹⁄₈ × 78³⁄₄ in)
Private collection

533

SARAH LUCAS (1962–)
Fighting Fire with Fire, 1996
Black and white photograph, 152.5 × 122 cm (60 × 48 in)

534

RON MUECK (1958–)
Mask, 1997
Polyester resin and mixed media, 158 × 153 × 124 cm (62 ¹⁄₄ × 60 ¹⁄₄ × 48 ⁷⁄₈ in)
Saatchi Gallery, London

MAURIZIO CATTELAN (1960–)
Spermini (Little Sperms), 1997 (detail)
Latex, paint, 500 heads, each 10 × 15 × 10 cm (4 × 6 × 4 in)
Installation, Galleria Massimo Minini, Brescia

539

541

Phaidon would like to thank all the private individuals and museums and galleries credited alongside the pictures who have kindly provided material for publication. Additional credits are as follows:

Acquavella Gallery, New York: 493; Advertising Archives, London: 479; AKG, London: 86, 340, 377, 440, 460, photo Erich Lessing 18, 55–7, 63, 76, 161, 375; Albright-Knox Art Gallery, Buffalo, New York: Room of Contemporary Art Fund (1942) 455; Allan Stone Gallery, New York: 473; Andrea Rosen Gallery, New York: courtesy of John Coplans 511; Anthony d'Offay Gallery, London: 532, 534, © Jeff Koons 528; Archivio Boetti, Rome: 499; Art & Commerce Anthology Inc, New York: 510; The Art Institute of Chicago: photo © 2000, All Rights Reserved/Mary and Earle Ludgin Collection (1981.257) 456; Art Resource, New York: 231, 304, 308, 317, 380, 405, 411, 419, 435, 452, 461, 512; Artephot, Paris: photo Nimatallah 273; Artothek, Peissenberg: 175, 178, 204, 207, 239, 262, 369, 428, photo Bayer & Mitko 220, photo Constantin Beyer 246, photo Joachim Blauel 126, 240, 300, 344, 348, 403, 407, 489, photo Blauel/Gnamm 46, 153, 441, photo Ursula Edelmann 183, photo Hans Hinz 64, 245, 299, 429, photo Bernd Kirtz 467, photo Jochen Remmer 326; Association Alberto et Annette Giacometti, Paris: photo Sabine Weiss 484; Association des Amis de Jacques-Henri Lartigue © Ministère de la Culture, France: 408; Baltimore Museum of Art: gift of Dr Morton K Blaustein, Barbara B Hirschhorn and Elizabeth B Roswell, in memory of Jacob and Hilda K Blaustein 225; Barbara Gladstone Gallery, New York: 531; Ernst Barlach Stiftung, Güstrow: photo Uwe Seemann 339; Nicolò Orsi Battaglini, Florence: 29, 109; Beeldrecht, Amstelveen: 322, 395; Bernard Jacobson Gallery, London: 443; Bibliothèque Nationale de France, Paris: frontispiece, 289; Ruth Bowman Collection, USA: photo Charles Uht 472; Bridgeman Art Library, London: 90, 135, 174, 291, 294, 312–3, 364, 371, 382, 391, 422, 458, 462; British Museum, London: 77, 150, 186; Broad Art Foundation, Santa Monica, CA: 519; Carnegie Museum of Art, Pittsburgh: Carnegie Institute Purchase 370; Centraal Museum, Utrecht: photo Ernst Moritz 120; Charleston Trust, Lewes: photo David Pardoe 480; Christie's Images Ltd, London: © 2000 306, 365, 423; Christie's Images Inc, New York: 516; Colnaghi, London: 119; Cordon Art BV, Baarn, Holland: © 2000, all rights reserved 470; Arnold Crane Collection, USA: 404; Davenport Museum of Art, Iowa: museum purchase through the Friends of the Davenport Museum of Art Endowment Fund 448; Robert Del Principe, New York: 514; by kind permission of His Grace The Duke of Westminster OBE TD DL 133; Archives Denyse Durand-Ruel, France: 295; English Heritage Photographic Library, London: 143, 181; Fine Arts Museums of San Francisco: Mildred Anna Williams Collection (1961.16) 288; Fondation Martin Bodmer, Cologny–Geneva: 14; Fraenkel Gallery, San Francisco: 491; Fuji Television Gallery, Tokyo: 353; Fundación Coleccion Thyssen-Bornemisza, Madrid: 74; courtesy Galerie Bruno Bischofberger, Zurich: 508; Galerie der Stadt, Stuttgart: 383; Galerie St Etienne, New York: 469; Galerie Micheline Szwajcer, Antwerp: 517; Galerie Ulysses, Vienna: © Arnulf Rainer 505; Galleria Nazionale Palazzo Pilotta, Parma/Soprintendenza Beni Artistici e Storici: 232; Garton & Co., Devizes: photo P J Gates Photography Ltd 341; Photographie Giraudon, Paris: 73, 91, 146, 151, 215, 247, 292, 307, 309, 315, 325, 351, 367, 392, 396, 442, 483, Giraudon/Alinari 40–1, 88, 269, 366, Giraudon/Lauros 85, 202, 320, 409, 434, 450, Giraudon/Photothèque René Magritte 459; Nan Goldin, New York: 513; Herzog Anton-Ulrich Museum, Braunschweig: photo Bernd-Peter Keiser 62, 187; courtesy Howard Greenberg Gallery, New York: © Joan Munkacsi 446; © David Hockney, USA: 506–7; Hulton Getty Picture Collection, London: Weegee/ICP/Hulton Getty 477; Index, Barcelona: 471; Index, Florence: photo Carrà 415, photo Pizzi 72, photo Summerfield 78, 105, 129, 170–1, 203, 229, 268, 334, photo Tosi 114, 162, 172, 259; Instituto Português de Museus, Lisbon: 354; Istituto Nazionale per la Grafica, Rome/Ministero per I Beni e le Attivita Culturali 147; Jasper Johns, USA: 490; Jersey Heritage Trust, St Helier: 430; Katholisches Pfarramt der Alt-Katholiken, Baden Baden: 70; Katrin Bellinger Kunsthandel, Munich: 194; Kettle's Yard, University of Cambridge: 436; Kunsthalle, Hamburg: photo Elke Walford 177, 261, 264; © Kunsthaus Zürich 2000, All Rights Reserved/Gottfried Keller-Foundation, Winterthur 95; Kunstindustrimuseet, Copenhagen: photo Ole Woldbye 319; Kunstmuseum Winterthur: gift of Gebrüder Sulzer AG zum 125 jährigen Firmenjubiläum, (1959) 414; Kunstsammlungen zu Weimar:

545

547

548

Phaidon Press Limited
Regent's Wharf
All Saints Street
London N1 9PA

First published 2000
© 2000 Phaidon Press Limited

ISBN 0 7148 3959 0

A CIP catalogue record for this book is available
from the British Library

Printed in China